MICHELANGELO AND THE VIEWER IN HIS TIME

☞ Books in the renaissance lives series explore and illustrate the life histories and achievements of significant artists, intellectuals and scientists in the early modern world. They delve into literature, philosophy, the history of art, science and natural history and cover narratives of exploration, statecraft and technology.

Series Editor: François Quiviger

Already published

Blaise Pascal: Miracles and Reason *Mary Ann Caws*

Caravaggio and the Creation of Modernity *Troy Thomas*

Hieronymus Bosch: Visions and Nightmares *Nils Büttner*

Michelangelo and the Viewer in His Time *Bernadine Barnes*

MICHELANGELO

and the Viewer in His Time

BERNADINE BARNES

REAKTION BOOKS

To my mother, Anastasia Ostrenga

Published by Reaktion Books Ltd
Unit 32, Waterside
44–48 Wharf Road
London N1 7UX, UK
www.reaktionbooks.co.uk

First published 2017

Copyright © Bernadine Barnes 2017

Printed and bound in China by 1010 Printing International Ltd

A catalogue record for this book is available from the British Library

ISBN 978 1 78023 740 4

COVER: Michelangelo Buonarroti, *The Holy Family* ('Doni Tondo'), c. 1507, oil on wood, diam. 173 cm with (original) frame. Galleria degli Uffizi, Florence (photo Nicolo Orsi Battaglini/Art Resource, NY).

CONTENTS

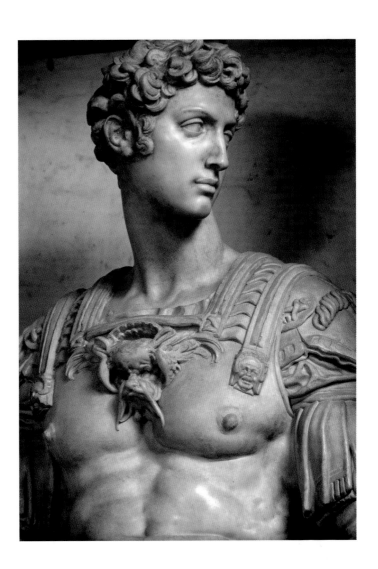

Introduction

ICHELANGELO HAS ALWAYS been seen as the heroically defiant artist – an individual creator who fought with patrons, scorned public reactions and created works that stood apart from the norms of society. It is my contention that these outbursts, anecdotes and quirks often mask a real concern for how the works should be seen by a specific audience. There were indeed conflicts with viewers but, from the beginning, how people saw his works mattered very much to Michelangelo. Some of his most famous works from his early career show adjustments made to compensate for the viewer's positions. Negative criticism of the artist's later work was not so much the result of Michelangelo turning his back on his audience, but due to the fact that the audience that responded to his work turned out to be very different from the one he thought would be viewing it.

Did people who lived in the fifteenth and sixteenth century see differently from ourselves? Certainly the development of linear perspective – the result of the study of optics and mathematics – meant that artists could create a world on a two-dimensional surface that would appear to be as 'real' as

1 Michelangelo, *Giuliano de' Medici* from the Medici Chapel of San Lorenzo, Florence, 1524–34, marble.

the world they lived in. Perspective dramatically changed ways of seeing, and some have considered it the defining characteristic of Renaissance visuality.[1] But few Renaissance artists played entirely by the rules, and they often made adjustments to correct for the distortions created by the perspective construction itself. Some artists – and I believe Michelangelo should be counted among them – recognized that perspective created not truth but illusion, and that illusion could be adjusted to call attention to itself. Much of Michelangelo's work through the early 1530s demonstrates that he was more interested in the distortions of vision than the certitude of perspective, as seen, for example, in some details of the Laurentian Library in Florence.

Michelangelo clearly knew the correct way to create space through perspective, but, with only one very interesting exception – the framework of the Sistine Chapel ceiling – he avoided perspectival constructions. Late in life he even corrected his biographer, Ascanio Condivi, who said that Michelangelo had studied the theory of perspective – such study, Michelangelo said, was 'a waste of time'.[2] Instead, he claimed to have 'compasses in his eyes' and said that he adjusted the proportion of figures according to the 'judgment of the eye'.[3] His work shows that, rather than creating a space and then inserting bodies into it, he created space through bodies. Foreshortening – a way of drawing a body or a limb so that it seems to extend perpendicularly from the picture's surface – was an especially important way of achieving spatial effects, and in the Renaissance it was associated with boldness and even violence. Foreshortening was difficult to do, as was the accurate description of anatomy, especially of figures in

extreme motion.[4] With good reason, Michelangelo became famous for his foreshortened and highly convoluted figures. These figures grabbed the viewers' attention and directed it to the important parts of a painting, but they also called attention to the skill and boldness of the artist.

Michelangelo's viewers, however, are not simply eyes gazing at a work. They are different sorts of people who engage with his work in various ways. They might be pilgrims who approach and move past a sculpture, sometimes touching it or imagining that the sacred figure is actually present, not just represented. They might be sophisticated connoisseurs who compare a sculpture to other works nearby or walk around it to observe it from every angle. They enter buildings and move up stairways or look through framing doorways. If they are fortunate enough to enter the spaces where Michelangelo's frescoes are painted, it is likely that they will be involved in specific rituals, moving through the spaces or being seated in specific ways that affect how the painting is seen. Even if some of his work may be seen from a fixed point of view, the work will be set in a context that conditions how people respond. This is true of devotional, domestic and even erotic works.

Michelangelo, like most Renaissance artists, gave visual form to many things not seen by human eyes: God and angels, apparitions and inner visions. After meeting Vittoria Colonna, and probably under her influence, Michelangelo wrote poetry that contrasted ordinary seeing to 'seeing with the heart' or to images 'impressed upon the heart'. Particularly in his late work, Michelangelo seems to have turned away from recording what is seen to making objects that allow the

formation of interior images.⁵ The visionary experience extends to architecture, particularly at St Peter's, where light, unity, openness and verticality create an experience for the visitor that leads them to the divine. Michelangelo's late work suggests that the object others would see mattered less than his own process of making it, as seen in his continuous cutting away at the late *Pietàs*.⁶

In this book, I want to call attention to those works that demonstrate Michelangelo's consideration of the people who encountered his work. It is impossible to know what any individual truly experienced, let alone what the many thousands of contemporaries who saw Michelangelo's work in public spaces felt, but there are certain strategies that help us get a partial sense of their experience. Imagining the original setting is one such strategy. Paintings and sculptures were almost always created with a particular setting and viewer in mind. However, recreating the original viewing conditions of a piece is often difficult, since many pieces were made for a specific location, only to be installed in another. In some cases, the object is still in its original setting, but the space itself has changed. Architecture is most problematic, since most projects were not completed in Michelangelo's lifetime and were often modified by later architects.

Written responses offer other insights. Some sixteenth-century viewers did describe their own reactions or what others said about an object. These range from travellers' reports and anecdotes, to discussions in theoretical treatises. Published criticism, biographies and guidebooks are types of sources that came to prominence in the sixteenth century; these provide valuable information about what really mattered to people

who lived in Michelangelo's time. However, each author
works within a genre, and each has particular motivations and
audiences in mind for a particular text.

Very few people who encountered Michelangelo's work
had any say in its formation. Still, patrons are an important
subgroup of viewers because they often convey expectations
about the subject of a piece or the type of space in which
it will be shown. Even if they were sometimes disappointed
because projects ran over budget or were never done, as a
group Michelangelo's most important patrons encouraged
him with their own ambitions and allowed him extraordinary
freedom to realize his vision.

Though it is difficult to be certain about who Michel-
angelo's intended viewers might have been, only rarely did
he offer a work for sale without a known buyer, and he could
not have imagined his drawings, paintings or sculptures
enshrined in museums. It is also not likely that he imagined
people studying his works in close-up detail, or comparing
them side-by-side as we are able to do in books or on the
Internet. The technology that allows viewing activities such
as these was only beginning to take shape in the sixteenth
century with the development of printed reproductions.
Michelangelo, it seems, was taken by surprise by this shift in
viewing practice and never fully adapted to it.

In doing the research for this book, I became keenly aware
of how many scholars and critics have considered the viewer
of Michelangelo's work. Often the viewer or audience is
mentioned in passing, but at other times the presence of an
ideal viewer is essential to an interpretation. Critical methods

have evolved so that there is now more interest in difference (political, gender, class and so on) within the audience, and in ritual or social contexts. In an effort to keep references to a minimum, I have focused on more recent literature that is accessible to English-speaking readers but which also contains precise references to earlier scholarship. Documents and letters are referred to by date to facilitate finding them in various editions. I refer often to the biographies by Giorgio Vasari (first published in 1550, with a revised and expanded edition published in 1568) and Ascanio Condivi (1553). These are valuable sources of information by contemporaries who knew the artist well; both claimed to have studied with Michelangelo, and Condivi seems often to record Michelangelo's own words, even if he sometimes misstates a point. There were no illustrations of artworks in their books, so both Vasari and Condivi needed to describe objects precisely so that their readers could visualize them. These authors record their own viewing experience and encourage their readers to see Michelangelo's work in particular ways. Again, these works are available in various editions, and the specific passages can be found without much difficulty.[7]

The Artist in Search of an Audience

RTISTS IN FIFTEENTH-CENTURY Italy worked for an audience. The idea that they would create a painting or a sculpture simply to express themselves is almost unimaginable. Major works were commissioned, while more routine productions stocked in workshops were aimed at a known market – a nicely crafted crucifix or Madonna and Child painting could always find a buyer. Michelangelo began his artistic career in a workshop that catered particularly well to client needs. In 1488, when Michelangelo was thirteen years old, his father signed an agreement that placed the boy as an apprentice in the Ghirlandaio workshop; another document reveals that he had already worked there at least a year earlier.[1] At the time the Ghirlandaio shop was one of the most active in Florence; altarpieces, portraits and frescoes were produced efficiently and in great number by the brothers, Domenico and Davide, and their large workshop. Best known are the fresco decorations in chapels commissioned by some of the most prominent families in Florence. Located in churches that served the larger community, the paintings gave visual form to important religious narratives so that ordinary Christians could understand and

remember those stories. The chapels also served the families who commissioned them: they affirmed the family's status since they were demonstrations of their taste and wealth, and they served as permanent memorials for deceased family members who were buried there. The Ghirlandaio workshop specialized in a type of painting that acknowledged the patrons in a most direct way: members of the family and their political allies would figure as supporting cast members within sacred dramas.

It is commonplace to cast Michelangelo as the brilliant student who completely rejected Domenico Ghirlandaio's style; Michelangelo himself can be credited with creating that impression, since late in his life he had his biographer Ascanio Condivi state that Ghirlandaio did not help him at all. Ghirlandaio plays the role of the plodding, prosaic old master to Michelangelo's fiercely creative, energetic young genius. But Ghirlandaio certainly taught him something. Undoubtedly he learned the technical skills needed to paint both panels and fresco. He probably learned something about colour from him as well, since Ghirlandaio's frescoes have a freshness and variety that aid their readability in dark chapels. These are skills that would be necessary some twenty years later when Michelangelo, rather unexpectedly, was given the commission to paint the Sistine Chapel ceiling.

We see something of what Michelangelo learned from Ghirlandaio by turning to his early drawings. Those that survive typically show only one or two heavily draped, bulky figures derived from frescoes by Giotto or Masaccio (illus. 2).[2] Copying was the normal practice in a Renaissance workshop. A young artist first learned from other masters; only

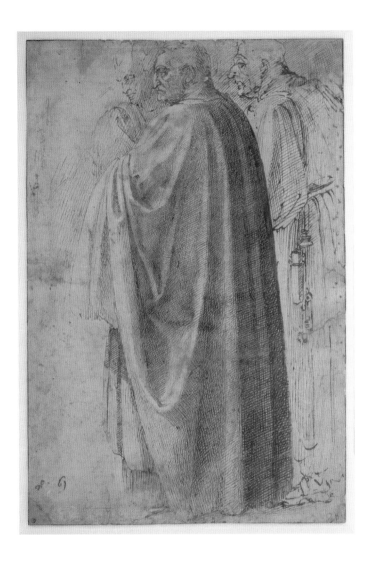

2 Michelangelo, *Three Standing Men*, c. 1492, pen and brown ink.

when the student had absorbed the styles of the best of his predecessors did he begin to develop his own style. Although none of the surviving drawings are related to Ghirlandaio's projects, the technique still owes much to Ghirlandaio. These are finely worked, beautifully observed pen-and-ink drawings, showing layers of cross-hatching to create subtle variations of light and dark. Some are done with different coloured inks or heightened with white to give them a more colouristic effect. Ghirlandaio himself used layers of cross-hatching on his pen-and-ink figure studies, although they are looser and less controlled. When Ghirlandaio wanted to study light falling on folds of cloth he often used wash on linen or paper – a technique that closely approximated painting – or chalk on coloured paper.[3] The sizes and focused nature of Michelangelo's early drawings are quite close to Ghirlandaio's drapery studies, but Michelangelo consistently relied on pen. Perhaps he was trying to outdo Ghirlandaio's pen technique, but there was probably another source of inspiration too. Michelangelo's subtle webs of cross-hatching may have been inspired by engravings, like the *Temptation of St Anthony* by Martin Schongauer, which Michelangelo's friend Francesco Granacci brought to him. Vasari says he copied the engraving first in pen and then with coloured paint on panel.

And yet there are many things that these drawings are not. No composition sketches survive from this period, but this is something that Ghirlandaio, as master of the shop, took upon himself and for which he became renowned. The early drawings do not show spatial constructions, although Vasari notes that Michelangelo made a drawing of his fellow artists from Ghirlandaio's shop at work on the scaffolding in the Tornabuoni

Chapel. Was this Michelangelo's attempt to demonstrate that he could set figures on realistically depicted stages just as Ghirlandaio did? Most conspicuously, Michelangelo's drawings are not portraits of respected members of Florentine society – one of Ghirlandaio's trademark methods of connecting with the viewers of his painting. Michelangelo's lifelong aversion to portraiture may have already been at work, but painting the portraits was another task Ghirlandaio kept to himself. Ghirlandaio's manner of inserting contemporary figures into sacred stories may have seemed too obvious or too jarring a break with the religious scene.

Though these surviving drawings were never used in a finished painting, they and the stories that surround them speak to the importance of sharing drawings. Michelangelo's memories of his conflict with Ghirlandaio centre on not getting access to a model book. Granacci encouraged Michelangelo's earliest artistic endeavours by bringing him drawings as well as the Schongauer print. The size and degree of finish of Michelangelo's early drawings suggest that he hoped to use them as models for other works. These drawings were kept, and although sketches on the back or in the margins reveal that they were reused later, the early finished figures are not obscured. It is easy to imagine Michelangelo himself looking at them and remembering his earliest efforts.

Michelangelo worked in Ghirlandaio's shop for as long as three years, but then he moved on to a very different kind of environment. Lorenzo de' Medici, the de facto ruler of Florence, had become interested in reviving the art of sculpture there, since two of the best sculptors of the city were no longer available: Andrea del Verrocchio had died in 1488,

and Antonio del Pollaiuolo was involved in projects outside
of the city. It is possible that Michelangelo's friend Francesco
Granacci, five years older than him and a fellow painter in
the Ghirlandaio shop, suggested that they present themselves
to Lorenzo, but it is more likely that, as Vasari says, Ghirlan-
daio was asked for recommendations. However it happened,
Michelangelo was brought to the Medici garden near San
Marco to learn the art of sculpture. Bertoldo di Giovanni, a
former assistant of Donatello, was head sculptor there, and
he may have instructed Michelangelo and the other young
sculptors in whatever technical problems they encountered.
But the Medici sculpture garden was not an art academy;
rather, it was a place where performances took place and
where some of Lorenzo's collection of ancient sculpture was
displayed.[4] The young men who came to the garden to learn
sculpture learned from his collection, just as they learned
about painting from the frescoes in local churches.

Lorenzo not only allowed Michelangelo access to his
collection, but made him part of his household. Michel-
angelo shared experiences with Lorenzo's son Giovanni and
nephew Giulio, who as popes Leo x and Clement VII would
later become his patrons, and he was taught by the learned
men whom Lorenzo had gathered around him. The men in
Lorenzo's circle were brilliantly creative; their projects involved
synthesizing the classical myths with Christian beliefs, search-
ing for ever more ancient truths and exploring new modes of
writing and thinking. One of those scholars, Angelo Poliziano,
served as a tutor to the Medici children, and from him Michel-
angelo heard the stories of the Lapiths and Centaurs and the
rape of Deianira. In Michelangelo's relief *Battle of the Centaurs*

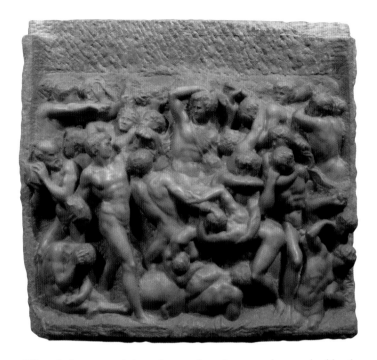

(illus. 3), he merged them into a chaotic scene that evoked both stories but quoted neither. It may have been Poliziano who encouraged the young sculptor to leave the stone unfinished – it was he who felt that poetry was never finished.[5] In Lorenzo's household Michelangelo experienced something about what the creative process was; how to take a literary source and make something more of it and how to stop before all details were defined, leaving something for the viewer to complete. This early exposure to classical art, poetry and philosophy surely allowed him to see how art could be imbued with meaning. More importantly, in the Medici household Michelangelo learned how a true patron would allow a creative person the freedom to explore and experiment.

3 Michelangelo, *Battle of the Centaurs*, c. 1492, marble.

The two surviving pieces that Michelangelo created in the Medici garden are both creative adaptations of early models; they seem not to have been commissioned to serve a particular purpose. His *Battle of the Centaurs* is a tangle of bodies that refers to a specific literary source only in the most subtle way – through a horse's rump and hoof at the lower edge, and the fact that the lower body of the man in the centre dissolves into what we can imagine is the body of a centaur. The piece is riotous and dense, but open to interpretation. A bald and bearded man at left prepares to hurl a rock; a younger man in the lower left corner holds his head as if injured; a woman wraps her arm around the neck of a man – is she struggling or holding on? Whether Michelangelo wanted the relief to be read in a particular way is unknown, but we do know that he treasured this early effort; years later, he told Condivi that he should have known then that he was meant to be a sculptor.

The other sculpture probably made while Michelangelo was in the household of Lorenzo de' Medici is the *Madonna of the Steps* (illus. 4). This relief is in many ways opposite to the *Battle of the Centaurs* – in fact, it has been suggested that the two sculptures are pendants, although this can only be true in a metaphorical sense, since they are very different in format and size. In terms of subject-matter they are opposites, one pagan and the other religious. They also display very different marble carving techniques: *Battle of the Centaurs* is carved in half-relief, with some figures approaching full three-dimensionality, while the *Madonna of the Steps* is carved in very low relief, known as *schiacciato*. This challenging technique relies on visual effect rather than three-dimensional, tactile form. The sculptor attempts to make sculpture do what drawing or painting is

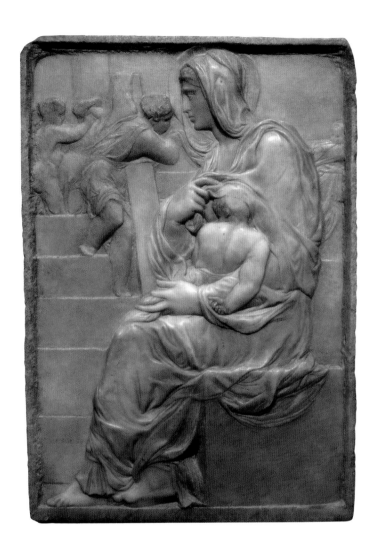

4 Michelangelo, *Madonna of the Steps*, c. 1491, marble.

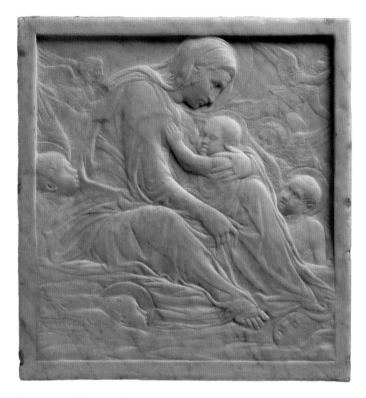

best suited for, such as creating subtle recession in space and atmospheric effects. Several of Donatello's experiments in *schiacciato* were easily accessible in Florence at the time (illus. 5), and similar, very low-relief sculptures were done by other artists, including Bertoldo.[6] The contrasting carving techniques in the two reliefs can be seen as another similarity: both are attempts to learn from and perhaps surpass two great models. In the *Centaurs* relief, Michelangelo is emulating the ancients, since his model was ultimately a Roman sarcophagus owned by Lorenzo de' Medici, while the *Madonna* relief invites comparison to Donatello, the greatest sculptor of the fifteenth

5 Donatello, *Madonna of the Clouds*, 1425–35, marble.

century. The *Madonna of the Steps* may not have been as valued by Michelangelo as much as the *Centaurs* relief. It may be this relief that he asked his father to pack away without letting others see it.[7] Even though he kept it among his possessions, he may have felt displeasure with its various awkward passages, especially the poorly proportioned right foot and the illogical drapery. While Michelangelo may have found this piece less than successful, the awareness that sculpture could be carved to create illusionistic effects would stay with him.

The Virgin Mary nursing the infant Jesus was a common theme in the Renaissance. When displayed in a domestic setting, the image would have served as a model for mothers, even if many mothers – including Michelangelo's – did not breastfeed their own children.[8] This early relief, however, seems not to have been displayed in a home, and its message is mixed. The Madonna is aloof, gazing off to the distance, focusing on neither her son nor the several children around her. Only part of her breast remains exposed as she covers it with her robe; she has apparently finished feeding the child, who has fallen asleep, slumped with his back towards the viewer. Perhaps Michelangelo expressed in the piece his personal feeling towards his own mother, without concern for its meaning to others.

The works of art that Michelangelo produced up to this point were not commissioned works – they were studies and experiments, demonstrating what he could do, what he had learned and how he synthesized or reacted to ideas that he had heard. They were generally done for his own purposes, and they were viewed by others in relatively restricted settings. The situation changed after Lorenzo de' Medici died in 1492.

Michelangelo left the household for a time, but it is likely that his career was still facilitated by Lorenzo's son, Piero de' Medici. Piero may have thought of Michelangelo as something like a court artist, creating whatever decorative object may have been needed at court. At least, so it seems from the single work that Piero asked him to make: a snowman. Nothing survives of that snow sculpture, of course. A statue of Hercules carved by Michelangelo at this time may have been an object of self-expression, but it is unlikely that he, only about eighteen years old at the time, could have purchased this block of stone, which was more than two metres tall – even if it was a castoff from some other project. It is more likely that Michelangelo was asked to create the piece by Piero, or possibly by the Strozzi family.[9] By 1506 the statue was in the Palazzo Strozzi, where it remained until around 1530, when it was sent to Francis I, the king of France, as a diplomatic gift. Michelangelo may not have known the intended location of the work when he designed it, and there is no way to know if he considered the viewer of this large sculpture in any specific way; the *Hercules* has been lost since the eighteenth century.

Michelangelo did have one commission for a specific location in these early years in Florence: a crucifix made for the prior of Santo Spirito (illus. 6) in exchange for cadavers, which Michelangelo dissected. This too was a situation in which Piero de' Medici probably played a role, since Piero had been elected to the administrative board of Santo Spirito in 1493,[10] around the same time the crucifix was made. The nearly life-size crucifix was originally placed so that it was visible just beyond the main altar.[11] This was a prestigious place for a sculpture no matter who made it, but also a traditional place;

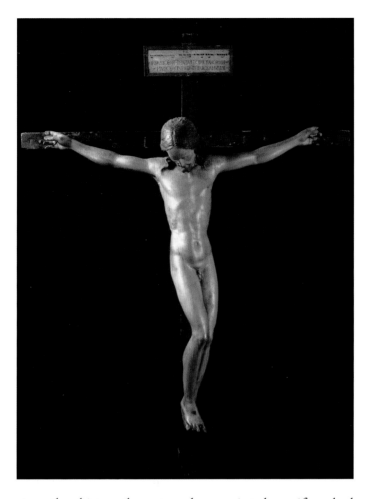

since the thirteenth century, large painted crucifixes had been set near the sanctuaries of churches, but by the fifteenth century sculptural crucifixes were more common, mounted or suspended above altars in choirs or side chapels. Often carved from wood, they were typically life-size and would frequently be provided with real loincloths, which increased

6 Michelangelo, crucifix, 1493/4, polychrome wood.

the sense that worshippers were seeing Christ's true presence. Michelangelo's crucifix is delicately modelled and highly realistic. The body is painted a pale flesh tone, with red streaks and droplets representing blood falling from Christ's wounds and from his forehead, where a crown of thorns would have been affixed. His hair is made of fibres covered with stucco; a loincloth would have covered Christ's genitals.[12] The intriguing plaque is inscribed with the words 'Jesus of Nazareth, King of the Jews' in three languages: Hebrew, Greek and Latin. The words read from right to left, in emulation of a relic found in Rome in 1492, which was thought to be the very sign that Pontius Pilate had placed above the cross of Jesus. Lorenzo de' Medici was told about the relic just before his death, and the inscription was publicized through woodcuts.[13] Michelangelo, probably working from a verbal description, corrected some letters for greater legibility, but otherwise repeated the orientation of all three inscriptions. For the pious visitor to the church, the realistic details of the figure and the 'authentic' inscription would have heightened the experience of seeing the real person of Christ. Some viewers may have reflected on the words of Girolamo Savonarola, the fiery Dominican preacher whose presence in Florence in these years left a lasting mark on Michelangelo. Savonarola's vivid description of Christ's body as 'delicate, and very sensitive' made the listener understand at a visceral level how intensely he would have felt the pain of the crucifixion.[14] Words like these may have inspired the slightness of this carving, which is so at odds with Michelangelo's later work.

In the tumultuous year of 1494, French troops marched through Florence and Piero de' Medici was driven from the city

in disgrace; in the subsequent power vacuum the charismatic preacher Savonarola took control. Only a month before the Medici were expelled from Florence, Michelangelo left their household intending to go to Venice, but he stopped in Bologna, where he found a patron whose broad learning and support may have reminded him of Lorenzo. Giovan Francesco Aldrovandi was a learned, wealthy and politically astute member of Bolognese society. The talented young artist read Dante and Petrarch to Aldrovandi, but there is little evidence that Michelangelo used his artistic talents for any purpose in the household. Still, Aldrovandi must have been instrumental in getting Michelangelo the commission to complete three small sculptures for the Arca di San Domenico (illus. 7), a large marble reliquary that held the remains of St Dominic, the great preacher of the early thirteenth century who founded the Dominican order. When seen in its entirety, Michelangelo's contributions blend in with the other sculptures already in place: his kneeling angel on the right corner below the sarcophagus is paired with Niccolò dell'Arca's angel opposite, while statues of Petronius and Proculus join those of six other saints along the edge of the sarcophagus lid. These three statues by Michelangelo are typically shown in isolation, but they would have been viewed – and still are – as part of the most important reliquary in Bologna. From its inception in the thirteenth century, the monument was meant to be free-standing; there are relief carvings on all four sides of the sarcophagus, and diagonally placed figures on the corners of the sarcophagus impel the viewer to move around it.[15] When it was first made, the sarcophagus was raised on figural supports, which would have increased visibility and also allowed

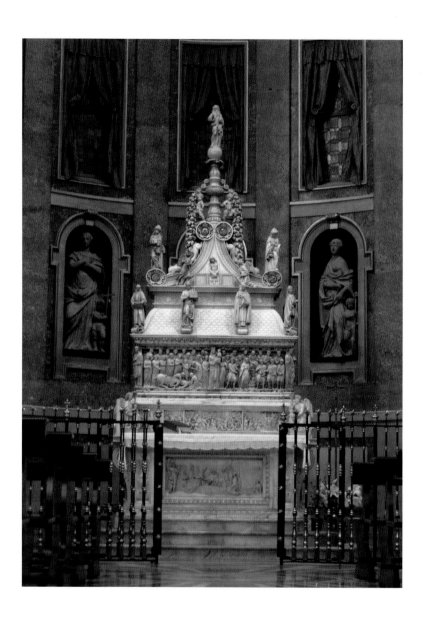

7 Nicola Pisano and others, Arca di San Domenico, begun *c.* 1265, marble.

pilgrims to stand below the saint's remains to receive more effectively their powers. The monument was further enriched in the late fourteenth and early fifteenth centuries, but the power of the relics it contained for the faithful was unabated. Believers very likely touched the monument as well, and many details on the oldest parts appear worn. Michelangelo seems to have wanted to emulate this effect on his kneeling angel holding a candlestick (illus. 8). The blurred surfaces, full facial features and generalized anatomy of the hands reflect the appearance of the earliest sculptures on the Arca, rather than the more recent additions by his immediate predecessor working on the tomb, Niccolò dell'Arca.[16] Even more than a reference to an archaic style, the finish on the angel seems to imitate the physical effect that hundreds of devout hands would have on a sacred sculpture. Of the three statues Michelangelo carved for the Arca di San Domenico, only this angel, kneeling within reach of the worshipper, shows these characteristics. His other two statues are set higher, and their proportions are adjusted so that they read most powerfully from below.[17] This is especially true of the young St Proculus (illus. 9), who is not visible unless the pilgrim enters the chapel. His position on the back of the shrine means that the viewer must look up at him from below – the rear wall of the chapel prevents the spectator from taking a more distant, level view. His body and especially his intense gaze is given more powerful presence as he looks down at the pilgrims visiting the shrine.

Michelangelo returned to Florence in 1495; Savonarola was still in control and Piero de' Medici still exiled. But another member of the Medici family, Piero's cousin Lorenzo

di Pierfrancesco de' Medici, played a role in Michelangelo's next career move, commissioning from the artist a statue of the young St John the Baptist. That sculpture is now lost, along with another sculpture that Lorenzo knew about – and indeed probably asked Michelangelo to make – the *Sleeping Cupid*. He definitely encouraged Michelangelo to give the *Cupid* a patina so that he could sell it in Rome under the pretence that it was an antique. Apparently neither of these modestly sized sculptures was made for a specific setting; the *Cupid* was simply sold – the buyer would choose the setting. This piece may have been Michelangelo's only one made for the open market. We do know exactly where one of its owners displayed it. In 1502, Cesare Borgia gave the *Cupid* to Isabella d'Este, the Marchesa of Mantua; Cesare had taken it as booty when he sacked Urbino. Isabella was an avid collector of ancient art, and a few years later she acquired a similar statue of a sleeping Cupid, which she thought was by the Greek sculptor Praxiteles. By the time of her death in 1539, the two sculptures were each displayed in cupboards on either side of a window.[18] Isabella knew that her first *Cupid* was carved by a modern sculptor, although she may not have known it to be by Michelangelo when she first acquired it. Guests would compare the two works to test their ability to recognize an authentic antique sculpture; the classical piece was expected to be the better work, but the two must have been similar enough to challenge the viewers. The creation of a counterfeit always implies that it will be compared to an authentic item, and judged equal to it if it is a success; Isabella's display of the *Cupid* is one documented instance where we know this happened.

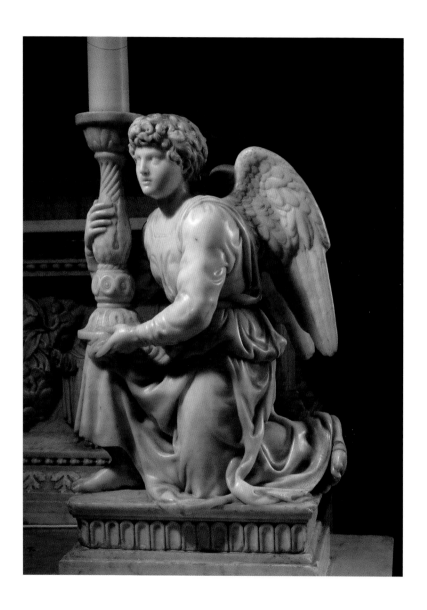

8 Michelangelo, kneeling angel, Arca di San Domenico, 1494–5, marble.

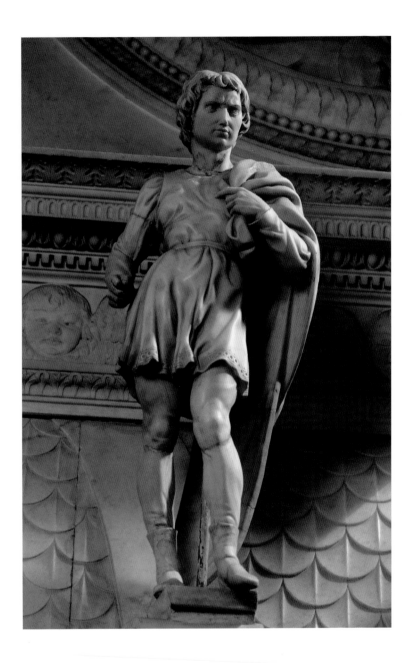

9 Michelangelo, *St Proculus*, Arca di San Domenico, 1494.

The *Sleeping Cupid* was first purchased by Cardinal Raffaele Riario, a grand-nephew of Pope Sixtus IV. The cardinal acquired it from a dealer under the pretence that it was an antique, only to learn afterwards that it was made by a young sculptor in Florence. The cardinal returned the sculpture to the dealer, but it is likely that the dealer's dishonesty, rather than his unhappiness with Michelangelo's sculpture, caused his dissatisfaction. He asked his friend Jacopo Galli to bring the young man to Rome, all expenses paid. Cardinal Riario must have been genuinely impressed with Michelangelo's ability to capture the spirit of Graeco-Roman sculpture, since he assigned to him the task of assessing his own collection of sculpture, which was on display at his new palace, the Cancelleria. By July 1496, three months after his arrival in Rome, Michelangelo was at work on the *Bacchus*, a life-size statue of the tottering god of wine with a young faun at his side (illus. 10). Documents show that Riario paid for the piece, but it was never delivered to him.[19] Condivi says that Michelangelo carved the *Bacchus* for Galli while Michelangelo was staying in his house, and the sculpture could still be seen there in the 1530s, when it was drawn by Maarten van Heemskerck. Its presence there does not necessarily mean the cardinal rejected it – he may have given it to Galli as a gift, or have been discouraged from installing it because of Pope Alexander VI's attempt to curtail the lavish activities of cardinals following the murder of his son, Juan.[20]

Michelangelo almost certainly expected the *Bacchus* to be set in the courtyard of Riario's palace, where visitors would be able to walk around it. The piece's meaning unfolds with each changing view. The cup Bacchus holds completely covers

the god's face when seen from slightly to the left;[21] Bacchus' glazed expression and teetering stance then appear. Finally, the fawn impishly holding the grapes becomes visible (illus. 11). In Riario's palace viewers would focus only on the *Bacchus*, but in Galli's garden, they would see it in a more crowded setting, amid other antique fragments. That new setting must have inspired Michelangelo to make the *Bacchus* appear more like a damaged classical carving. The right hand was very likely broken off by Michelangelo to give the piece a more antique air; by 1553, when Condivi described the sculpture, it had been replaced. The penis also appears to have been damaged, although chisel marks in this area suggest that the effect was intentional.[22] By 1591, the *Bacchus* had found its way into the Grand Ducal collections and was set among the classical sculptures in the gallery of the Uffizi. Francesco Bocchi described how it was placed there 'to invite comparison'; knowledgeable viewers found that the comparison proved 'Michelangelo's rare and singular merit'.[23]

Almost immediately after completing the *Bacchus* in the summer of 1497, Michelangelo began to plan what would become one of his most beloved sculptures, the *Pietà* (illus. 12). Through Cardinal Riario and Jacopo Galli, Michelangelo was introduced to Jean Bilhères de Lagraulas. The French cardinal had come to Rome in 1491 in a delegation sent by King Charles VIII, and quickly established himself as a key figure in diplomatic negotiations between the Vatican and France. In 1497 the cardinal was nearing the age of seventy and in declining health; the *Pietà* was meant to be his funerary monument. He died in August 1499.[24]

The *Pietà*'s original location was in Santa Petronilla, an ancient Roman rotunda attached to the south transept of

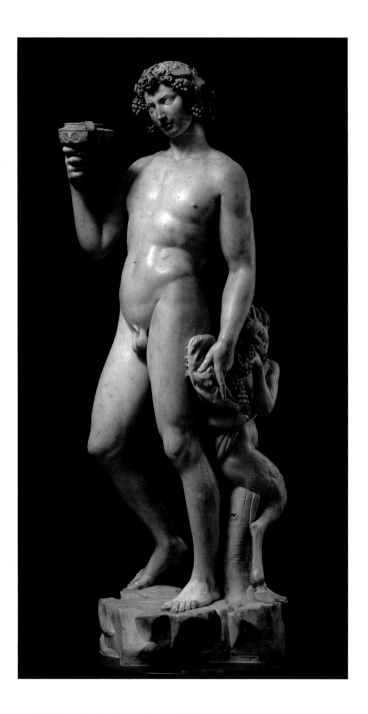

10 Michelangelo, *Bacchus*, 1496–7, marble.

Old St Peter's Basilica; the rotunda was used as an imperial mausoleum throughout the fifth century. It fell into disrepair in the next two centuries, but by the eighth century St Petronilla's relics were transferred to the rotunda, and at the same time she was named special protector of the French monarchy. St Petronilla was thought to be the virgin daughter of St Peter; whether she was or not, her reliquary monument was placed in a particularly honoured place. In a sense, she was interred at the right hand of St Peter, who was buried below the main altar of the church.[25] The chapel that held her relics was opposite the entry from the transept of St Peter's. The visitor would pass three other chapels on the right before coming to Petronilla's altar. Each of these chapels would have their own altar – sometimes more than one – decorated with artefacts, votive offerings and candles.[26]

We do not know where Michelangelo's statue was set beyond the fact that it was close to or within the chapel that held the relics of St Petronilla. It could not have been on the main altar in that chapel, since that was dedicated to the saint, but it may have been on the pier between two chapels, on one of the side walls of the Petronilla chapel, or in another chapel nearby. The sculptural group was almost certainly set in a niche, since the back is not polished, but we do not know at what height it was placed. If it had been set behind an altar, its base would have been at a height of around 1.5 metres, but the sculpture was commissioned to mark a tomb, and so it could have been placed much lower.[27] A crucifix may have been placed behind the group; Condivi mentions this addition, and it is seen in some, but not all, reproductive prints from the time.[28]

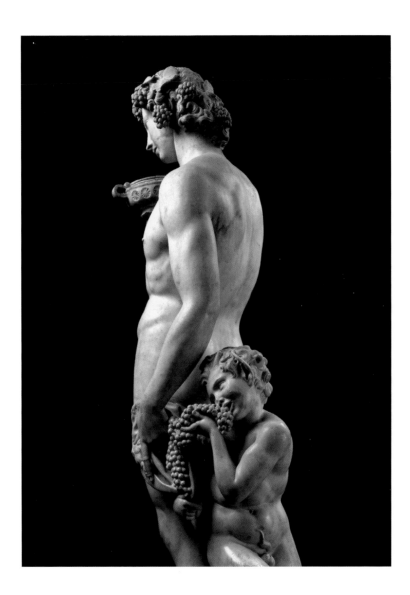

11 Michelangelo, *Bacchus*, detail.

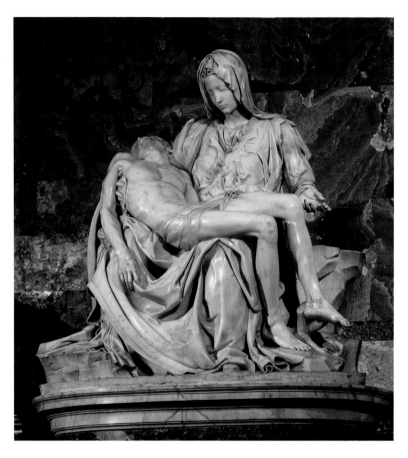

The arguments about the *Pietà*'s location make clear that
what a spectator focuses on and the emotion the viewer feels
depend very much on a specific point of view. When viewed
from the right, Mary's gesture opens towards the viewer,
but the head of Christ is invisible. As the spectator moves,
Christ's head comes into view. Mary's face is most clearly seen
from a low position. These shifting focal points correspond
to the movement of the pilgrim, who would pass slowly along

12 Michelangelo, *Pietà*, 1498, marble.

the front of the sculpture, perhaps kneeling to pray before moving forward. Still other details require close viewing: the wounds in Christ's hands, feet and side are worked so delicately that they are almost invisible from afar. Differences in the depth of carving also show an awareness of the viewer: Christ's left arm, which is almost invisible from any point of view except directly overhead, is carved almost as if in relief, while other areas, like the drapery folds above and below his right hand, are very deeply cut. The drapery makes the Virgin's body appear to be massive, while Christ's body wraps around hers, concealing its greater length.

The *Pietà* is also the first of Michelangelo's sculptures for which we have evidence of a public response. One story concerns the signature that Michelangelo carefully carved on the band across the Virgin's breast (illus. 13): the Latin can be translated as 'Michelangelo the Florentine was making this . . .'. It is said that Michelangelo signed the work after he overheard some men from Lombardy saying that the *Pietà* was carved by an artist from their region;[29] this anecdote was reported hesitantly to Vasari many years after it supposedly happened, and if there is any truth to it, it probably reveals only that many people were interested in the sculpture group and wanted to claim it as the work of a compatriot.[30] There is physical evidence that Michelangelo planned the inscription from the start, and indeed it would have been a good way for the young man to advertise his name and origins to a wider public.[31] Both the illusionistic way the inscription is carved and the precise wording on the band suggest that Michelangelo not only planned it carefully but wanted a sophisticated viewer to appreciate it. The use of the imperfect

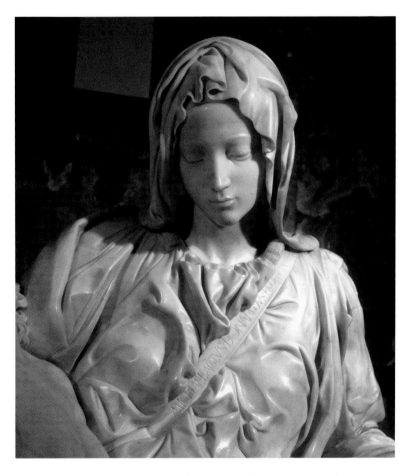

tense indicates incompleteness and process, and the inscription itself is literally incomplete, since the word *faciebat* disappears under the Virgin's veil so that its final letter is only understood. It may well reflect the ideas of Poliziano, who had told Michelangelo years before that art, like poetry, was never finished.[32] And Poliziano (or any number of other learned people Michelangelo had encountered) may have

13 Detail of Michelangelo's signature from the *Pietà*.

told him about Pliny the Elder's stories of the ancient Greek artists Apelles and Polyclitus, who similarly signed their works with *faciebat*. Pliny's anecdotes were widely known and other artists in the fifteenth and sixteenth century signed their works in a similar way.[33] For those who understood the reference, the signature also set Michelangelo in competition with the greatest artists of ancient Greece – just as he had competed with them in the *Battle of the Centaurs* or the *Sleeping Cupid*.

Another anecdote told in the same letter that likely informed Vasari's account mentions a nun who heard Michelangelo carving the *Pietà* and asked for a fragment of marble from the wound in Christ's side.[34] This anecdote, omitted by Vasari and usually dismissed by scholars, provides evidence for a different kind of response – the pious woman sought a 'relic' of the *Pietà* in the same way that she might want a relic of the Virgin's own mantel or blood from the wound in Christ's side. The sculpture seemed so convincingly real that she imagined it to be a substitute for the actual figures. The realism of the group was later praised by more literary types, including Giovan Battista Strozzi il Vecchio, who wrote a poem, quoted by Vasari, that describes Christ and Mary as 'alive in the marble'. This poem, and others like it, fit into Renaissance traditions of imagining sculpture as if truly living – lacking only breath.[35] But the sculpture was not realistic enough for some: there were complaints that Michelangelo had made the Virgin too young, not the nearly fifty-year-old woman she would have been at the time of Christ's death. Some later copies correct this 'flaw'; an example is the full-sized marble variant by Nanni di Baccio Bigio in the Del

Riccio-Baldi chapel of Santo Spirito, Florence. Michelangelo himself responded to the criticism, as recorded by Condivi: he said her youthfulness was a sign of her purity, since virgins retain their youth. All these responses attest to the sculpture's renown. Michelangelo had become a public figure.

The Heroic Body

ICHELANGELO'S EXPERIENCES in Rome bore fruit in two ways: first, through his connections with cardinals he received a commission to contribute several sculptures to the altar of the Piccolomini family in the cathedral of Siena, and second, his growing fame put him in a good position to get even more prestigious commissions in Florence. The most important of these was the colossal *David* (illus. 14). The history of this sculpture shows Michelangelo meeting numerous challenges – material, art historical and even political. The work was a triumph and became the most iconic image of a heroic male nude the world had seen.

Michelangelo's *David* was never meant to be an isolated sculpture, but rather one of a series of prophets that was to be placed atop the buttresses of Florence Cathedral (Il Duomo). The idea for the series existed already in the fourteenth century, as seen in a fresco in Santa Maria Novella that envisions not only sculptures along the roofline of the cathedral but also the completed dome of the cathedral. Both the sculptural series and the dome suffered from the same condition: the Florentines imagined projects that outpaced their technical expertise. In the case of the dome, the problem of supporting

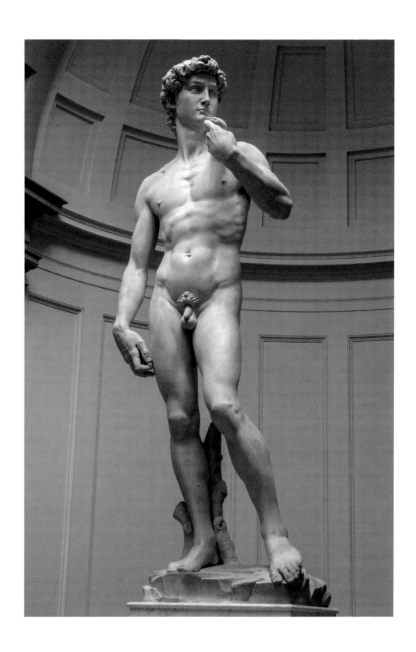

14 Michelangelo, *David*, 1501–4, marble.

it while it was being constructed as well as the structural difficulties of setting such an enormous dome atop already existing walls – which rose some fifty metres above street level – were only resolved in the 1430s through the ingenuity of Filippo Brunelleschi. The prophet sculptures were also affected by the height of the existing walls: not only did they need to be visible from such a distance, but they had to be raised up to that height and then maintained there for generations. The first serious attempt to realize the prophet series came in 1408 when the Opera del Duomo – the building committee for the cathedral – commissioned Donatello and Nanni di Banco each to create a prophet, slightly over life-size.[1] Although there are some arguments about which of their surviving sculptures are those meant for the Duomo buttresses, none of them is large enough to be legible at such a height. Nanni's statue was put in place on the north tribune but was quickly removed, and in 1410 Donatello was commissioned to create a much larger figure – this time a Joshua, approximately six metres tall. The medium now would be terracotta, a ceramic material that would have been fired in sections before being raised to the buttress and assembled. Terracotta is fired at a relatively low temperature and is susceptible to weather damage, so the statue was coated with gesso to protect it as well as to give it the whiteness of marble. This sculpture of Joshua remained in place until at least the late seventeenth century. Its broad outlines can be seen in early prints of the Duomo,[2] and it would have been visible to Michelangelo as he began to contemplate his addition to the series.

There were further experiments, but the most important development came about in the 1460s, when Agostino di

Duccio, a protégé of Donatello, took up the task of carving a giant prophet in marble for the Duomo. Documents show that he was to have used four blocks of marble, but he must have decided to try to carve it from one huge block. The challenge was apparently too great for him, and in December 1466, soon after he received the block and began carving, his contract was cancelled.[3] A decade later Antonio Rossellino was given the commission to make the prophet from this block, but what he did is unclear. The block remained in the work yard of the cathedral for the next 25 years.

On 2 July 1501, the Opera del Duomo ordered this same roughly carved block of marble, almost six metres long and now considerably weathered, to be raised up so that experts could examine it and determine whether it could still be used to create a finished work. The block itself was referred to as 'David'. This test must have been talked about for some time, since Michelangelo's father alluded to it in a letter he sent to his son in Rome in December the previous year. At least one other sculptor, Andrea Sansovino, considered the project; he proposed that more stone be joined to the block so that a full figure could be carved from it. Michelangelo presented a wax model to the Opera demonstrating that the figure he envisioned could be made from the misshapen block; this model survived into the seventeenth century.[4]

The marble was awarded to Michelangelo and the contract signed about six weeks later. On 9 September 1501 he took a symbolically important step: with 'one or two blows' he knocked a protrusion (*nodum*) off the front of the block, which may have been the remnants of Agostino di Duccio's method of transferring the design from his model. This bold

and public gesture affirmed that Michelangelo was discarding Agostino's model and taking an entirely different approach to the block. Instead of gradually removing stone from all sides, guided by a full-size model from which measurements were mechanically transferred, Michelangelo approached the block directly from the dominant view. Years later, Benvenuto Cellini would describe Michelangelo's carving technique as working from a drawing on the face of the block and proceeding as if carving a relief. Vasari's description is more colourful, saying that the figure was revealed as if it were emerging from a draining bath. Michelangelo's method was remarked upon because it was so unusual and so bold, requiring the ability to visualize the entire statue and revealing the form as if it existed in the block, rather than gradually shaping the form by removing thin layers on all sides.

After Michelangelo's first bold gesture, his work was hidden from view by a wooden enclosure; this was surely to reduce public chatter about the progress of the enormous undertaking. However, curiosity must have been great, and on 23 June 1503 the public was allowed a preview; the sculpture was then concealed again until May 1504, when the arduous process of moving the finished sculpture began.

The colossal *David* was meant to be placed on a corner of the cathedral's north tribune; that structure is a section of an octagon, so the corner forms an oblique angle. In 2010 a full-size fibreglass replica was hoisted into place to see whether the *David* would have been effective had it been placed there. The experiment revealed, first, how necessary the colossal size was, since even it was dwarfed by the massive structure, and second, that Michelangelo's figure did successfully address

the angled view, with the essentially frontal view of the torso aligning with one face of the tribune, and the gaze and raised arm negotiating the turn. The overhang of hair also provided a line of shadow that set off the face against the sky. Most photographs of the sculpture as it now stands in the Museo dell' Accademia are taken from a viewpoint more or less at the level of David's chest. They show a young man slim through the hips, but with a more robust torso and an oversized head. But most viewers, even today, seeing the statue on a base set just above eye-level, are undisturbed by the strange proportions. Even from this viewing angle perspectival recession corrects most distortions.

And yet there is some reason to doubt that anyone actually thought the sculpture could be placed on the buttress. After the switch to terracotta for Donatello's *Joshua*, why would a similar-sized marble statue even be considered? Additional supports would have been necessary to secure the statue, and the risk of breakage while it was being installed would have been great. These doubts must have occurred to Michelangelo as he completed the piece, and on 25 January 1504 a committee met to determine the best location for it.[5] The preamble of the minutes to this meeting suggests that Michelangelo was most concerned with the structural support for the statue. Of the thirty or so committee members, most were professionals in the visual arts, including painters such as Leonardo and Botticelli, the architect Giuliano da Sangallo and sculptors such as Andrea della Robbia, but also including woodcarvers, gem engravers and goldsmiths. A fife player and the herald for the city government completed the group. The minutes of the discussion, which was remarkably civil in tone,

show that these men considered many points. Those who
favoured the statue's location under the Loggia dei Lanzi
emphasized the preservation of the stone but also worried
how it might interfere with public ceremonies. Political sig-
nificance could be underscored by placing the *David* in front
of the Palazzo della Signoria, Florence's city hall, or within
its courtyard, while its religious meaning would be preserved
by placing it on the steps of the cathedral. But these consid-
erations were as often combined with concerns about how
the sculpture would be seen: one committee member held
out for placing it on the buttress after all, the place for which
it was designed. The herald, Francesco Filarete, recognized
the potential political power of the sculpture, were it placed
before the Palazzo della Signoria (he wanted it to replace
Donatello's *Judith*, which he called 'an emblem of death . . .
[since] it is not fitting that a woman should kill a man') as
his second choice, he suggested putting it in the courtyard,
because the statue there – Donatello's *David* – did not look
perfect in that place. Botticelli argued for the statue to be
placed on a pedestal at the corner of the cathedral, where it
could be seen by passersby. The architect Giuliano da Sangallo
agreed with Botticelli but, concerned about the fragility of
the marble, argued for placement under cover, in the Loggia
dei Lanzi, either in the centre, where people could see it from
all sides, or against the back wall of the central arch, to enframe
it as if it were in a kind of tabernacle. In contrast to those who
wished the sculpture to be set within the courtyard, Giuliano
countered: 'it is a public thing.' The goldsmith Il Riccio
argued for its placement under the Loggia as well, but with
slightly different reasoning: 'for we and the passersby should

go to see it, rather than the figure coming to see us'. Perhaps his meaning was that the *David*'s nudity was too confrontational – that if it were set under the cover of the loggia, the public would have to choose to go and see it.

Perhaps the most astute observations came from the fife player, who appreciated the benefits of setting the *David* in the Loggia, but felt that it was necessary to be able to see the statue from all sides. And yet, he concluded, having the sculpture where the public could see it exposed it to the risk of vandalism. Perhaps for that reason others suggested placing it within the courtyard or even inside the palace in the large Sala del Gran Consiglio, the Hall of Great Council. The sculpture was conspicuous for its size and its nudity, and even as it was being transported to the front of the Palazzo della Signoria, where it would be installed near the door, people pelted it with stones.[6] The culprits were arrested and identified; their actions were probably the result of sheer delinquency rather than political beliefs or a strong sense of morality. Even so, soon after its installation, Piero Soderini, the chief magistrate of Florence, ordered that a garland of copper leaves be made to sit around the *David*'s hips and to cover his genitals.[7]

Michelangelo's colossus became a symbol of Florentine political strength when it was set in front of the Palazzo della Signoria, but it also became the most visible public display of male nudity in the city to date. By the early sixteenth century, classical nudity was becoming more commonplace, and precedents like Donatello's bronze *David* were well known. But the earliest known location of that sculpture was in the relatively secluded courtyard of the Medici Palace; it was moved to a different courtyard within the Palazzo della Signoria

when the Medici were ousted in 1494. Michelangelo's *David*
was big, public and much more 'in your face'. One scholar
has linked the appearance of the garland to the fact that Piero
Soderini's wife and her female retinue lived in the Palazzo.
Previously, women had been barred from the palace; their
husbands resided there during their two-month term of
office. Soderini, who had been elected head of the city gov-
ernment for life, must have felt other accommodations were
necessary.[8] But was this really the reason for the collective
modesty? And even if it was, the garland seems to have stayed
in place long after that moment; it was referred to in one of
Pietro Aretino's letters, dated 1543. Similar garlands were
placed around other nude sculptures near the Palazzo della
Signoria, as seen in a painting of a festival made around 1600.[9]
On the other hand, the garland was only one of several gold
ornaments made for the *David* in 1504: the tree trunk and sling
were gilded, and a wreath (*ghirlanda*) was made for its head.
Surprisingly, there is little said about the figure's nudity in
written criticism; two sixteenth-century observers do men-
tion that its proportions do not seem right, but they excuse
this, attributing it to the misshapen block Michelangelo had
to work with.[10] It seems as though an aura existed around the
sculpture that discouraged critics from mentioning anything
that might be seen as a flaw.[11]

These critical remarks and nods to modesty could not
lessen the power of the *David*. David traditionally symbolized
the triumph of good over evil, the weak over the strong, or
more specifically the true Church over its oppressors, but
Michelangelo's sculpture was more complex.[12] David's trad-
itional attributes, like the stone and sword, are absent; he

holds what appears to be a sling over his left shoulder, but as it crosses his back it clings to his body and ends as a scroll-like form held in his right hand. David is normally depicted as an adolescent – the Bible describes him as a youth – but he is clearly more mature in Michelangelo's version. The *David*'s enormous stature, muscularity and pose suggest that Michelangelo was thinking of a Hercules as he worked, and several examples in Florence and Rome could have served as his inspiration (he had, after all, carved a Hercules about a decade earlier). This ambiguity only added to the sense that David represented not just an Old Testament figure, but strength and defiance no matter who the enemy might be. The meaning of the sculpture changed not only when it was relocated, but also as new leaders came to power. As a monument standing before the Palazzo della Signoria it acquired political meaning – as a symbol of the triumph of the Republic. Later, when the Medici returned to power and took possession of the palace, it became a symbol of the Medici triumph. Through all these vicissitudes, it was Michelangelo's first genuinely public statement that the ideal nude male figure would embody a triumphant display of male strength: *virtù*.

Although the *David* was Michelangelo's largest and most conspicuous project in these years in Florence, he took on many other commissions between 1501 and 1505: fifteen marble figures for an altar in Siena, a life-size bronze David, two marble reliefs of the Madonna and Child with St John the Baptist, and a full-size sculpture of a Madonna and Child. In addition, he worked on at least one panel painting and accepted a commission for his first independent fresco. These projects are remarkably varied in subject and medium; they

also vary in the function they were designed to serve and the type of viewer who might be expected to see them.

The commission most like the colossal *David* in terms of ambition and audience was the *Battle of Cascina*. If it had been completed, this massive painting would have measured about 7 by 17.5 metres and would have been set within the cavernous space of the Sala del Gran Consiglio in the Palazzo della Signoria. But it was not completed. In fact, painting never began, although preliminary drawings and a cartoon that would have been used to transfer part of the design onto the wall were made. Our knowledge of what the fresco would have looked like is based upon reconstructions, and those reconstructions are largely based upon a modestly sized grisaille copy made by Aristotile da Sangallo almost thirty years after the commission was given to Michelangelo (illus. 15).[13] Even more overtly than the *David* standing before the Palazzo della Signoria, the *Battle of Cascina* had a political meaning, expressed through the many nude figures in powerful movement.

While rivalry with Donatello may have been on Michelangelo's mind as he carved the *David*, the *Battle of Cascina* was commissioned with a genuine competition in mind. Leonardo da Vinci and Michelangelo were both commissioned to paint large battle scenes that probably would have been seen on the same long wall of the Sala, flanking the seat of the chief magistrate.[14] Leonardo was at work on his piece by autumn 1503; Michelangelo was ordering supplies for his painting in October 1504, just a month after his statue of *David* was unveiled. Both paintings were to represent scenes from historic victories of the Florentine Republic: the Battle of Anghiari, fought in 1440 against the Milanese, and the Battle of Cascina,

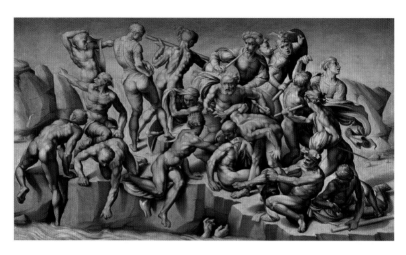

fought in 1364 against the Pisans. Since both Milan and Pisa were still rivals of Florence in the early sixteenth century, the themes were inspirational as well as commemorative. The frescoes, had they been completed, would have been composed of several scenes, but all that remains of either work are copies of the scenes that the two artists very likely wanted to give centre stage. Leonardo chose a ferocious entanglement of horses and men for his *Battle of Anghiari*; Michelangelo did not show a battle at all, but rather a moment of sudden alarm. The soldiers had been at ease, bathing in a stream, when their leader, seeing their lack of vigilance, sounded a false alarm. Vigilance, still necessary as struggles with Pisa continued into the sixteenth century, was Michelangelo's theme.

The spirit of artistic competition must have overtaken any desire to create visually coordinated works; however, the fact that neither painting was completed precludes any conclusions about them. Nor do we have much in the way of written descriptions from contemporary viewers. In his

15 Aristotile da Sangallo after Michelangelo, *Battle of Cascina*, c. 1542, oil on panel.

Memoriale of 1510, Francesco Albertini briefly mentions that
the horses of Leonardo and the drawings of Michelangelo
were in the Sala del Gran Consiglio, but he describes neither
how they were displayed nor what the effect was.[15] Michel-
angelo's cartoon was moved several times until it was torn
apart and the pieces dispersed, perhaps as early as 1515. But
the *Battle of Cascina* was seen — in fact, it was seen by a wider
audience than Michelangelo could have imagined. Several
artists made drawings from the cartoon, which were shared
with other artists. The most enterprising of these artists
was Marcantonio Raimondi, a printmaker from Bologna who
visited Florence in around 1508 on his way to Rome.
Marcantonio's engravings of single figures or of selected
groups displayed Michelangelo's figures in completely differ-
ent settings and removed them from the political context.
These prints were in turn copied or emulated by others, and
they certainly helped spread Michelangelo's fame. But there
can be no doubt that the experience of studying a small-scale
engraving is very different from observing even one of
Michelangelo's painted nudes, each of which would have been
three metres tall, powerfully muscular, and posed in ways that
would make the viewer imagine the tension and energy of
each body. Through the fragments of the cartoon and engrav-
ings made from it, the *Battle of Cascina* became a kind of school
for artists studying human movement and anatomy; whether
it would have been an inspiration for the leaders of the
Florentine Republic is anyone's guess.

Even before committing to carve the colossal *David*, Michel-
angelo had signed a contract to produce fifteen statues for
an altar in Siena Cathedral. It was a commission he needed

at the time: the *Pietà* was finished, and he had a commission
for an altarpiece in the church of Sant'Agostino in Rome in
hand, but he wanted to return to Florence.[16] The patron was
Cardinal Francesco Todeschini Piccolomini, who surely knew
Michelangelo's Vatican *Pietà*, since he was an executor of
Cardinal Bilhères de Lagraulas's will. Cardinal Piccolomini
was the nephew of Pope Pius II and would himself become
Pope Pius III on 22 September 1503, but he died within a
month of his election. Work continued on the altar under
the direction of the pope's heirs, but only four of the fifteen
statues ordered in the contract were delivered. The unfulfilled
obligation foreshadowed Michelangelo's later frustrations
with the Tomb of Pope Julius II; both commissions would
haunt him into old age.[17]

The Piccolomini Altar commission can best be compared
to the Arca di San Domenico (see illus. 7). As with that earlier
work, Michelangelo was asked to step in and complete figures
for a structure that was already in place. About twenty years
earlier, the altar had been begun by Andrea Bregno, who
designed its architectural framework, which was similar in
form to a triumphal arch, with finely worked relief decora-
tions (illus. 16). However, unlike in the Arca di San Domenico,
the altar is not set within a chapel that to some extent deter-
mines the viewer's position. Instead, it faces the vast nave of
the cathedral; observers could view the ensemble of figures
from a distance or close up. The contract, dated 5 June 1501,
specified that the figures were to be two *braccia* tall (about
116 centimetres, although they each measure about 135 centi-
metres), but a figure of Christ for the summit of the altar was
to be larger than the others, to adjust for the distance from

the eye.[18] This particular figure was never completed, but the two figures now at the lowest level, SS Peter and Paul (illus. 17), were adjusted for a viewer standing close to the altar, whose eye level would be near the base of these statues: Peter looks downward, and Paul's elongated torso resolves if seen from this low angle.[19] The other statues are more neutral, possibly because they would likely be seen from afar. The way the sculptures would be seen mattered a great deal to the patron as well. Since the artist would carve the statues in Florence, not Siena, the contract instructs him to go to the cathedral to measure the niches. It also specifies that he must submit drawings of the figures so that 'their clothes and gestures can be seen . . . so that additions and subtractions can be made if necessary', and Michelangelo agreed to have the pieces he completed evaluated by two judges – one chosen by Piccolomini, the other by himself, with a third judge called in if those two could not agree. Such evaluations were not uncommon for ordinary artists, but this seems to be the only time that Michelangelo was made to submit to one.

The four sculptures that Michelangelo delivered by 1504 depict SS Peter, Paul, Pius and Gregory. Their specific identities must be puzzled out: Peter and Paul are surely the two dressed in simple garments and can be differentiated because Peter traditionally has the shorter beard; they both hold books, however, rather than their more usual attributes of keys and a sword, respectively. The other two figures wear ecclesiastical garments, one with the papal tiara and the other a bishop's mitre. Since both were popes, that distinction is not very helpful, although probably the one with the tiara is St Pius. This would allow observers to connect the canonized

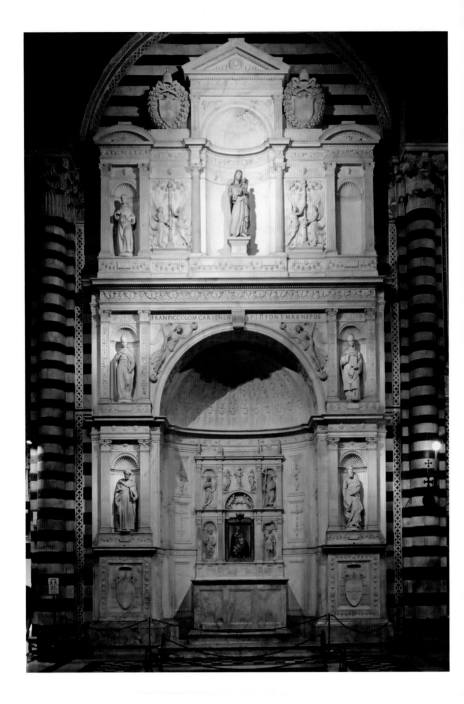

16 Andrea Bregno and others, Piccolomini Altar, begun 1481, marble.

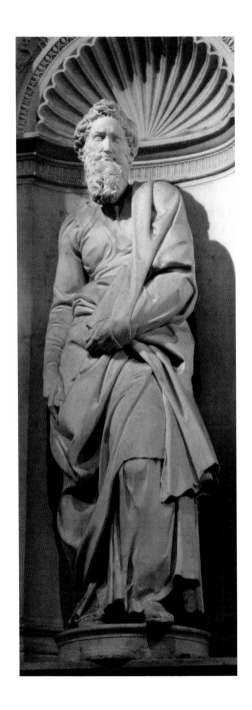

17 Michelangelo, *St Paul*, from the Piccolomini Altar, 1501–4, marble.

Pope Pius I to the two Piccolomini popes, who chose that name and who are honoured by the altar. Another statue, of St Francis, had been begun by Pietro Torrigiano, and Michelangelo was explicitly instructed to finish it 'out of honour, courtesy and generosity' (that is, without compensation) and make it harmonize with the other sculptures.[20] This must have been galling, since Torrigiano is the very person who broke Michelangelo's nose when they were both teenagers in Ghirlandaio's shop. Michelangelo's work on that figure seems to have been negligible, and it is certainly possible to tell the styles apart. Some element of rivalry may explain the greater complexity of the drapery and pose in Michelangelo's figures – precisely the opposite of Torrigiano's manner of working seen in the St Francis. But another competition is also implied in the 1501 contract: it states that Michelangelo's sculptures should be more perfect than any modern sculpture in Rome. Implicitly, therefore, Michelangelo was competing with his own *Pietà*, which was already famous by then. In this he failed; his attention was clearly on the far more heroic, much more challenging sculpture of *David*, which he was creating at the same time. By 1508 Michelangelo was attempting to free himself from the Piccolomini commission.

The Piccolomini figures stand in sharp contrast to another series commissioned at this time: the Twelve Apostles to be set within the choir of Florence's Duomo. The contract was signed on 24 April 1503, before Michelangelo had finished the *David*; perhaps by that time, the Opera had realized that the series of prophets for the buttresses along the roofline would never be completed as planned. But this series would never be completed either; indeed, only one sculpture was

begun, in 1506, after the original contract had been cancelled.[21]
The *St Matthew* (illus. 18) shows the apostle in a dynamic pose,
with his left leg pressing forwards as if he were about to step
up on a block, while his left shoulder presses back and his
head turns sharply to his right. Various explanations have been
offered for this unprecedented pose: that it was inspired by
Donatello's figure of *Abraham* for the campanile of the Duomo
or that it shows Michelangelo's first-hand experience of the
Laocoön, which he had been called upon to evaluate when it was
unearthed in Rome in January 1506. Michelangelo's *St Matthew*
was never installed, but other artists' contributions to the
series were, and from them it is possible to deduce that his
would have been set in a niche on the last pier on the right,
just as one enters the space below the dome. *St Matthew*'s
extraordinary pose could then be explained as a reaction to
the mystery of the Eucharist, performed at the main altar.[22]
Whichever explanation is chosen, the unfinished sculpture
presents an image of a living figure emerging from stone,
his body moving in what would become known as the *figura
serpentinata* – the serpentine pose – that later writers would
say embodied life more than any other.[23] If the *David* and the
Battle of Cascina allowed Michelangelo to explore how the scale,
proportions and poses of the male body could be used to
express the heroic ideal, the *St Matthew* was his first attempt
to create a body that seemed to truly move.

Michelangelo continued to experiment with creating a
powerful sense of life in his sculpture for the tomb of Pope
Julius II and in the Sistine Chapel frescoes, as will be discussed
later. One other sculpture is worth bringing up here, however,
especially because it shows how Michelangelo rethought the

pose in a second version of the sculpture. The *Risen Christ* in the church of Santa Maria sopra Minerva in Rome was commissioned in 1514 by the executors of the will of Marta Porcari.[24] It would have been part of an altar dedicated to her memory that was planned for the left aisle of the church, near the entrance to the cloisters. Michelangelo began work on the life-size figure soon after the contract was signed, but in 1516 he discovered an unsightly vein in the marble that would be visible on Christ's face. He abandoned that sculpture, which was in a roughed-out state (illus. 19). It was finished by another sculptor in the seventeenth century, but the pose would by then have been established. The second version (illus. 20) was begun in 1519 in Florence, where Michelangelo was starting to design the Medici Chapel. It was nearly complete in 1521 when Michelangelo gave it to his assistant, Pietro Urbano, to finish after it arrived in Rome. Urbano botched certain details, which Federigo Frizzi was asked to repair; Frizzi also created a niche and installed the sculpture. By the time it was installed in December 1521 the statue's location had changed. Frizzi had written to Michelangelo on 19 October about the poor lighting in the aisle of Santa Maria sopra Minerva, and suggested two other locations – one in the nave and the other against a pier just to the left of the main chancel. The patrons agreed to the more prestigious location nearer the main altar, where the sculpture can still be seen, although the niche was destroyed in the nineteenth century.

The poses of the two *Risen* statues are strikingly different. Whereas in the first version Christ sways in a gentle *contrapposto*, the second figure is much more actively posed: his head turns sharply to his left, he pulls his left shoulder around to

embrace the cross on the right with both hands, while his left
hand holds the rope, a pole and sponge. The cross itself is
tilted so that his action is necessary simply to balance it. At
the same time he strides forwards, as if out of the tomb – this
effect may have been much more evident when the figure
stood before its original niche.[25] The image of Christ with the
instruments of the Passion brings to mind the Man of Sorrows,
a traditional form that typically shows a frontal, half-length
figure of the suffering Christ, meant to be contemplated by
the pious viewer. But in Michelangelo's sculpture these objects
seem to be symbols, rather than the actual objects that tor-
mented Christ – the cross especially is too small. The final
version of the *Risen Christ* instead enacts his role in the narra-
tive of salvation. His physicality and active pose emphasize
his triumphant return to life, while the objects he holds recall
his death. In the sculpture's original location, these objects
would have been the elements a spectator saw first as s/he
moved through the church; Christ's face would then have been
revealed, drawing the viewer's attention to the main altar and
the re-enactment of Christ's sacrifice in the Mass.

In both versions Christ is nude, as specified in the con-
tract. This does not seem to have disturbed many contem-
porary viewers, as the *Risen Christ* was probably always fitted
with a loincloth. The one that is on the statue today is just
the most recent of several loincloths it has worn through the
years, as can be seen in early reproductive prints and more
recent photographs. The right foot of the *Risen Christ* was also
covered with a bronze shoe to protect it from the touch of
the faithful affirming the physical presence of Christ after the
Resurrection or the caresses of young women who thought

18 Michelangelo, *St Matthew*, *c.* 1506, marble.

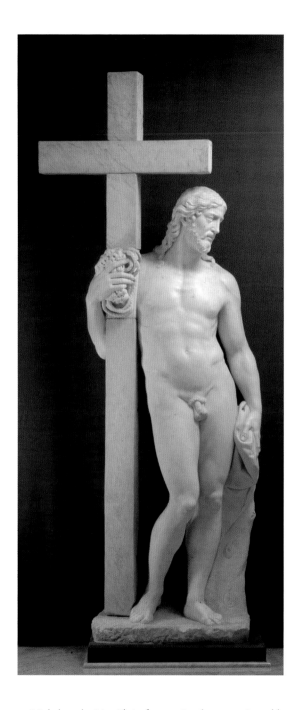

19 Michelangelo, *Risen Christ*, first version, begun 1516, marble.

that kissing it would bring them luck in finding a spouse.[26]
The emphatic physicality of Christ emphasizes that his body
had truly been raised from the dead, but in the eyes of at least
some viewers it also inspired more carnal associations.

How do these explorations apply to the images of women
that Michelangelo produced around this time? The Madonna
and Child that is now known as the Bruges *Madonna* (illus. 21)
was one of the projects that overlapped the Piccolomini Altar
commission, but the idea that it was meant to be installed
in the uppermost niche of that altar seems unlikely.[27] The
Flemish cloth merchants Alexander and Jean Mouscron paid
for the sculpture, which was shipped to Bruges in 1506. When
it arrived there it was installed in the chapel of the Blessed
Sacrament in the Church of Our Lady. Its original setting
may have been quite simple, but in 1514 the son of Alexander
Mouscron commissioned a 'sumptuous tabernacle' for it; the
even more elaborate setting in which it now stands dates from
the seventeenth century.[28] This chapel was the burial place for
the Mouscron family and their descendants. When consider-
ing this piece we have to imagine that the Virgin's gaze and
that of the Christ Child were directed downwards, towards
a person praying for the dead at the altar.

The Bruges *Madonna* has much in common with the Vatican
Pietà, which was made about eight years earlier, while Michel-
angelo was in Rome. Both are for funerary chapels and are
meticulously finished on the surfaces that would have been
visible when the sculptures were installed. Both Madonnas
are clothed in fabric that falls in deep, complex folds that
sometimes seem excessively ornamental. The elaborate ren-
dition of fabric can be explained by the fact that these pieces

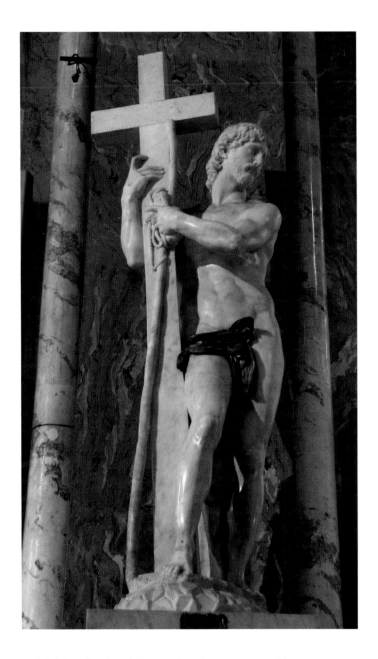

20 Michelangelo, *Risen Christ*, second version, 1519–21, marble.

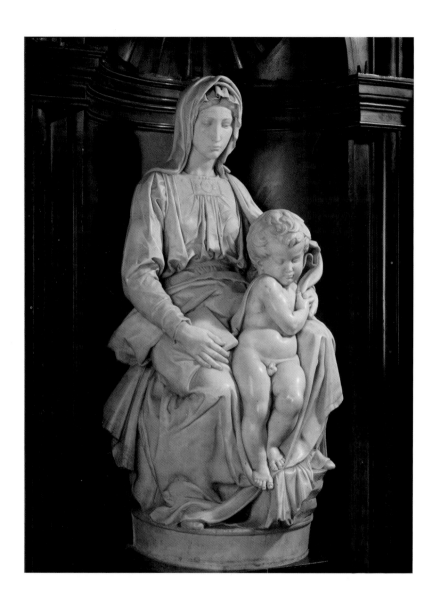

21 Michelangelo, Bruges *Madonna*, 1503–6, marble.

were commissioned by patrons from northern Europe, where
such displays of artistry were much appreciated. In both, Mary
holds Jesus between her widespread legs – a reference to his
birth from her body. Mary's expression is also strikingly serene
in both works; she is a model of dignity and strength, whether
she is holding the hand of an energetic child or the lifeless
body of her tortured son. But here is where the comparison
turns to contrast, since the figure of Christ in the *Pietà* is
drained of life, while the figure of the Christ Child in the
Bruges *Madonna* twists and squirms – full of life, like any child.
He slides from her lap while still grasping her thumb. She
holds his hand, but lightly, knowing that this release of her
son, like her final release of his body after the Crucifixion, was
necessary and preordained. His demeanour is as serious as
his mother's; he steps forwards as if into the fate that both
of them know.

Other works made in Florence between 1504 and 1506
depict the popular theme of the Madonna and Child. Two
are sculptures and one is a painting, but all three were meant
for private homes. The unfinished marble reliefs were done
for Taddeo Taddei and Bartolommeo Pitti, while the *Doni Tondo*
(illus. 22) was most probably made on the occasion of the
marriage of Agnolo Doni and Maddalena Strozzi in 1504.[29]
The bride's family is acknowledged with the Strozzi arms
that appear on the contemporary frame, which was probably
designed – but not carved – by Michelangelo. The three share
a round format – in Italian a *tondo* – that was particularly
popular in Florence between around 1480 and 1515. Most
often, *tondi* depict the Madonna and Child or the Holy Family,
frequently accompanied by the infant St John the Baptist;

tondi would typically be displayed in homes, very often in bedrooms. They are closely associated with another type of decorative object for the home, the *desco da parto*, or birth tray. *Deschi* were double-sided, shallow bowls that often showed longed-for male children, while the *tondo* was a devotional object displaying the ideal family of Christ.[30] Still, cross-over meaning must have occurred: these images present Mary and the infant Christ as models of a caring mother and a lively, healthy son, and at the same time serve as devotional images to which women and men could pray for their own families.

All three of Michelangelo's *tondi* include the Virgin with the infant Christ and a young St John the Baptist, and in all three the Christ child is an active, very human child – climbing, laughing or reacting to a teasing mate. His mother, in all three, is serenely in control, seated humbly on the ground or a rock, and holding or reaching for her boy – without, however, restraining him. The *Doni Tondo*, however, is more complex. The Virgin Mary is seated on the ground, and she reaches back to the Christ Child, but her fingers curl in a way that is difficult to interpret. If she were receiving him from Joseph (or even giving him to St Joseph, as Vasari says) she would surely have a more open gesture. Her left hand seems to call our attention to Christ's genitals, indicators that he was truly born a human. Joseph steadies the boy with a hand against his chest and gazes at him with a furrowed brow. Mary and the young St John gaze at him, too, but in a more adoring way, in contrast to Joseph's concern. The family is set before a low wall, which separates them from John and the five naked young men who lounge on a ledge in the background; the Holy Family and St John are oblivious to them.

As a domestic painting meant to remind a family that they
should model themselves after the Holy Family, the *Doni Tondo*
offers an example of parental guidance, concern and strength.
The Virgin's muscular arms are frequently noted by scholars –
sometimes with outrage or repulsion – and can be explained
away easily by the common practice of using male models
in the workshop. However, Michelangelo's other images of

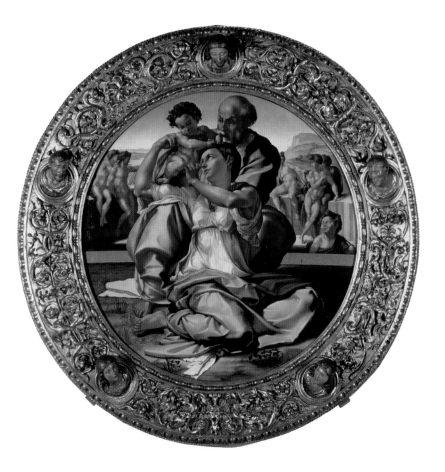

22 Michelangelo, *Doni Tondo*, *c.* 1504, tempera and oil on panel.

the Madonna, from the Vatican *Pietà* to the contemporary *tondi*, have more feminine proportions, and covered arms. He seems in this painting to have chosen to use physical strength in the female body as a sign of inner strength, just as he used it in the male bodies of the *David* and *St Matthew*, and the soldiers in the *Battle of Cascina*.[31] In opposition to the sharply defined bodies of the Virgin, the Christ Child and Joseph, the bodies of the nude young men in the background of the *Doni Tondo* seem veiled and their movements languorous. These figures have been interpreted in many ways: as pagans in contrast to those who lived in the era under the Law (the Hebrews) or under grace (from the time of Christ), as 'athletes of virtue', or as souls of unbaptized children in Limbo, now grown to an ideal age.[32] Might they be seen in opposition to the clearly defined, active figure of St Joseph, who offers an ideal of a mature adult and the steady guidance of a concerned father?

Michelangelo may have felt he had the freedom to test the limits of the genre in this painting, since Agnolo Doni was a friend. The closest precedent for the painting is one that he saw while working for members of the Medici family. It is by Luca Signorelli, an artist whom Michelangelo greatly admired, and Signorelli probably presented it to Lorenzo de' Medici during the time Michelangelo was working in the Medici garden.[33] A rectangular painting, it contains within it a fictive *tondo* depicting the Virgin and Child, with three nude young men in the background. Signorelli was clearly trying to impress the Medici family with his knowledge of the human body and possibly with his ability to insert recherché meaning into this common theme, and Michelangelo may have been doing the same. But, as an anecdote detailed by Vasari

reveals, Agnolo Doni must have been expecting something a little more ordinary. He balked at the price Michelangelo was asking for the *tondo* – seventy ducats – and countered with an offer of forty instead. After further bargaining, Agnolo ended up paying twice as much as Michelangelo had requested in the first place.

23 Michelangelo, design for the tomb of Julius II, 1505–6, pen and ink, brush and brown wash, over stylus ruling and leadpoint.

Visions of Majesty: Projects for Pope Julius II

 N 1505 MICHELANGELO was called to Rome by Giuliano della Rovere, who had been elected Pope Julius II two years earlier. The project the pope had in mind was his own tomb. Michelangelo's earliest design for it was of a wall tomb, with the pope's body held up by angels before the Virgin and Child; a sibyl and Moses would be at a lower level, and below that, clothed figures probably representing saints (illus. 23).[1] This scheme quickly evolved into something much more monumental, and more classical in spirit. Condivi describes this version of the tomb as a free-standing monument, eighteen braccia deep and twelve braccia wide (approximately 10.5 × 7 metres). With its three levels, scholars estimate that it would have been between seven and twelve metres high. There would be four figures at the second level (Condivi only names Moses) and above that angels holding the sarcophagus, but without the Virgin and Child looking down upon it. At the lowest level there would be niches for victories, with captives bound to herms between them. Condivi identifies these as personifications of the liberal arts (he includes painting, sculpture and architecture in this group) who had become prisoners

of death when Julius died, since no one would favour them as much as he did.

Vasari's description of the original design is somewhat different. He says that the bound figures represented provinces subjugated by Julius (although he also says there were bound figures representing the arts) and states that the two figures supporting the bier represented Heaven and Earth. Even though Vasari generally relies on Condivi, his emphasis on the representation of Julius' military conquests seems more in keeping with the pope's priorities. Julius II fashioned himself as a second Julius Caesar, and he soon embarked on campaigns to capture lands for the Church. For the knowledgable viewer, the massive free-standing, multi-level tomb might have called to mind the funerary monuments of Roman emperors, rather than the more typical wall tombs of popes.[2]

Also at this time the pope's architect, Donato Bramante, was creating designs to renovate St Peter's Basilica in line with Julius' ambitions for a Christian Rome that would rival the glory of the imperial city. Bramante had come to Rome from Milan in around 1500, and quickly established himself as an architect in command of the classical style with the building of the Tempietto at San Pietro in Montorio. When Julius was elected pope in 1503, he became the pope's chief designer and confidant; Bramante was able to give form to the pope's ambitions. Bramante may have planned for the pope's tomb to be placed in a mausoleum outside St Peter's, but eventually the pope decided to have the tomb set within the west choir arm of the basilica, which would rise on the foundations put in place some fifty years earlier. In time, even that scheme was found to be inadequate, and Bramante

was charged with redesigning St Peter's entirely (see Chapter Seven). The tomb of Julius II would still be located in the most prestigious place in the church, behind the main altar.

From the beginning, conflicts between the pope and Michelangelo caused delays, while other major commissions would take the artist's attention away from the tomb. These included commissions that Julius himself gave to Michelangelo: first for a monumental bronze statue of himself that once stood on the facade of San Petronio in Bologna, and then to paint the Sistine ceiling. After the pope's death the design for the tomb reverted to a wall tomb and the number of sculptures on it was reduced. The tomb of Julius II was a project that would plague Michelangelo for much of his life, until it was finally installed in San Pietro in Vincoli in 1545. Through all its vicissitudes, Michelangelo continued to control the design and consider the viewers, even when the setting and requirements of the commission were very different from what he had originally planned.

Had the free-standing tomb been completed and installed in the choir arm of St Peter's, it would have been seen from the nave rising up beyond the altar that marked the tomb of the first apostle. Although it is difficult to imagine, the tomb, which would have been taller than a two-storey building, would have fitted easily within the enormous space. The tomb would have been lit from above by an oculus and by windows in the upper walls around the apse. An altar dedicated to the Virgin Mary would have been set in the apse beyond the tomb, and a chapel to the side would have probably held the tomb of Sixtus IV, relocated from the Cappella del Coro on the south flank of the basilica. Sixtus' tomb, by Antonio

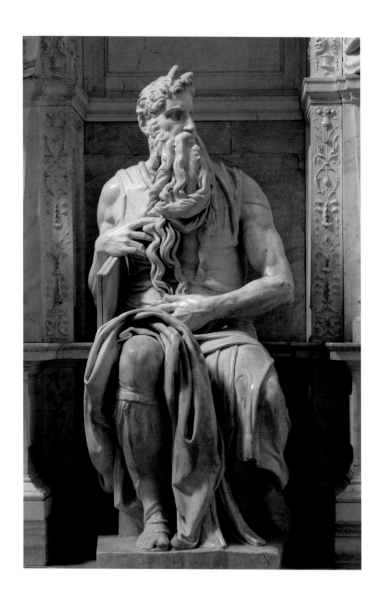

24 Michelangelo, *Moses* from the tomb of Julius II, *c.* 1513–16, marble.

del Pollaiuolo, was commissioned in 1484 by Julius II, when he was still a cardinal. It shows Sixtus' effigy surrounded by the virtues, with personifications of the arts displayed on the low sides. These include the seven traditional liberal arts, as well as philosophy, theology and *prospectiva* (perspective). Perhaps Condivi's description reflects Michelangelo's own intention to create a correspondence between the two tombs. Had Sixtus' tomb been set in a nearby chapel, the two tombs would have been seen in quick succession, causing the viewer to make a connection between them. But the contrast between them was also great: the low height of Sixtus' tomb, less than a metre above the ground, demonstrated the pope's humility. The immense size of Julius II's tomb would have signalled his ambition, and perhaps to some viewers, his hubris.

Only three sculptures survive that can be associated with the 1505 version of the tomb: *Moses*, the *Dying Slave* and the *Rebellious Slave*. Of these, *Moses*, which was meant for the second level of the tomb, best shows how Michelangelo considered the viewer (illus. 24). When the tomb was a free-standing monument, rectangular in plan, Moses's body position and gaze would have worked like that of the colossal *David*, nego-tiating a corner and encouraging the spectator to move around the structure. When the monument was reconfigured as a wall-tomb in 1513, the need to circumambulate disappeared, but the sides still extended almost eight metres from the wall. A drawing in the Uffizi (illus. 25), now attributed to Michel-angelo himself, shows the figure of Moses turned as if in conversation with another figure further back, while another in Berlin by Giacomo Rocchetti shows Moses on the right corner facing straight ahead.[3] But the figure of Moses in both

of these drawings is quite different from that in the finished sculpture. Perhaps the sharp turn of his head and the withdrawn leg would have been counterbalanced by the other two figures along the side of the monument; the contract of 1513 specifies six seated figures at the second level, although their identities are not given. This contract, however, does make clear that these seated figures should be about twice life-size, to accommodate their distance from the eye. Today at San Pietro in Vincoli, that height and distance have been obliterated, and *Moses* is set close to ground level, with tourists held back several metres from it by a thin railing.

The captives, now called the *Dying Slave* and *Rebellious Slave* (illus. 26 and 27), were probably also planned for the first version of the tomb, but they were not started until 1513. Designed for the bottom register of the tomb, early drawings show them standing on bases that would raise them above eye level, but not dramatically so. They could be approached quite closely and the differences between them could be compared. The *Dying Slave*, which is more lithe and elegant in pose, seems to sleep even though bound, while the coarser *Rebellious Slave* struggles mightily against his constraints. Although it would have been impossible to see behind them entirely, a viewer could have glimpsed the ape peering out from behind the *Dying Slave*. The creature might signify the art of painting (painting being the 'ape of nature'), though other interpretations are possible.[4] The captives would probably have flanked *Moses* in the 1532 project, but the tomb was reconfigured again in 1542 and they were replaced by the allegories of the *Active Life* and the *Contemplative Life*. These figures were now cast as Leah and Rachel, the two wives of Jacob described in

Genesis, but conditioned by Michelangelo's reading of Dante's
Purgatorio.[5] All references to Julius' military conquests or sup-
port of the arts were erased. The heirs of Julius II had agreed
to this substitution – Michelangelo argued that the captives
were too large and no longer appropriate to the tomb in its
new configuration. Since they were no longer needed for
the tomb, Michelangelo gave the nude captives to his friend
Roberto Strozzi, in gratitude for allowing him to stay in his
home during a serious illness. They were shipped to France,
and eventually entered the royal collections.[6] They are now
displayed in the Louvre as free-standing sculptures, divorced
from their original context.

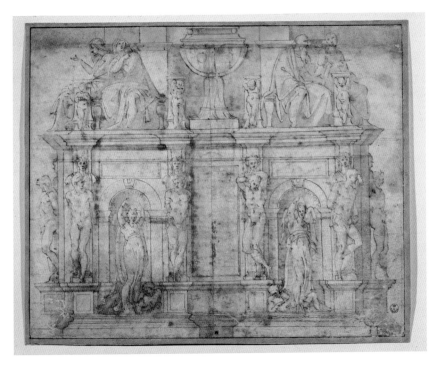

25 Michelangelo (?), modello for the tomb of Julius II, c. 1513 or later,
pen and brown ink.

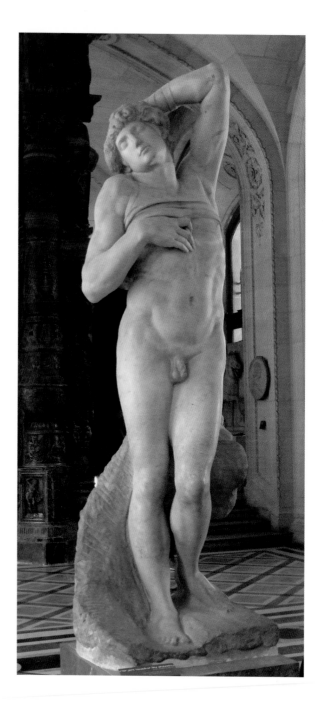

26 Michelangelo, *Dying Slave* from the tomb of Julius II, begun *c.* 1513, marble.

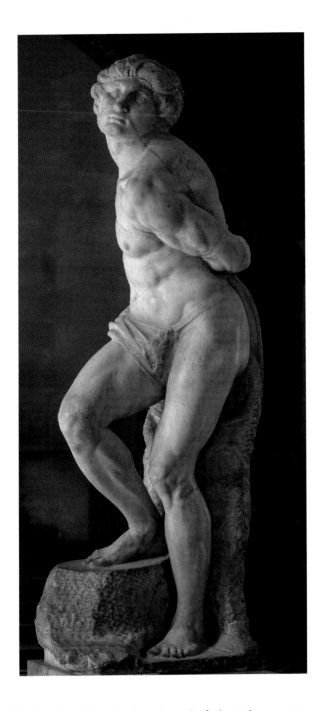

27 Michelangelo, *Rebellious Slave* from the tomb of Julius II, begun *c.* 1513, marble.

Five other figures, the so-called *Boboli Slaves* and the *Victory*, are also associated with the tomb. The *Victory* is not documented in a contract, but Vasari mentions the sculpture along with others for the tomb, and its subject is fully in keeping with the theme of conquest that Vasari saw in the early free-standing version of the tomb.[7] The *Boboli Slaves*, begun around 1520 for the fourth iteration of the tomb, were carved at an even larger scale than the *Dying* and *Rebellious* slaves and were probably intended as figures that supported an entablature rather than bound to terms. Work on these sculptures must have been sporadic after 1520, when Michelangelo's attention was diverted to the Medici projects. They were still considered important for the project in 1532, since the contract drawn up then refers to them. By that time a new location for the tomb, in Santa Maria del Popolo, was being discussed, but Michelangelo was adamant that it should go in San Pietro in Vincoli, because the light was better there and the church more spacious.[8]

All five statues were left in Michelangelo's workshop in Florence when he moved to Rome in 1542. The *Victory* found a natural home amid other similarly themed statues in the Salone del Cinquecento (formerly called the Sala del Gran Consiglio) in the Palazzo della Signoria, where it was installed in 1565 below the painting showing the victory over Siena. The *Boboli Slaves*, on the other hand, were completely recontextualized. In 1585 they were installed in the Medici's Boboli Gardens, in a grotto designed by Bernardo Buontalenti near the Palazzo Pitti. There, they appear to support the enormous weight of the cave. Their unfinished state, which has so often been seen by modern viewers as representing

Michelangelo's titanic struggles to free the image from the stone or of the soul trapped in matter, was then associated with the roughness of nature. The sculptures, along with others of shepherds, animals, gods and nymphs, seem to be immersed in the rocky accretions, ferns and dripping water. The grotto was a place where visitors could escape the heat and be amused by Buontalenti's invention. One viewer, Francesco Bocchi, imagined Michelangelo's figures trying desperately to escape from the cave collapsing around them. The illusion both terrified and delighted him.[9]

Even in its reduced state, the monument to Julius II as it was constructed in San Pietro in Vincoli did become a noted tourist attraction. Engravings of the tomb were regularly included in the *Speculum romanae magnificentiae*.[10] These volumes of prints were assembled by visitors to Rome and by curious foreigners who could not visit the city. Most of the prints in the *Speculum* represented ancient Roman monuments or sculpture; that Michelangelo's work was included at all shows how highly it was regarded in its time. Sometimes these collections would include an engraving of *Moses* isolated from the surrounding figures and structure, and *Moses* was also illustrated in guidebooks, such as Pietro Martire Felini's *Trattato nuovo delle cose maravigliose dell'alma città di Roma* (New Treatise on the Marvels of the City of Rome), where it is placed in the section devoted to classical sculpture. Vasari points out that the tomb was also popular with Jewish pilgrims, who came by the hundreds on the Sabbath 'like starlings, to visit and adore [the *Moses*], for it was not a human, but a divine thing that they worshipped'. While some Jewish visitors – like Christian visitors – probably did flock to see the statue,

Vasari's statement is carefully constructed and implies that the *Moses* is so beautiful and powerful that the Jews, who were prohibited from adoring graven images, were compelled to adore it and perhaps even be converted because of it.[11]

Even as Michelangelo was procuring blocks of marble for the pope's tomb, Julius II was thinking of another project. There are several versions of the events of April 1506, when Michelangelo angrily left Rome to return to Florence, but all suggest that Julius did not want to spend any more money on the tomb. He had already spent more than 1,600 ducats, some of which may have been diverted to Michelangelo's own investments.[12] Major cracks had developed in the ceiling of the Vatican's most important chapel, making repainting necessary. The Sistine Chapel project was very probably seen as both more immediately necessary and less expensive than the tomb. In a letter dated 10 May 1506 the builder Piero Rosselli tells Michelangelo that he had heard the pope and Bramante discussing Michelangelo's qualifications to paint the Sistine ceiling. Bramante pointed out that Michelangelo had little experience with painting and that the height and curvature of the ceiling would create distortions that would confound even an experienced master. Michelangelo's experience with fresco painting was indeed quite limited at the time. He learned something about the process while working under Ghirlandaio, but his only commission for a fresco was the *Battle of Cascina*, which never progressed beyond the cartoon stage.

The task set before Michelangelo was immense. The Sistine Chapel is the largest of three papal chapels in the Vatican. It served as the location for ceremonies on special

feast days when the pope, cardinals and other leaders of the Church and city were in attendance.[13] The public was allowed to view these ceremonies; however, the size and character of this public audience was certainly controlled. Those allowed to view the ceremonies from behind the screen were probably in the entourages of the cardinals or other officials.[14] No women were admitted. This audience was constrained to stand behind the *cancellata*, or chancel screen, which originally divided the space roughly in half. There may have been occasions when the space was truly open to all, as for example when the completed ceiling paintings were unveiled, but it is likely that at those moments spectators would have been hurried through the chapel. They would have had little time – and probably little inclination – to consider the possible meanings of the images they saw.

Michelangelo's paintings were meant to be seen in concert with the other frescoes already decorating the chapel (illus. 28). These included a frescoed altarpiece by Perugino that depicted the Assumption of the Virgin Mary, to whom the chapel was dedicated. On either side of the altarpiece were narrative paintings depicting the Finding of Moses on the viewer's left and the Nativity of Christ on the right.[15] The two narratives began the series of frescoes that wrapped around the chapel, showing the parallel lives of Moses and Christ, both leaders of their people and who foreshadowed the authority of the pope. The chronology of the narratives implied movement from the altar around each wall to the door, but a counter-movement across the chapel was equally important: each scene of Moses's life was typologically paired with a scene from the life of Christ. Through similarities in the

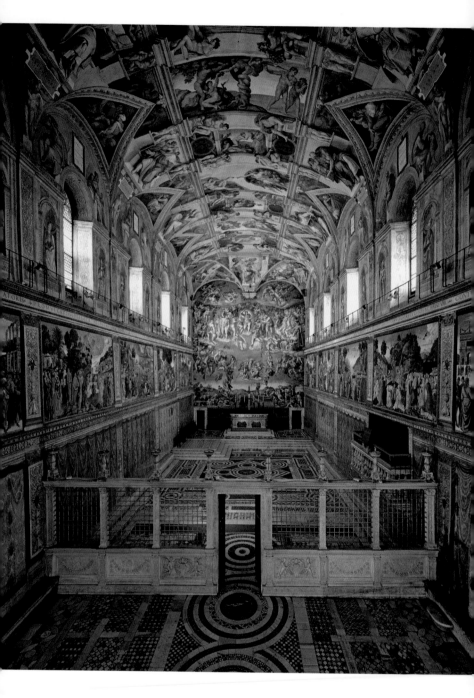

28 Sistine Chapel, Vatican City.

compositions and the titles above each painting, viewers were encouraged to look across the chapel and find connections between the pair. Above the narrative paintings were portraits of the early popes, while the ceiling displayed constellations on a blue background.

These fifteenth-century frescoes established the themes in the chapel: the importance of the Virgin Mary, the primacy of papal authority and the specific honour given to the patron of the chapel, Sixtus IV (Franceso della Rovere). They also set up a visual structure that articulated the architecture of the chapel. The tall windows (five on the each side wall and originally two on either end wall) are surmounted by round lunettes. These join the curved vault of the ceiling by means of corner pendentives and framed fields of roughly triangular shape called severies. The narrative frescoes and the fictive drapery below them are separated by illusionistically painted pilasters, which become actual pilasters above the main cornice. The three-dimensionality of these framing elements makes the niches in which the popes stand appear to be truly concave spaces, while their bodies are given real presence through clearly cast shadows.

Julius's first idea for the new ceiling paintings was to have the Twelve Apostles painted in the spandrels that rise up from each of the dividing pilasters. Michelangelo himself described this conception in a letter he wrote in 1523 to his friend Giovan Francesco Fattucci. The theme was reasonable enough, since the apostles formed a link between the ministry of Christ and the later popes painted on the Sistine walls. The surviving drawings for the overall design of the ceiling show how Michelangelo initially tried to work with this idea, but

difficulties quickly arose. He may not have fully appreciated the actual geometry of the ceiling when he made these first sketches, perhaps because he had not had the chance to observe it at first hand.[16] His efforts to unify the thrones with the framework of the pendentives and severies above the lunettes proved to be impossible, and only when he began to think of a separate cornice framing larger central scenes did the plan come together. As Bramante realized early on, Michelangelo had little experience in creating architectural illusions, and it has even been suggested that Bramante may have assisted Michelangelo in designing this cornice.[17]

When the Twelve Apostles idea was abandoned, the entire conception of the ceiling changed. Rather than glorifying the human followers of Christ, the themes became more expansive, reaching back to the beginning of time. Theological advisers may have been called in at this point – many names have been suggested – but Michelangelo's main concern must have been that his paintings be understood and communicate visually. Whether they were participants in the papal procession to the altar or observers who stood behind the chancel screen, members of the congregation would enter the chapel from the door on the east wall. From there, the narrative scenes along the central spine of the ceiling appeared upright (illus. 29). The scale of the figures in these histories is relatively small closest to the entrance, but gradually increases in size so that the figure of God in the scene closest to the altar fills the entire frame. God's power is expressed with increasing force in the scenes closest to the altar as well. In the scene showing the *Creation of the Sun and the Moon*, God zooms outwards and then back into the space.

In the final scene, the *Separation of Light and Darkness*, he seems to break through the ceiling – it is only in this fresco that a viewer looking directly up from the altar would see the effect in full force. These changes in scale and movement are usually explained as the result of Michelangelo's growing confidence as he proceeded painting from the entrance to the altar, or as an adjustment he made at the approximate midpoint of the project, when the scaffolding which covered half the ceiling was repositioned and he could see the effect from the floor. A recent interpretation suggests that this 'crescendo' was planned from the start, so that the entire ceiling would be visible from the entrance to the chapel.[18] Visibility and meaning worked together: by increasing the scale of the figures, Michelangelo was also signalling their importance, while foreshortening was recognized by Renaissance viewers as a sign of force or power. At the same time, dramatic fore-shortening called attention to Michelangelo's own boldness, since only the most daring artists were able to master this difficult technique.

Michelangelo also shifted his approach to colour in the scenes closer to the altar, no longer keying the colour scheme to the lower frescoes but using brighter, cooler colours.[19] In the earlier sections, colour is used in a more traditional way, with areas of colour modelled in lighter or darker shades of the base hue. Later, Michelangelo used *cangiante* colours, that is, colours that change from one hue to another, using the natural tonality of the pigment itself to create the illusion of three-dimensionality. This brilliant way of creating form with colour helped make the figures more visible, especially in darker corners and in areas where light from the windows

overleaf: 29 Sistine Chapel ceiling.

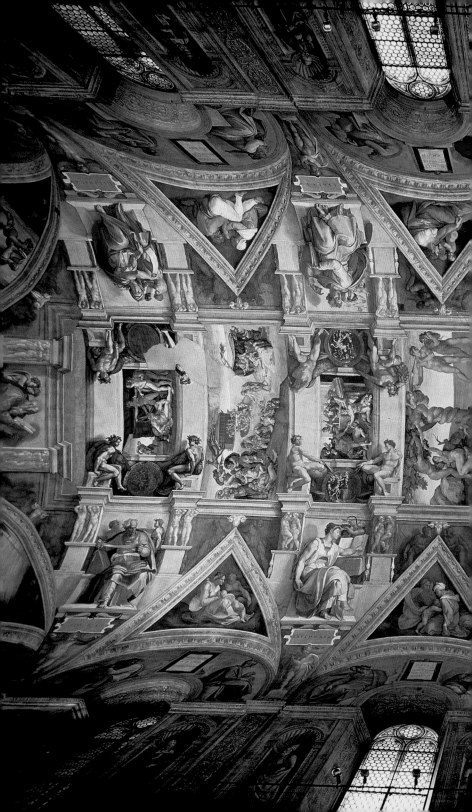

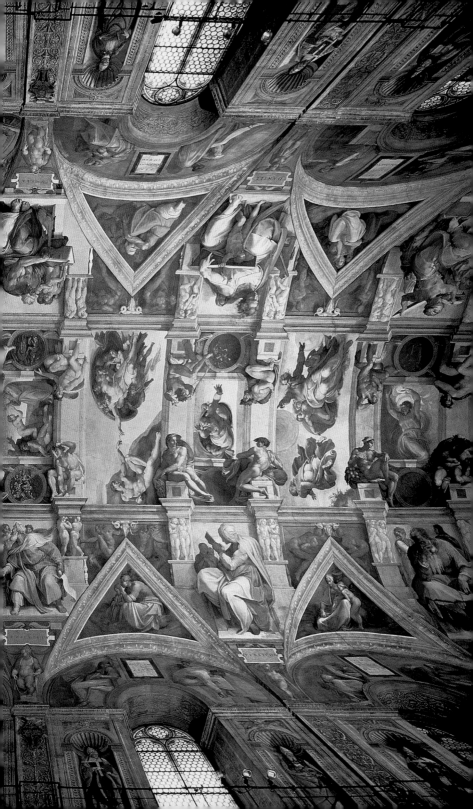

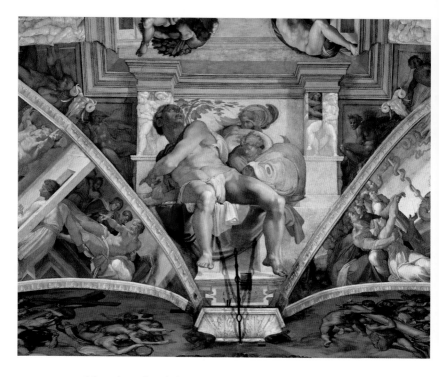

would make it hard for the eye to adjust. In all cases it seems that Michelangelo's main concern was to create the clearest possible forms when seen from the floor, and his success is evident to viewers who have seen the frescoes since their cleaning in the 1980s. Present-day viewers who are fortunate enough to see the frescoes on a sunny day with the artificial lights turned off can get a sense of how the frescoes would have looked when they were first unveiled. But it is impossible to fully reconstruct the lighting in the chapel. In the early sixteenth century the tall windows in the chapel would have been made of stained glass, which would have both tempered and subtly changed the hue of the light.[20] Torches and candles

30 Michelangelo, *Jonah*, c. 1512, fresco. Sistine Chapel, Vatican City.

would have provided additional light, especially during evening services, and the touches of gold on the medallions might have picked up that flickering light, just as did the gold on the wall paintings.

The view from the entrance was not, of course, the only view one could have of the ceiling frescoes. People within the chapel would turn to see the prophets and sibyls; these seers sit on illusionistic thrones, each drawn in perspective with its own vanishing point to correspond to the spectator's changed point of view. The wall behind these figures seems to be the actual wall of the chapel, so, logically, these figures must be sitting in the space of the chapel.[21] The slight forward curve of the spandrel as it extends from the physical pilaster below reinforces this illusion, and many of the seers extend a hand, an arm or an elbow even further into the space. Most dramatic is Jonah, in the spandrel over the altar. He leans backwards as if trying to see the entire vision of the ceiling; with his left arm he points behind, while his foot kicks forwards. As if struggling to keep his balance, Jonah's right foot hovers in the air, projected beyond the surface of the wall (illus. 30). As with the powerfully foreshortened figures of the creating God in the adjacent scene, this complex display of masterful foreshortening serves to call attention to the most significant part of the ceiling.

Even the subsidiary figures present intriguing visual effects. The nudes who frame the creation scenes sit on stone blocks seen from slightly above – they do not conform to the perspective of the thrones below. This and their scale would demonstrate to a viewer skilled in seeing perspectival constructions that they exist in a space apart from the prophets

and sibyls. Below the gigantic figures of the seers are the ancestors of Jesus, in the lunettes and in the severies above them. They cast strong shadows, implying that a light from the front of the chapel illuminates them. When Michelangelo was painting these figures, two tall windows on the altar wall would have cast such light, although that light would have come from a lower angle. What matters is not that the illusion is perfectly logical from any given point of view, but that the viewer is drawn into each scene; if they wonder how it all holds together, it becomes even more riveting.

Michelangelo illusionistically paints a variety of materials on the ceiling, and sometimes these materials shift from one substance to another. Lively putti appear to be carved from marble, while similar children painted in realistic colours serve as caryatids supporting the labels below each prophet. Startlingly realistic rams' skulls separate nudes that seem to be made of bronze. These bronze nudes, tucked into shadowy crevices, are framing elements, with the body used as ornament, in near-perfect symmetry. They carry the eye to the similarly coloured medallions, which are laced with diaphanous ribbons that are stretched or twisted by beautiful naked men. Attentive viewers will see the heavy garlands of oak leaves and acorns these nudes hold. They encircle the ceiling, proclaiming the identity of the patron whose coat of arms featured the rovere oak tree; Julius II's coat of arms may still be seen below the prophet Zechariah on the altar wall. The stories illustrated on the medallions may also be a more subtle reference to Julius, since they are based on the Book of Maccabees; relics of the Maccabean martyrs were venerated in San Pietro in Vincoli, which was Julius' church as a cardinal.

Michelangelo himself, it seems, found inspiration for many of the scenes from an illustrated Italian Bible, but those simple woodcuts are given fullness and life in his hand.[22]

Michelangelo could have invented the visual means of conveying importance, repeating themes for clarity or creating fascinating plays of space and plasticity, and elaborated the woodcuts he found in a Bible, but it is unlikely that he would have been able to devise the complex iconographic programmes that scholars say lie behind the frescoes. Most of the members of the papal court, particularly the clergy within the group, could be expected to mentally elaborate on the themes presented on the ceiling, drawing connections between them from their own knowledge of sacred texts and commentaries. The imagery would serve to stimulate memories, particularly when a liturgical text, hymn or sermon referred to some detail on the ceiling.[23] The important scene of *The Creation of Adam*, for example, has been linked to the hymn *Veni Creator Spiritus*, which is sung at the election of a new pope and at other ceremonies where the Holy Spirit's guidance is needed.[24] The line 'digitus paternae dexterae', the finger of God's hand, may well have given Michelangelo the inspiration for the *Creation of Adam*; the imagery of that scene would certainly have reinforced the meaning of the hymn when a cardinal chanced to look up. Other scenes along the length of the ceiling have resonance with the liturgy that would have been used by Julius II on Holy Saturday, while the selection of prophets depicted in the spandrels is keyed to the liturgical seasons.[25]

In some cases the liturgy reflects specific theological positions held by Sixtus IV and Julius II.[26] Most important

is the Immaculate Conception, the idea that Mary was con-
ceived free of original sin, which was still being debated in
the sixteenth century. Liturgical offices that focused on the
Immaculate Conception were commissioned by Sixtus, and
these same offices continued to be used in the Sistine Chapel
during Julius's time. If women rarely set foot in the chapel,
they nonetheless have a prominent place in Michelangelo's
frescoes. One is embraced by God himself as he creates
Adam – she may be Eve but is more likely the Virgin Mary
in the mind of God before the world was formed. Another
suggestion, drawing on imagery from Proverbs 8:22–30, holds
that she is Wisdom (Sophia), who was present as he 'set the
heavens in place . . . constantly at his side'. This interpreta-
tion converges with her identification as Mary, since this very
passage was associated with Mary's Immaculate Conception
in a sermon given by Sixtus IV.[27]

The sibyls, as heroic as the men they are paired with,
display power and strength through all their ages.[28] The
importance given to the sibyls has been seen as evidence
that Egidio da Viterbo may have advised Michelangelo on
the programme. Egidio was Julius' favourite preacher and a
skilled reader of Hebrew, Latin and Greek sources; he had
a strong interest in prophecy, especially the prophecy of the
pagan sibyls.[29] However, images of sibyls are not uncommon
in Renaissance art, and they sometimes appear in religious
settings, such as the floor mosaics of Siena Cathedral. But how
would the viewers in the chapel respond to them? What
stereotypes or hopes would they bring to bear on these power-
ful images of women? They, more than the male prophets,
seem to represent types, whether the ages of women (from

the youthful Delphic sibyl to the hunched and nearly blind Persian sibyl) or geographic regions (although three are from Greece, the Libyan sibyl would represent Africa, and the Persian sibyl Asia). All are pagan, yet all were inspired to write about the coming of Christ and his passion. Perhaps some viewers connected them to the dream of a universal Church, whose reach would extend to the distant regions they represent.[30] Like the prophets, these women create visual connections to the other scenes on the ceiling, while those viewers who had read the sibylline books or even knew about their popularized legends would find other connections. One of these legends held that the Eritrean sibyl was Noah's daughter-in-law; in the adjacent *Sacrifice of Noah*, the woman who lights the sacrificial fire might be her.[31]

The ancestors of Christ are perhaps the most puzzling. This series is based on the list presented in Matthew 1:2–15, a text that was read on the feast of the Nativity of the Virgin Mary and as the papal court processed into and out of the chapel.[32] Painted on the lunettes above the windows, each is accompanied by a plaque that seems to identify the figures, but it does so only in the most general way. On some, the names of three men are given but only one man is shown, so there is no clear connection between the represented figures and the names.[33] In each lunette there is a man and a woman (although in one lunette, labelled 'Roboam and Abias', the gender of the person turned away from the viewer is not clear). In most, but not all, there are children completing the family groups. More families are depicted above the lunettes in the triangular severies; they are usually considered part of the ancestors series, even though they are not labelled.

Whether in the lunettes or the triangular severies, they depict the Jewish ancestors of Christ's human parents, originally beginning with Abraham and ending with Joseph.[34] Their expressions range from nurturing to coquettish, and con-templative to belligerent. Some are almost comical, like the old man who rails at a sculpted head on his walking stick that looks a lot like him. But in the same lunette is a mother ten-derly caressing a sleeping child. Others read or write, look in mirrors or comb their hair, spin or sleep or struggle with young children. Should they be seen as sinful or lazy – or merely human? These frescoes on the walls of the chapel are quite easy to see, and Michelangelo's use of sharply defined colours and quick strokes makes them stand out next to the bright light of the windows. Until recently, however, the bright colours were obscured by accumulated dirt and dulled glue that had been applied in earlier attempts at restoration. Their sooty darkness encouraged interpretations that saw the groups as representing people in an unredeemed state. They do, in fact, represent Jewish people, often dressed in recognizably contemporary clothes.

One of the most intriguing figures is in the lunette labelled 'Aminadab' (illus. 31). His sleeve is marked with the yellow circular badge that was used in sixteenth-century Italy to distinguish Jews from Christians, in order to demonstrate the traditional view of Christian superiority. He also wears ear-rings to signal his servitude and his otherness (he is the only male figure on the ceiling who does so).[35] Placed above the portrait of Pope Evaristus, who, as the inscription points out, was born to a Jewish father, and below the pendentive that depicts the story of Queen Esther, these clear markers

of his Jewish identity are significant. Esther hid her Jewish
identity from her husband, the Persian king Ahasuerus, until
a plot devised by Ahasuerus's minister Haman had been set
in motion to have the entire Jewish population killed. Esther
then presented herself before her husband and pleaded with
him to stop the plot, revealing that she too would be killed
if the plot succeeded. In the pendentive, Michelangelo focuses
on Haman, who is shown dramatically foreshortened, as if
crucified on a tree. His death had long been celebrated by
Jews, since it brought about salvation to the Jewish people;
here the image of his outstretched body on a tree foreshad-
ows Christ's Crucifixion, whose death brought salvation to
Christians.[36] In the pendentive on the other side of the altar
wall, the narrative of the brazen serpent, which was raised up

31 Michelangelo, Aminadab lunette, *c.* 1512, fresco. Sistine Chapel,
Vatican City.

to save the Jewish people, offered another prefiguration of the Crucifixion. There is no evidence that Michelangelo was either especially sympathetic to or prejudiced against the Jews. The broader culture of the papacy and of the Roman people in the early sixteenth century was highly conflicted with regard to the Jews: individual Jews in Rome could be honoured for their learning, valued for their skills in finance and medicine, and even exempted from wearing the ignomious badge, while the Jewish community was still being onerously taxed and humiliated in public spectacles.[37]

There were few visual precedents for the ancestors of Christ, and those that exist usually only depict men. In searching for poses to fill these spaces, Michelangelo sketched rapidly, probably observing ordinary people around him.[38] Perhaps in his search for figural variety and liveliness, he captured the ways Jews of his time dressed and the variety of their occupations, seeing them in a range of roles, rather than as a single type. At the same time, depicting the contemporary badge on a biblical ancestor of Christ was unprecedented.

Although Condivi and Vasari say that all of Rome flocked to see the Sistine ceiling when it was finally unveiled on 31 October 1512, there are only a few comments that have come down to us from the first decades after its completion.[39] The Dutch pope Adrian VI, who reigned from 1522 until 1523, was incensed by the nudity; his reaction was dismissed even in the sixteenth century as reflecting his antipathy to Italian art in general. In 1525 Paolo Giovio praised the *Judith and Holofernes* pendentive for its convincing three-dimensionality and for the way that the figure of God seemed to move as the viewer changed position. Some artists, most notably Raphael,

paid homage to the ceiling in their own works. Drawings were made of the ceiling but only a few were transformed into engravings; those that were published show only selected figures, without giving a sense of the complex whole. The Sistine ceiling frescoes remained a work to be contemplated only by the privileged for decades.

Power and Illusion: Commissions for the Medici

ULIUS II DIED IN 1513, just months after the unveiling of the Sistine ceiling frescoes. His successor was Giovanni de' Medici, who took the name Leo X. He was the same age as Michelangelo and knew the artist from the years when Michelangelo was present in the household of Lorenzo the Magnificent, Giovanni's father. Leo X was a great patron of music for the Sistine Chapel, and he made significant contributions by commissioning new vestments, liturgical items and, above all, the luxurious tapestries that Raphael designed for the area closest to the altar; but he gave little work to Michelangelo. A refashioned window frame for the exterior of Leo's chapel in Castel Sant'Angelo was his only commission in Rome. With its free use of classical elements to accommodate the contingencies of the structure, it gives some sense of how his creativity would develop. Perhaps Michelangelo felt free to experiment, since the facade is rather hidden from view, facing a courtyard on the third level of the castle. Other, more prestigious opportunities awaited him in Florence.

The Medici had regained power in Florence in 1512, and there were projects there that would glorify the family and

beautify the city. Chief among these was the facade of the Medici church of San Lorenzo. The church had been splendidly decorated for the pope's ceremonial entry into the city in 1515; other buildings, including the Duomo, had also been given temporary facades that surely impressed the pope.[1] Condivi makes it seem that Leo X set Michelangelo to this task immediately after his coronation and that Michelangelo was reluctant to take on the job because of his desire to finish the tomb of Julius II. Indeed, around this time Michelangelo had agreed to complete a reduced version of the tomb. How Michelangelo could have managed both projects at the same time is hard to imagine, since the San Lorenzo facade alone involved at least ten sculptures in its original conception (ultimately about forty were planned), along with the architectural design. Condivi also vividly describes the conflict between Michelangelo and Leo about which quarry should supply the marble. The image he paints is one of Michelangelo weeping because he could not finish the tomb of Julius and frustrated because he could not choose high-quality marble for the San Lorenzo facade.

Condivi's account is clearly based on Michelangelo's memories, but in retrospect it seems only to offer excuses for not finishing either the tomb or the facade project. It is also a cover for one of Michelangelo's most devious grabs of a commission. Vasari's rendition of events is closer to the truth, since he gives the names of five other architects who were asked to submit designs for the facade. In addition, drawings survive by the hand of Giuliano da Sangallo, Michelangelo's longtime friend and a respected architect who had worked for both the Medici and Julius II. Guiliano, however, died in 1516, before

the commission was awarded to anyone; Michelangelo surely
knew about these drawings, for he used them as the basis of
his earliest designs.[2] It is not clear whether there was a true
competition for the facade, but it is certain from documents
that other artists and architects believed that they would be
involved in the project.[3] Michelangelo at first teamed up with
Baccio d'Agnolo. The idea was that Michelangelo would do the
sculpture, Baccio the architectural design. But Michelangelo
soon took over the entire project. More than thirty surviving
drawings show his process, and what may be the final design is
seen in the large wooden model now in Casa Buonarroti (illus.
32). After considering the idea of a veneer facade with a taller
central section covering the nave, Michelangelo decided on a
full two-storey structure, a bay deep, with architectural orna-
ment and sculpture on the sides as well as the front. Recently
there has been some interest in actually completing the facade
using this model as a guide; a computer simulation suggests

32 Model of the San Lorenzo facade, wood.

that the construction would be imposing but perhaps forbidding.[4] Might Michelangelo have made adjustments to increase the play of light and shadow or to vary the planes even more? How would the sculpture have changed its appearance? The documents state that these over-life-size figures were adjusted to be more visible, but the few drawings that show sculpture give little indication of the effect.[5] The facade would surely have been an impressive celebration of the Medici family, but how the public would have reacted will never be known. Marbles were ordered and foundations begun, but in 1519 the project was abandoned and the contract cancelled the following year.

Again Michelangelo was taken away from a project on which he was enthusiastically engaged to begin a different project that seemed more pressing. This was the Medici Chapel, a mausoleum for four members of the Medici family: Lorenzo and his brother Giuliano (the *Magnifici*), as well as Lorenzo the Magnificent's son, Giuliano, and grandson, Lorenzo (the *Capitani*). The deaths of the two younger men in 1516 and 1519 respectively surely inspired the project, since they were the last legitimate members of the Medici line that descended from Cosimo il Vecchio.

In its earliest conception, the chapel would very likely have included the tomb of its patron, Cardinal Giulio de' Medici.[6] He was cousin to the reigning Pope Leo X, and like him had known Michelangelo since childhood. Giulio de' Medici would prove to be one of Michelangelo's most engaged and co-operative patrons. He had served as a go-between for the San Lorenzo facade project, and as archbishop of Florence he was fully responsible for the other Medici commissions, including

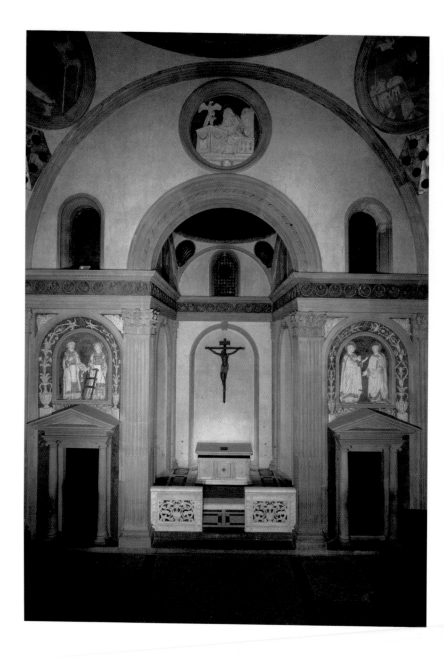

33 Filippo Brunelleschi, Old Sacristy, 1420–29. San Lorenzo, Florence.

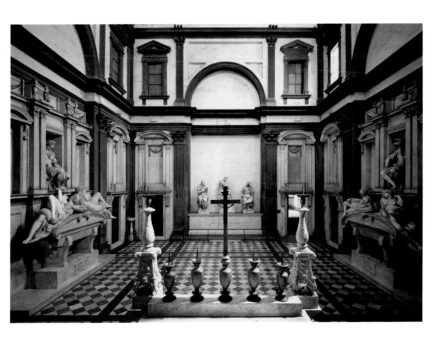

the Medici Chapel and the Laurentian Library. In 1523 after
the brief reign of Adrian VI, he was elected pope, taking the
name Clement VII; his interest in Michelangelo's projects in
Florence continued unabated.[7]

The project for the mausoleum involved architecture as
well as sculpture. The structure would adjoin the north transept
of San Lorenzo in a symmetrical relationship with the Old
Sacristy, designed a century before by Filippo Brunelleschi.
The plan and the grey pietra serena moulding in the chapel
make clear reference to Brunelleschi's sacristy, but Michel-
angelo made significant changes as well (illus. 33 and 34). The
site was constrained by buildings belonging to the Nelli
family, which blocked some of the possible places for windows.[8]
Michelangelo solved the lighting problem by adding another

34 View of the Medici Chapel, San Lorenzo, from the altar.

storey, creating a much taller space than that of the Old
Sacristy. At the level above the tombs there appear to be eight
windows in tabernacles, but only four admit light, and two
of these receive only indirect light. In the uppermost zone,
the four 'perspectival' windows are most functional, but at
the same time they are the most illusionistic: they are trape-
zoidal, so they appear to the viewer – who would expect a
window to have vertical sides – to be receding in space. The
effect is that they seem even taller than they actually are, and
yet no viewer would be truly fooled, for the uprights converge
too steeply. Other elements of the chapel's architectural
details seem to be designed to fool the eye. At the second level,
the windows (or false windows) are illusionistically 'sup-
ported' by flat tabs of pietra serena. The pilasters between
the windows at the second level seem to continue the line of
the ones below, but there is no connection between them. In
the Old Sacristy, Brunelleschi created a similar space between
the pietra serena entablature and the bases of the windows
above, but there the space is filled with stucco roundels – the
effect is a solid frieze, not an empty space. Similarly,
Brunelleschi's doors topped with Donatello's sculptural reliefs
in arched frames probably inspired the doors and tabernacles
in Michelangelo's chapel, but Brunelleschi's relatively simple,
architectonically stable shapes are turned into dynamic forms
by Michelangelo. Swags and medallions embellish the most
recessed surfaces, while the frames and arched pediments
create shifting planes that step forwards at least four times.
There is no lintel to tie the frame together, yet the tabernacle
is visually supported by brackets. This entire complex unit,
carved from white marble, seems to press against the pietra

serena elements, just as the effigies of the deceased seem to be constrained by the niches they occupy.

In the earliest plans for the tombs, a free-standing monument was considered, but this proved unworkable because of limited space and liturgical considerations.[9] By 1521 the design had evolved into three wall tombs: one for each of the *Capitani*, and another double tomb for the *Magnifici*, the elder Lorenzo and Giuliano, who would share a monument on the wall facing the altar. The tombs were never completed as intended, although two finished drawings in the Louvre give a good sense of how they might have looked.[10] The double tomb for the *Magnifici* would have been surmounted by a statue of the Virgin and Child, now called the *Medici Madonna* (illus. 35). It is the only sculpture Michelangelo started for the double tomb complex. The flanking figures of Cosmas and Damian, the patron saints of the Medici family, were carved by Fra Giovanni Montorsoli and Raffaello da Montelupo following Michelangelo's models. The wall tombs for the *Capitani* are much more complete (illus. 36), but still they lack many pieces: allegorical figures that would have stood on either side of the effigies; herms; trophies and crouching figures that would have decorated the upper zone (one of the figures is in the Hermitage in St Petersburg); and the river gods that would have been installed at the base of the tombs (a full-size clay model for one of these survives in Casa Buonarroti). The vault too would have been richly decorated, with gilded and painted stucco garlands by Giovanni da Udine. These were almost complete in 1532, but from Vasari's remarks in his biography of Giovanni, they must have been difficult to see, and Vasari wanted to remove them when he took over

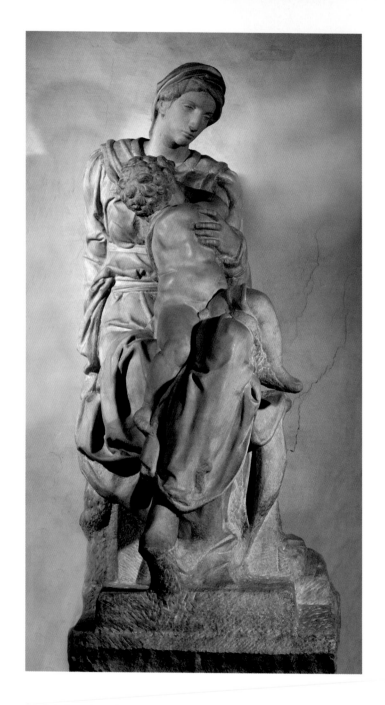

35 Michelangelo, *Medici Madonna*, *c.* 1524–34, marble.
36 Tomb of Giuliano de' Medici, Duke of Menours, *c.* 1524–34, marble.

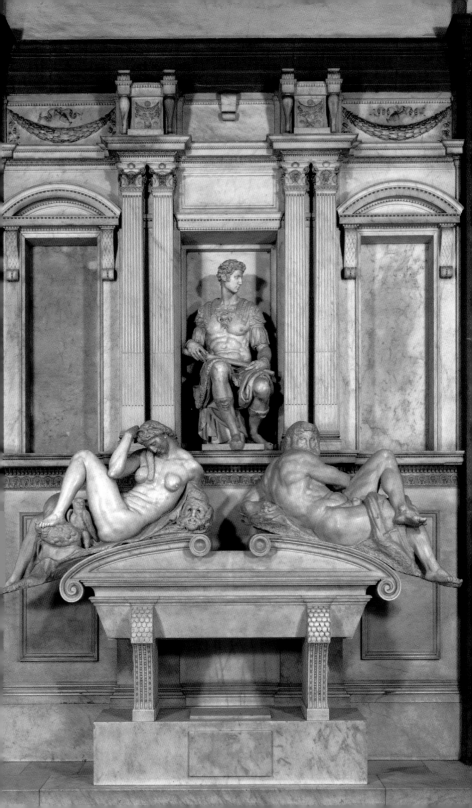

supervision of the project in 1556.[11] It may not be coincidental that in 1563 Vasari proposed to the aged Michelangelo that members of the Accademia del Disegno finish the ensemble with 'paintings, sculpture and stuccowork'.[12] Michelangelo never responded to Vasari's plan. Frescoes may have also been planned for the lunettes above the tombs, but the subjects have been debated. A Resurrection is one likely possibility, since the chapel is dedicated to Christ's Resurrection and drawings of the theme, done around this time by Michelangelo, survive today.

Michelangelo reported on his progress in a letter dated 17 June 1526: the architectural framework for one tomb was largely complete, several sculptures were 'sketched out', and he was preparing to have workmen set the stones for the tomb on the opposite wall. In the same letter he indicated his intention to finish the statues of the *Capitani*, the figures on the sarcophagi (the *Times of Day*), the river gods on the floor, and the Madonna; he would leave the other figures and decorative carving to assistants. Within a year political unrest brought work to a halt. On 6 May 1527 Rome was sacked by anti-papal troops associated with the Holy Roman Empire, and Clement VII was confined to Castel Sant'Angelo. Antipathy towards the Medici in Florence could now be expressed openly, and ten days later the family was expelled and the Republic reestablished. Images of the Medici were destroyed in other parts of the city, but the effigies in the Medici Chapel survived. In 1529 Florence was besieged by forces from the Holy Roman Empire, now in alliance with the Medici. Michelangelo was a supporter of the Republic – in fact, he was put in charge of the fortifications of Florence – which set him

directly at odds with his patron. In 1530 Medici rule was re-established in Florence, and the illegitimate Alessandro de' Medici was installed as duke of the Republic. Michelangelo was always fearful of Alessandro (with good reason), but Clement reaffirmed his support of the artist and work continued on the chapel – a remarkable testament to his respect for Michelangelo. By 1532 Michelangelo was making plans to return to Rome, and he finally left in 1534 to take up the commission for the *Last Judgment*. He had made an effort to finish some of the figures before his departure, but some – especially *Day* – remain very rough. The tomb sculptures were set in place only around 1545, under the direction of Niccolò Tribolo, while the sculptures of the Madonna, Cosmas and Damian were only installed in 1559, when the remains of the two *Magnifici* were transferred to the chapel by order of Cosimo I.[13]

Who were the viewers in the Medici Chapel? The question is more difficult to answer than one might suppose. Despite being called the New Sacristy, the Medici Chapel never functioned as such. From its beginning it was meant to be a family mausoleum chapel, a sacred space where prayers would be said in perpetuity for the deceased. The ceremonies to be performed there are laid out very precisely in a papal bull that Clement VII issued on 14 November 1532. Three Masses for the dead were to be said every day, but in addition the entire Book of Psalms would be sung continuously through the day and night.[14] The clergy charged with this duty would stand behind the altar, looking towards the image of the Virgin Mary nursing the Christ Child – the symbol of her ability to intercede for the dead. There was no provision for public ceremonies, and in the early seventeenth century

Pope Paul V would grant an indulgence to the priests who prayed at the altar. This indulgence is inscribed on a plaque still on the altar; there is no mention of anyone else in the chapel receiving one.

These two priests, perhaps occasionally joined by members of the family, might be considered the intended audience in the chapel. It is clear, however, that the sculptures of the Medici *Capitani* are not the focus of that audience's attention, but rather the carved figures seem to join the living in looking towards the wall where Lorenzo the Magnificent and his brother were interred below the Madonna. Their poses are quite different – Giuliano actively cranes his neck to see out of his niche, while Lorenzo (illus. 37) seems to be lost in contemplation – but both turn in her direction. Since there was constant chanting in the chapel, which stopped only when Mass was being said, Lorenzo's pose might indicate listening more than seeing; in fact his eyes are 'blind', that is, they lack pupils.[15] Sound may have been an important element in the design from the beginning, but even if Michelangelo did not anticipate Clement's institution of these rituals, the poses of the statues suggest that they are more than objects of a visitor's gaze. Whether they look precisely at the Madonna and the saints who can intercede for the deceased, at the tombs of the elder Medici or even at the door from which visitors originally entered, they seem to be active participants, reacting to objects and activities within the space.[16]

But certainly there were other visitors to the chapel. There are indications that it was an attraction for foreign visitors, including Holy Roman Emperor Charles V, who was brought there in 1536.[17] Members of the Florentine literary

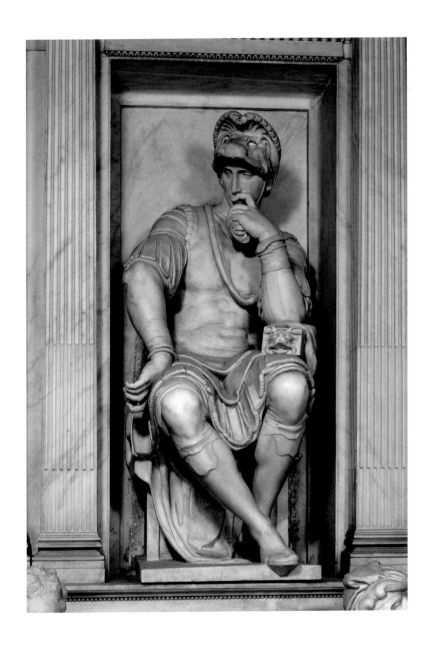

37 Michelangelo, *Lorenzo de' Medici, Duke of Urbino*, Medici Chapel, *c.* 1524–34, marble.

community visited and responded in a unique way: they wrote poems and dialogues in which the sculptures come to life and speak to each other.[18] A very common way to praise sculpture in this period was to say that it lacked only breath to make it come alive, and stories such as that of Pygmalion – in which the sculptor falls in love with his work, who rewards him by coming to life – were well known in the Renaissance. The opposite effect, of a sculpture turning a person to stone, drew on the story of Medusa and Perseus, and it too echoes in the comments people made about Michelangelo's sculpture. In Anton Francesco Doni's *I marmi* (The Marbles), *Dawn* speaks and tells a story of how Michelangelo brought a visitor to the Medici Chapel. After 'looking and looking at everything', the man was transfixed – turned to stone – when he saw the figure of *Night*. Michelangelo, who had no power over God's creations – only his own sculpture – could not wake him but instead roused *Night*, who changed positions and broke the trance. An interlocutor marvels, 'O what a stupendous thing this is . . . I have become marble and she flesh.'[19] Michelangelo himself participated in this exercise, as seen in two poems quoted by Vasari in his 1550 life of Michelangelo. In the first, the poet Giovanni di Carlo Strozzi insisted that *Night* was so lifelike that if the viewer were to wake her she would speak; in response Michelangelo had *Night* reply that as long as there was misery in the world, she would rather stay as stone: 'Not to see, not to hear, to me is a great boon; so do not waken me, ah, speak but softly.'[20]

Artists were drawn to the chapel. Vasari says that he and other young artists secretly entered the chapel to copy the sculptures even before Michelangelo left for Rome in 1534.

No secrecy was needed later, and drawings and prints of the *Times of Day* can be dated to as early as 1536.[21] A drawing by Federico Zuccaro dated after 1564 vividly shows artists sketching or just conversing in the chapel; one sits on the tomb of the *Magnifici*, another stands on a piece of sculpture still on the floor.[22] These artists were undoubtedly much more interested in seeing Michelangelo's art than in praying for the souls of the Medici. Yet religious, touristic and artistic activities must have coexisted. Vasari's learned friend and adviser to the Medici court Vincenzo Borghini complained that smoke and dust made a bad impression on visitors.[23] The dust may have been from construction work, but the smoke very probably came from a stove that the priests had installed, evidently to keep warm in the winter. Vasari also complained about that stove when he was trying to convince Duke Cosimo I that the space should be used as the main meeting place of the Accademia del Disegno. Since the chapel did not have an adequate chimney, smoke could not escape and soot accumulated on the sculptures.

Later in the century, Francesco Bocchi devoted several pages to the Medici Chapel in his guidebook *The Beauties of the City of Florence*.[24] Bocchi's description is more extensive than others written in the sixteenth century, and he gives careful attention to the architecture and ornamental details, such as the candelabra designed by Michelangelo, which he says 'gladden the soul' and inspire wonder. He calls the seven sculptures by Michelangelo the Seven Wonders of the World, and together they show how our life is consumed through time. He particularly notes the virile quality of *Day* (seen in the roughness of the unfinished stone, his muscular physique

and his vigorous pose as he turns towards the viewer) and the elegance of *Night*, who is equally beautiful when seen from the left or the right, but especially so from directly in front. The alertness of Giuliano's pose, the monstrous face on Lorenzo's helmet that inspires terror in the enemy, the dignity and naturalism of the Madonna – all these and many other details are noted with care. He, like all sixteenth-century writers, had no trouble identifying the *Times of Day*, even though only one, *Night*, is provided with attributes. With great sensitivity Bocchi describes how the body of each figure conveys age or youth, power or lassitude.

Bocchi was writing a book for lovers of art, and specifically for the growing number of tourists to Florence who sought out works that they may have heard about. It is clear that he wanted to establish the Medici Chapel as the most important artistic monument in Florence, one which could rival the important sites in Rome, with sculpture that surpassed renowned classical works. But by 1591, when Bocchi's guidebook was published, Michelangelo's work was being criticized for its artistic licence.[25] Bocchi responded directly to criticism of the architecture, which does not follow the rules set down by Vitruvius; this, he says, is because architecture does not merely imitate nature, but rather was invented by human industry and gets better through human ingenuity. Bocchi's lavish praise of Michelangelo's knowledge of anatomy might also be a response to criticisms of the exaggerated proportions and poses of the figures. Unlike many other critics, however, Bocchi does call attention to the sacred function of the chapel, where Masses and prayers were said with 'unceasing diligence' for the Medici family.

Bocchi is one viewer, writing more than half a century after Michelangelo stopped working on the chapel. While he confirms the way that a viewer's attention shifts from the architecture to the details at the lower level, he does not mention certain other things that add even more fascination, such as the band of small masks, each slightly different, running behind the tombs. Bocchi's omission may be explained as being because he knew the masks had not been carved by Michelangelo himself, and his purpose was to praise Michelangelo's work alone.[26] But it is odd that Bocchi does not notice any of the masks found throughout the chapel: on the tomb capitals, on one of the candlesticks that Michelangelo designed for the altar, and even on the back of Giuliano's cuirass (though no one would ordinarily see this).[27] In particular, he does not notice the large mask below *Night*'s left shoulder that seems to stare directly at the viewer. This strange image has been interpreted as a self-portrait and a reference to Michelangelo's first encounter with Lorenzo de' Medici, who recognized the talent of the young sculptor who carved a satyr for him.[28] Bocchi may not have made that connection or thought it was significant, or he may have found the use of masks to be a common way of signalling the illusions of art. It was a sign that Michelangelo himself would have known; perhaps the masks are a way of telling the viewers that what they see is an illusion, without substance. In this sense the 'portraits' of the *Capitani* are also illusions, representing neither the physical appearance nor the personality of their subjects. Michelangelo is reported to have said that he gave them greater grandeur, decorum and grace, since no one would recall what they looked like in a thousand years' time.[29] Michelangelo presented them as

abstractions and ideals, giving them 'masks' that make them appear better than they were.

The architectural motifs of the Medici Chapel were reused and developed in the Laurentian Library, which was designed beginning in 1524 only steps away from the chapel. However, it has a secular and public use, having been designed to house the great collection of manuscripts that the family had amassed. Michelangelo designed the library as three separate spaces above the existing monks' cells in the cloister at San Lorenzo: the vestibule (or *ricetto*) adjoining the church's south transept, the long reading room and a small triangular room for rare books (never built). All three areas were designed simultaneously, but the design of the staircase of the *ricetto* (illus. 38) continued to evolve after Michelangelo left Florence. This extraordinary cascade of curves and eddies, held in check by rectangular steps, was not completed until 1559, under the supervision of Bartolomeo Ammannati. Remarkably, the *ricetto* would have been lit with a skylight, something Clement VII thought would be novel and quite beautiful, though he worried it would be quickly obscured by dust.[30] As it turns out, natural light enters the *ricetto* through windows at the third level; as in the Medici Chapel, this higher elevation was added for practical reasons, but was exploited for expressive effect. Entering the space of the vestibule, one feels almost pushed against the wall – the dramatic stairway fills the room with its presence. This design evolved late in Michelangelo's thinking; it was actually Clement's idea to have a wide, free-standing single staircase, not a double set of stairs that ran along the side walls, as Michelangelo had first planned.[31] Heavy double columns set

38 Staircase in the vestibule of the Laurentian Library, c. 1524–34; completed after 1559. San Lorenzo, Florence.

into the walls seem to rest on brackets, but these are sepa-
rated from the columns by a slight band of white wall; if they
suggest a muscular push upwards, that connection is contra-
dicted ever so slightly, and the brackets themselves appear to
hang on the white walls. At the next level, the columns flatten
into pilasters and the motif of the smaller frames grows into

39 Vestibule of the Laurentian Library, c. 1524–34; completed after 1559.
San Lorenzo, Florence.

rectangles crowned with roundels (illus. 39). These are flatter
elements, mere decorations on the walls, and yet they are
also the real windows of the space. Set between the columns
are shallow aedicules, which look something like windows or
niches for sculpture, but function as neither. They are framed
by pilasters that taper towards the bottom and are topped
with 'capitals' that are pinched rather than swell outwards.
Michelangelo surely expected those who visited the library to
know how the classical orders were supposed to look, and he

40 Reading Room, Laurentian Library, 1534. San Lorenzo, Florence.

might have imagined that these well-informed visitors would be fascinated by the many inversions or revisions of the classical rules. Indeed, some of Michelangelo's followers recorded his ideas about architecture and said that he thought that mixed forms – such as *grotteschi* or unusual combinations of architectural elements – were preferable to those that simply imitated reality or followed normative rules. He believed that these combinations offer respite or pleasure to the senses, or satisfy 'an insatiable desire', and they show the imagination of the artist, which is like that of the poet.[32]

The reading room (illus. 40) is more regular, rhythmic and calming – perhaps less distracting for those who studied the manuscripts chained to the desks. Yet motifs such as the

41 Drawing for the Rare Book Room of the Laurentian Library, *c.* 1534, pen and brown ink and wash.

rectangular insets above the windows carry through from the *ricetto*. Michelangelo carefully designed the floor, ceiling and seats so that they would coordinate with the framing elements on the walls. The seats not only fit within each framed bay, but when viewed obliquely they form a kind of base or platform for the lighter walls above. The warmth of the walnut seats and the floor is reflected in the ceiling. In a letter describing one of his final ideas about the stairway, Michelangelo said that he wanted it to be made of walnut as well, so that the two rooms would be connected. And yet he designed an extraordinary visual effect that seems to make the *ricetto* invisible to someone looking out from the centre of the reading room, for directly opposite the door is a blank panel that fills the entire field of vision.[33] This panel is not obvious to a person entering the vestibule, since the visitor's attention would be on the looming staircase. Entering the reading room would be relief from the architectural drama, which was sustained until the visitor was almost through the door upon exit.

The triangular rare book room (illus. 41), like so much else in the San Lorenzo complex, is an innovative solution to a practical problem: in this case, a house cut into the property at an angle. How Michelangelo would have fashioned the reader's experience can only be guessed from two surviving drawings.[34] In a room so tightly angled, enclosed and maze-like, the reader might have felt the space to be as precious as the material he read.

Painting the Visionary Experience: Frescoes for Pope Paul III

HE MEDICI PROJECTS in Florence were associated with popes, but they were really commissions meant to serve the family. In 1533, however, Pope Clement VII was beginning to think about another project. On 17 July 1533 the painter Sebastiano del Piombo, Michelangelo's friend and collaborator, wrote to Michelangelo, telling him to return to Rome since he had heard the pope talking about 'something you would never have dreamed'. Michelangelo travelled to meet the pope in the following months, and by February of the following year scaffolding was being erected in the Sistine Chapel for a new project on the altar wall. Neither the Medici Chapel nor the library was finished. Once again, Julius II's heirs were eager to have Michelangelo return to work on his tomb, since a much-reduced wall tomb had been agreed upon in 1532. Surely this new project being dreamed up by Clement was a way to keep the artist working on Medici projects rather than the della Rovere tomb. It was also Clement's way of putting his personal stamp on the chapel, which was so dominated by della Rovere imagery. Michelangelo had other reasons to relocate to Rome. Florence was now in the hands of Duke Alessandro de' Medici, who hated

Michelangelo for supporting the Republic during the siege. If Michelangelo stayed in Florence he would surely be harassed, imprisoned or even killed. The artist had always maintained friendships in Rome, and had recently become acquainted with a young nobleman, Tommaso de' Cavalieri; his letters to Tommaso from this time are full of longing. In early summer 1534, Michelangelo visited Florence one last time, returning to Rome on 23 September. Clement VII died two days later. His successor, Alessandro Farnese, who took the name Paul III, ordered Michelangelo to complete the work planned for the Sistine Chapel, a Last Judgment (illus. 42). Paul III was from one of the wealthiest and most sophisticated families in Rome. His willingness to continue this commission begun by the Medici pope has less to do with shared theology than with his desire to have the greatest painter working for him. Michelangelo had asked to be removed from the project when Clement died; Paul's response was recorded by Condivi: 'I have had this wish for thirty years, and now that I am Pope, can I not gratify it?'

Michelangelo knew the Sistine Chapel, its functions and its primary audience very well. These things had changed little since he had worked there a quarter of a century earlier. But other things had changed. There was a greater sense of threat to the Church, brought on by the Protestant Reformation. The disastrous Sack of Rome of 1527 had brought rape and ruin to the city. German and Spanish mercenaries under the aegis of the Holy Roman Empire had rampaged through Rome, claiming to be chastening the papacy for years of corruption. Clement's lack of resolve and shifting alliances set the stage for the sack, and his remorse is often seen as the

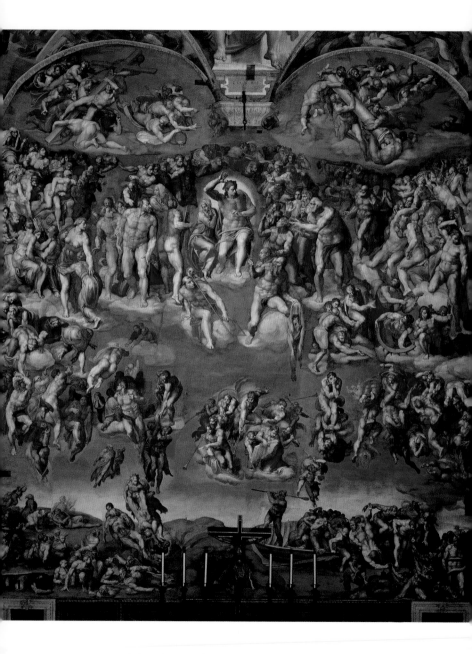

42 Michelangelo, *Last Judgment*, 1538–41, fresco. Sistine Chapel, Vatican City.

reason why the Last Judgment was chosen as the theme for the altar wall in the Sistine Chapel. But the Last Judgment may not have been the only subject considered. A letter written in March 1534 says that Clement had commissioned Michelangelo to paint a 'Resurrection'; the writer also mentions that the scaffolding had already been erected. This subject makes some sense, since the entrance wall of the chapel with its painting of the Resurrection of Christ had been damaged in 1522. However, the reference is vague and has been interpreted by some scholars as meaning the resurrection of the body – a subject that is a necessary part of the traditional Last Judgment theme.[1] Vasari, in his 1568 edition, says that Michelangelo was asked to paint both the entrance and altar walls, with the Fall of the Rebel Angels and the Last Judgment respectively. The entrance wall fresco in the Sistine Chapel never materialized; that wall would finally be repainted by other artists in the 1570s, following the decorative scheme established in the fifteenth century.

Vasari's statement does point to an important reason why the Last Judgment was an appropriate theme given the other decorations in the chapel. It represented the end of human time, and it was implied from the moment that the Creation was chosen as the theme for the ceiling. It is quite normal for Renaissance histories of the world to begin with Creation and end with the Last Judgment; examples can be found in early frescoes such as those at the Collegiata in San Gimignano, as well as in the famous *Nuremberg Chronicle* by Hartmann Schedel, published in 1493. If the entrance wall were painted with the Fall of the Rebel Angels, it would make an even stronger connection between images of judgment at the

beginning and end of time. It has even been proposed that Julius II intended to have a Last Judgment painted on the altar wall when he first commissioned the ceiling frescoes in 1508.[2] Indeed, it was during Julius's reign that the doctrine of the resurrection of the body was affirmed at the Fifth Lateran Council in July 1511. Perhaps most importantly, the Last Judgment is a fundamental tenet of the Catholic faith – not something to be thought about only in times of crisis. For the faithful is it a moment of triumph and glory, and if it inspires fear in the beholder it is because that beholder has reason to fear.

Whatever the reasons for choosing this particular theme, the project was developed and brought to completion under Pope Paul III. Under his patronage the project both contracted and expanded. Any thought about the Fall of the Rebel Angels on the entrance wall was abandoned, but the scope of the painting expanded to take in the entire altar wall. Drawings done before Clement's death show that Michelangelo first tried to work around the rectangular altarpiece as well the lunettes he had painted some thirty years earlier.[3] But under Paul III, the entire wall was completely resurfaced with brick, so that it canted forwards about thirty centimetres at the top. This was done, so Vasari says, to reduce the amount of dust falling on the fresco, but it also removed the architectural elements that had defined the wall: two windows were blocked up, and the fifteenth-century paintings as well as the cornices and pilasters that framed them were eliminated. In the process, Michelangelo's own frescoes on the lunettes were destroyed, a spandrel between the two lunettes was shortened, and the putto that once stood below the prophet Jonah

disappeared.[4] By 1536 the expanded field was ready for Michelangelo's uninterrupted vision.

The Last Judgment is a complex theme, representing an event that Christians believed would happen, but which they could only imagine. References to it are found in Old Testament prophecies, the Gospel of Matthew and the letters of Paul, but it is described most vividly in the Book of Revelation. Other popular and literary descriptions existed, and most of Michelangelo's contemporaries would have known earlier examples, which are found in churches throughout Italy. Although these display great variety in details, the visual tradition also demonstrates that there was an established way of mapping the events of the last day. Biblical texts and early examples make clear that those on Christ's left will be condemned to eternal suffering, while those on his right will be brought to eternal glory. Jesus, returning in triumph on the final day, is at the centre, surrounded by glorified beings, whether angels or saints. Traditionally, the most important of these are the great intercessors for humanity, the Virgin Mary and St John the Baptist, who together with Jesus are known as the Deësis. People rising from their graves are shown at the bottom of a representation; some of these move upwards to join the blessed, others are directed to Hell, which is conventionally shown in the lower right corner – that is, at Christ's left and as far from him as the format allows. Michelangelo generally follows this expected scheme. It is true that even in his earliest sketches Michelangelo emphasized movement and connections between groups, but to see the composition as circular or parabolic, as some scholars have, imposes later concerns on the fresco. Those who later

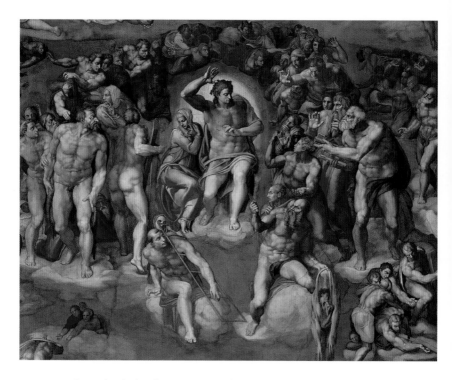

described the fresco – Condivi, Vasari and critics including Giovan Andrea Gilio – talk about the groups of figures that Michelangelo created. These are essential for the legibility of the theme.

However, Michelangelo also worked against expectations, and sometimes specific meanings can be read into his choices. For example, viewers expect to see the Virgin Mary at Christ's right and St John to his left. Michelangelo instead puts John on Christ's right, and substitutes St Peter as his paired opposite. Sixteenth-century viewers would have been very attuned to the equivalency of meaning that symmetrical or near-symmetrical pairs implied. They might think about

43 Detail of the *Last Judgment* showing Christ and surrounding saints.

how the two could be thought of as equals – perhaps St John symbolizes baptism and entry into the Church, while Peter represents the Church and the power of the papacy to maintain membership within the Church. Vasari used exactly this reasoning in his description of the pair, although he identified St John the Baptist with Adam, father of the human race, while Peter represented the founder of the Church. St Peter's position to the left of Christ may have also brought to mind other images found in Roman churches, especially Christ giving the keys to St Peter, a scene frescoed on the Sistine Chapel walls.[5]

Michelangelo sets these figures in bands that correspond to the bands encircling the chapel. The lowermost zone of the resurrection of the dead and Hell corresponds to the fictive hangings; the more monochromatic tones seem to pick up the silver and gold tones of the drapery. The effect would be different on those occasions when Raphael's tapestries were in place, but even then associations could be made between imagery in them and the *Last Judgment*. Above that the zone of mortals being pulled up or down corresponds to the zone of the fifteenth-century history paintings. Most dramatically, the zone that includes Christ, St Peter and many other saints aligns with the windows and the portraits of the popes. During the day the windows illuminate this zone especially well, creating a glow that adds real luminescence to the artistic glory created both by the yellow mandorla painted around Christ and by the forward thrust of the figures surrounding him (illus. 43). This entire group surges forwards, illusionistically pushing into the space of the chapel itself. Those who were seated in the presbytery, the area closer to the altar in

front of the choir screen, thought of themselves as an exten-
sion of the heavenly court; Michelangelo uses the forward
extension of the group around Christ to emphasize that
parallel. Renaissance viewers would have been much attuned
to such spatial effects, which are here created not through
linear perspective but exclusively through foreshortening,
overlap and changes of the scale of the bodies.

Michelangelo also made meaningful connections with the
ceiling frescoes. Angels carrying the instruments of the passion
are common elements in traditional Italian Last Judgments.
In the lunettes these angels are sharply foreshortened and
highly active nudes. With spectacular figural complexity, they
crown the scene of judgment, but they seem to exist in a space
apart from it. That separation helps to create a transition to
the ceiling, while the lines of the column and cross make very
clear visual parallels to Haman's scaffold and the brazen ser-
pent's post in the adjacent pendentives. These are not just
visual connections; rather, they serve to emphasize that the
Old Testament stories of the death of Haman and the raising
of the brazen serpent are typological foreshadowings of the
Crucifixion.

Sixteenth-century viewers would have been far more
aware than most of us are today of the costliness of various
pigments. In the *Last Judgment*, Michelangelo used expensive
ultramarine blue on the entire background of the fresco, often
in the *buon fresco* technique, that is, before the plaster was dry.
To increase the intensity of the deep blue, he also applied it
a secco (over dry plaster), but much of this has flaked off. No
gold was applied to the surface of the painting, but the yellow
behind Christ, especially in contrast to the deep ultramarine

blue, creates an effect similar to that of gold.[6] One scholar has observed that the yellow mandorla behind Christ is about the same size and at the same height as the windows in the chapel, creating a virtual source of light emanating from Christ in glory.[7] Michelangelo portrays Christ as a beardless Apollo-like figure, derived from the famous statue known as the *Apollo Belvedere*, which entered the Vatican collections during the reign of Julius II. The conflation of Christ with Apollo has early Christian roots, and a visual reference to Apollo is especially appropriate in a Last Judgment, since he was not just the god of light and the sun, but also the god of justice. An allusion to the sun may also point to Copernicus's idea that the sun was the centre of the universe, something Clement III had learned just before his death.[8] Whether others in the chapel would recognize the astronomical reference is debatable, but many critics did take note of Michelangelo's beardless Christ, and some artists who created works derived from Michelangelo's fresco reverted to the more traditional bearded Christ; Alessandro Allori's condensed versions of the theme do just that.[9]

Within the painting certain figures signal that this event is so glorious, so blinding that it cannot be perceived by human eyes. Some shield their eyes from the image of Christ; others seem to swoon with eyes closed. The *Last Judgment* is also in another way 'veiled' from the eyes of the unworthy: its complex meanings, expressed through references to poetry or other works of art, were not directly presented but rather shown obliquely through allusions and metaphors. This is seen most clearly in the Hell scene in the lower right corner (illus. 44); it is one of Michelangelo's most inventive and

challenging creations. He selectively used figures from Dante's *Inferno* that were easily recognized, even by those who only knew the poet's work at second hand. The boatman Charon ferries sinners across the river Acheron, while Minos assigns them to the ring of Hell that corresponds to the number of times he wraps his tail around himself. Yet even if most people could easily recognize these figures, those who studied the scene closely and knew the *Inferno* well would notice many ambiguities. The boatman does not use his oar to move the boat – in fact he seems ready to swing it around to push them the other way. Minos looks more like Satan; his 'tail' is actually a snake. None of Dante's torments are shown, but the sinners seem to be physically suffering already. Other details might fascinate even the most expert readers of Dante: a winged demon carries one of the damned on his back,

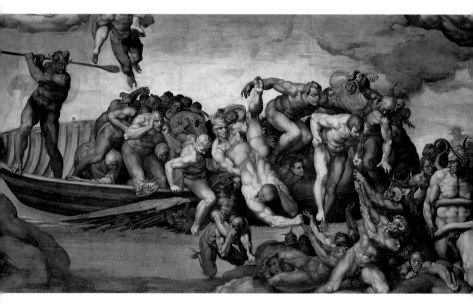

44 Detail of the *Last Judgment: Hell*.

reminiscent of Geryon, the devilish creature who takes the fraudulent to their fate.[10] Suitably, this is a dark corner of the fresco, but it is 'lit' by metallic paints used on some of the demons. These areas and the fiery glow in the background would have attracted the viewer's attention, especially on days when candles were used to light the darkened chapel.

Since the publication of Leo Steinberg's provocative essay 'The Last Judgement as Merciful Heresy' (1975), the dominant interpretation of Michelangelo's the Last Judgment has been that it covertly expresses ideas held by sympathizers of the Catholic reform movements, specifically those espoused by the Spirituali group, which included Michelangelo's friend Vittoria Colonna.[11] Whatever Michelangelo's hidden beliefs may have been regarding justification through faith alone, the fresco that he painted for the pope includes many references to the prayer, good works and the sacraments. At the lower left of the fresco, among the resurrection of the dead, is a tonsured man who makes a gesture of anointing a man who is barely alive, recalling the sacrament of Extreme Unction (Anointing of the Sick), one of the sacraments maligned by Protestant reformers.[12] Other figures are pulled up to Heaven with rosary beads or are helped up by mortals who have already been saved. Many among the blessed fold their hands in prayer (so too does one person who is falling headlong into Hell – clearly, prayer loses its efficacy for the damned). The martyrs, seen at the right of the fresco holding items by which they were tortured or killed, embody free will joined with faith to achieve salvation; in addition, the cult of their relics was (and still is) affirmed by the Church.[13] Through veneration of relics, the faithful could gain indulgences for

themselves or those who had died; this idea was the one most vehemently opposed by the Protestant Reformers. Within the painting, some of the blessed kiss the objects of veneration, whether the cross – a reference to the relic of the True Cross in the altar crucifix in the Sistine Chapel – or the rosary beads, in clear gratitude for their efficacy in salvation.

While many in the Sistine Chapel would have been pleased to see these signs of accepted Catholic belief, if they scrutinized the fresco they would also have seen pointed references to corruption in the Church. A bag of coins with two keys hang from one of the sinners being pulled to Hell at the right. This is the only attribute of a specific vice shown in this group, which surely represents the seven deadly sins. The keys are not gold and silver like the ones St Peter holds out to Christ above, but they bring to mind those keys, now tarnished with greed. Two angels hold books that record good and evil deeds. These are described by Condivi as being held so that 'each person can read his past life and almost judge himself', but few figures within the fresco are positioned so that they could actually read them. Those who could read the books most clearly would be within the chapel, close to the altar. Addressing the audience in the chapel even more directly is a sneering devil, who hovers over the sacristy door. This would be an unusual Last Judgment if the very people who were meant to see it did not find themselves reflected among both the good and the bad.

One of the most effective ways of making a connection with members of the audience is by including within the painting portraits of people they would recognize. It was a strategy that Michelangelo had learned as a youth in the

shop of Ghirlandaio. There are portraits in the *Last Judgment*, although probably not so many as have been proposed; as modern viewers we are hampered because we do not have accurate portraits of many people who would have easily been recognized by contemporaries. Biagio da Cesena was the papal master of ceremonies who criticized the fresco before it was unveiled. In the second edition of the *Lives*, Vasari tells the story that Michelangelo, in retaliation, painted his portrait in Hell as the figure of Minos. But Lodovico Domenichi wrote about the incident in his *Facezie*, published in 1562; in his version Biagio is portrayed as one of the damned 'tormented by devils', who may be a shadowy figure at the right edge of the fresco.[14] At least four portraits of Michelangelo himself have been found in the painting, although only one, on the skin held by St Bartholomew, has really captured the imagination of recent viewers, who have found in it evidence of Michelangelo's self-doubt, since the lifeless skin is held precariously over Hell. However, no sixteenth-century critic noticed it. Neither did any contemporary critic notice the portrait of Pietro Aretino in the fresco. Aretino was a writer who vehemently attacked Michelangelo's fresco, and viewers of our own time have often seen him as St Bartholomew, who brandishes a knife in one hand and holds the skin with the semblance of Michelangelo's face in the other. However, Aretino's criticism was not written until 1545, four years after the fresco was completed. Even Aretino's good friend Vasari did not recognize him.[15]

Considering the fact that the della Rovere arms are displayed throughout the Sistine Chapel, it is odd that neither Clement VII's nor Paul III's coats of arms are seen. Both

of Michelangelo's biographers offer an explanation of why Paul's was omitted: Michelangelo wanted to honour the fact that the commission was given to him under Clement. Perhaps more importantly, there are references to particular ideas espoused by Paul: the black figures pulled upwards by the rosary point to Paul's condemnation of the slave trade, as proclaimed in the papal bull *Sublímis Deus* dated 2 June 1537. There he affirms that natives in the New World as well as black people and other enslaved persons are truly human, and that they too could be saved.[16]

The *Last Judgment* was unveiled on 31 October 1541, the vigil of All Saints' Day and 29 years to the day after the Sistine Ceiling frescoes were unveiled. Vasari says that it opened to public view 'to the amazement and delight, not of Rome only, but of the whole world'. This is, of course, an exaggeration; the chapel may have been open for viewing on that day, but Vasari himself was out of town, in Venice, and the reaction was not universal delight. Vasari does hint at something significant: not all the viewers of the *Last Judgment* needed to see the fresco from within the Sistine Chapel. Within weeks of the fresco's unveiling it was being copied by Marcello Venusti at the behest of Cardinal Ercole Gonzaga. A few years later, Venusti painted another copy for Cardinal Alessandro Farnese, the pope's grandson; that copy is now in the Museo di Capodimonte in Naples. Other artists were called in to make drawings, and engravers used these drawings to produce prints of the *Last Judgment* that could be purchased by people of ordinary means. Indeed, the *Last Judgment* is the first of Michelangelo's works to have been widely disseminated as reproductive prints. Some were large engravings

made from multiple plates that could be glued together to create a complete image over a metre and a half tall. The advantage of this format was that very precise details could be recorded. The earliest of these, by Niccolò della Casa, was issued piecemeal starting in 1543.[17] The first segments issued were those scenes that Niccolò's publisher must have thought would sell best: the central scene of Christ and the Hell scene. Other prints were more sensibly sized (around 22–58 centimetres tall) and showed the entire *Last Judgment* on one sheet. Giulio Bonasone's print appears to have been the first to be issued, and in the inscription at the bottom he says he worked directly from the fresco. The fact that this was noteworthy suggests how rarely it must have happened; later prints were most often copied from other engravings.

Comments published even before the painting was complete make clear that critics expected the *Last Judgment* to be the high point of Michelangelo's career. Pope Clement VII may have felt the same; both of Michelangelo's biographers state clearly that the theme was chosen by Clement so that Michelangelo 'could show everything that the art of design could do', and indeed there are few subjects so well suited as this to Michelangelo's renowned skill in depicting the nude in powerful movement. Under Paul III, Michelangelo may have felt empowered to include more references to classical art and literature. The Farnese were among the greatest collectors of antique sculpture, and other works commissioned by Paul are some of the most sophisticated of the sixteenth century and were done in a style that was associated with epic literature.[18] It appears that Michelangelo was allowed great freedom to elaborate this theme – which, after all, was supposed to inspire

awe and terror in those who experienced it. He certainly must have relished the opportunity to invent poses, gestures and expressions, with nude bodies that showed humanity in all its variety and feeling extreme joy or pain.

But with the distribution of this image in prints to a very different kind of viewer than Michelangelo would have envisaged in the Sistine Chapel, criticism predictably followed. Published letters and entire treatises were devoted to the painting, complaining about the excessive nudity, exaggerated poses and lack of clear meaning. Some critics worried about what women and children would think – even though neither women nor children were likely to see the actual fresco. There were real repercussions from this criticism. In the late 1550s, Pope Paul IV expressed concern about the nude figures in the fresco. As Vasari reported, Michelangelo responded that such things were easily fixed, and that the pope should be more concerned about solving the world's problems. Beginning in 1564, the year Michelangelo died, a team of painters led by Daniele da Volterra painted loincloths on some of the most potentially offensive figures, including St Bartholomew and the saint holding the cross on the right edge of the fresco. They made more drastic changes to the figures of SS Blaise and Catherine, so that Blaise no longer looked down at Catherine but instead turned to face towards Christ. Perhaps even more importantly, the controversy set in motion calls for a new type of painting that would better communicate the ideas of the Catholic faith. Rather than an art that called attention to its own sophistication and challenged viewers to puzzle out the meaning of figures and actions, art was to serve religion, using more direct iconography and evoking

a stronger emotional response. It would take a few decades – and the inventiveness of artists such as Caravaggio and Bernini – to create a new style that was engaging and clear, and yet artistically sophisticated.

Michelangelo was 67 years old when he began work on the Pauline Chapel. For twenty years he had been complaining that he was too old for the work he did, and these frescoes do display a restraint that may be the result of weariness. There is little evidence that he had lost any of his technical ability, but the two frescoes showing the conversion of Saul (illus. 45) and the crucifixion of St Peter (illus. 46) have fewer signs of artistic virtuosity than does the *Last Judgment*. Foreshortening in these works is dramatic but selective, and they contain fewer serpentine poses. While there are some puzzling details, the iconography is less ambiguous, with fewer references to literary or classical sources. And nudity is certainly less abundant in these frescoes than in the *Last Judgment*. These changes are usually considered part of Michelangelo's 'old-age style' or the result of his increasing religiosity after meeting Vittoria Colonna (her influence will be considered in the next chapter). However, they are also partially explained as responses to the criticism that the *Last Judgment* had provoked, even if, at the beginning of this new project, those criticisms were only a trickle.

The Pauline Chapel is a smaller and more private space than the Sistine Chapel. It is quite close to it, just to its south and east; both chapels are accessed through the Sala Regia. Designed in the late 1530s by Antonio da Sangallo the Younger, the Pauline Chapel served as the place where the Holy Sacrament was displayed, and until 1670 it was the place where

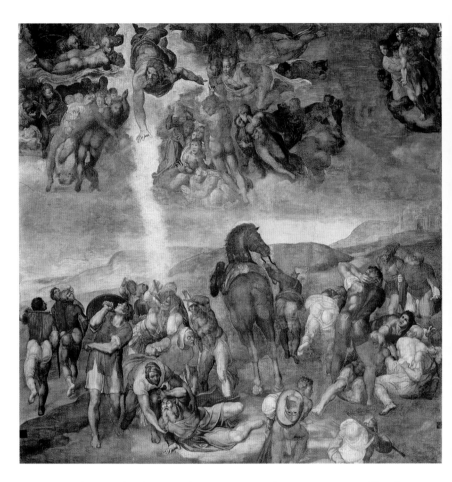

the cardinals cast their votes to elect a new pope.[19] After election, the new pope would first receive obeisance from the cardinals, and he would be announced to the people gathered below from a window that formerly opened on to the piazza in front of St Peter's. The Pauline Chapel has long served as the pope's private chapel, and the space was – and remains – very restricted. However, in the later sixteenth

45 Michelangelo, *Conversion of Saul*, c. 1541–5, fresco. Pauline Chapel, Vatican.

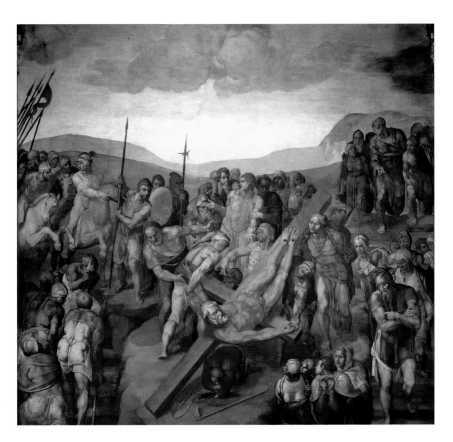

century, two astonishing rituals, the Holy Sepulchre during Holy Week and the Forty Hours' Devotion, attracted thousands of pilgrims, who could view the theatrical apparatus on the altar from the entrance door.[20] These two ceremonies involved burning hundreds of candles and torches, and the smoke and soot darkened the frescoes so much that even those visitors who caught a glimpse of them complained that they were almost impossible to see. Restorations in the 1930s removed most of that accretion, and another restoration

46 Michelangelo, *Crucifixion of St Peter, c.* 1545–9, fresco. Pauline Chapel, Vatican.

campaign, completed in 2009, allows us to see Michelangelo's paintings much more clearly.[21]

Stories from the lives of SS Paul and Peter seem to be obvious subjects for the space. They are the two great apostles of Rome, and episodes from their lives are depicted on the tapestries designed by Raphael for use in the Sistine Chapel. Paul III had a special devotion to St Paul; he not only took the saint's name upon election but he regularly celebrated the feast of Paul's conversion at San Paolo Fuori le Mura for years before the Pauline Chapel was completed.[22] St Peter's importance in a chapel in which the new pope was elected needs no explanation. However, the pairing of these two particular episodes from the saints' lives is unexpected. In his first edition of the *Lives*, written in the late 1540s before he could have seen the frescoes, Vasari said they depicted the more usual combination of the Conversion of Saul and Christ Giving the Keys to St Peter. An equally concordant pairing would be to show the beheading of St Paul with the Crucifixion of St Peter, as seen in Filarete's great bronze doors of St Peter's Basilica. The decision to have Michelangelo pair conversion with martyrdom was surely made in consultation with the patron, Pope Paul III. The themes are directly related to the activities in the chapel, personal interests of Paul, and threats to the papacy at this time. The pope eagerly awaited the completion of the frescoes, and came to visit Michelangelo to see the progress on 13 October 1549. He died on 10 November 1549, a few months before the frescoes were completed.

Since he was working on a newly constructed chapel, Michelangelo was not compelled to compose his paintings in relation to other narrative scenes. The wall space was divided

by pilasters, and in the next several decades additional paintings depicting scenes from the lives of SS Peter, Paul and Stephen (the first Christian martyr) were completed by Lorenzo Sabbatini and Federico Zuccaro. A stuccoed ceiling was finished before Michelangelo began work; this has been replaced and other stucco sculpture and faux marble panels now enrich the space. When the frescoes were first completed, however, the effect would have been much sparer, and as a result, viewers could concentrate more completely on the images before them. The subjects are powerfully relevant for the cardinals who would sit on benches originally built along the side walls so that most faced the frescoes.[23] Their proximity to the frescoes – much closer than the cardinals would have been to the paintings in the Sistine Chapel – would have only increased the effect.

In many ways, Michelangelo composed the painting in relation to the actual space and viewing conditions in the chapel. Recent observers have noticed how the asymmetrical compositions of the two frescoes seem more balanced when seen from an oblique angle from the entrance, and how the narratives unfold as the viewer moves from entrance to altar. These effects would be especially noticeable as the pope and cardinals entered and moved to the altar in procession. When Michelangelo painted the frescoes the natural light in the chapel would have fallen more strongly on the scene of Paul's conversion, where light plays such an important role. Peter's crucifixion, on the other hand, would be cast in shadow through much of the day, adding to the sombreness of the scene.[24] The windows in the chapel are above the frescoes, but the landscapes in both paintings create an illusion of

openness, as if the scenes were taking place just beyond the walls, and figures within both paintings even seem to cross into the viewer's space.[25]

Because of its similarities to the *Last Judgment*, the scene of Saul's conversion is considered the earlier fresco, believed to have been painted from 1542 to 1545. The story is told in several passages in the Acts of the Apostles. Saul, on his way to arrest Christians in Damascus, was violently thrown to the ground, stunned by both a brilliant light and the voice of Jesus. His companions saw the flash of light and heard sound but could not understand its meaning. Saul, blinded, had to be led into the city by his companions, whereupon his sight was restored. From then on he became the great missionary to the Gentiles and used his Roman name, Paul, when working with them.

Michelangelo presents the moment of conversion in two zones. Above, angels fly towards Christ as if drawn to him; many of these celestial figures recall the blessed or the angels in the *Last Judgment*. The sudden apparition of Jesus is given form through his twisting body, an exaggerated serpentine figure which in itself expresses the energy of life through its movement. He is foreshortened sharply in a way that draws the viewer's attention by its virtuosity, while simultaneously signalling the vision's suddenness and force. Christ's right hand reaches down to Saul, while his left points to Damascus, where Saul will receive his new mission. A golden beam of light traces a path from Christ's outstretched hand to Saul; it seems to spread below Saul to create a kind of earthly aureole. Openness to Christ's message is expressed in the saint's curved body, which seems to continue the line of the

beam and mimics the curve of Jesus' form. Other soldiers and onlookers are momentarily blinded or deafened – they cover their eyes and ears – but they, along with Saul's horse, scatter in all directions. Only one man stops to help Saul; he is very likely one who will lead the new convert to Damascus (Acts 9:8 and 22:11). On the left edge of the fresco, the city is lightly painted with strokes of white, appearing as insubstantial as a mirage. Michelangelo probably did not have a very clear sense of what Damascus looked like, but he may have heard verbal descriptions, since the pedimented facade and the large dome in the background are similar to those of the city's Great Mosque. This delicate cityscape was revealed only during the restorations completed in 2009; it had been painted over with a scene and that made the city look more 'Oriental', with additional domes and apses.[26] Michelangelo's attempt to create as real an image as possible emphasizes how important Damascus was at the beginning of Paul's ministry. This was the moment when Saul was called upon to take up his new responsibility of leading the Church, parallelling the moment when the newly elected pope would answer his calling.

On the opposite wall, St Peter suffers the humiliating martyrdom of crucifixion, which Peter himself made even more humbling by asking to be crucified upside-down; he felt he was not worthy of being crucified like Christ.[27] Peter was originally painted nude; the loincloth we see now was added later. He is the only naked figure in this fresco, but there is nothing heroic about his nudity. To be stripped of clothing was a way of humiliating a convict before execution; coupled with his inverted pose, the effect is even more degrading. The

fresco is more densely populated than *The Conversion of Saul*, but most of the figures stand or step forward without much torsion or complexity of pose. The exceptions are found closest to St Peter: the man digging the hole and those lifting the cross in place are bent sharply, calling our attention to the central scene and at the same time showing the physical effort needed to complete their tasks. Peter twists his upper torso off the cross and turns his head to glare outwards. His gaze is piercing – it engages viewers throughout the space. He is still vigorously alive, shown at the moment when his leadership will pass to his successor.

The setting very precisely shows the place where Peter was crucified as Montorio Hill. Stairs that led up to the hill and the distant mountains visible from the top of the hill correspond to elements in the actual landscape at the site.[28] It is now marked by Bramante's Tempietto, begun in 1502; today it is as much a destination for lovers of architecture as for pilgrims, but the holiness of the spot is uncontested. Michelangelo surely knew of the more traditional representations of Peter's crucifixion, in which the cross was already inverted and the apostle faced forwards. In his fresco he instead shows the cross in the process of being raised, before being set in the hole. The place where the cross was set was itself revered, marked by an opening in the floor of Bramante's Tempietto. Pilgrims would reenact the scene by bending down and touching the place.[29] The four women cut by the frame of the painting in the lower right corner are the most advanced of several clusters of pilgrims who come from beyond the crest of the hill in the upper right, stand behind the scene gazing in wonder – some hushing others – and then proceed

down and out of the space. Two of the women steal one last glance; two others stare ahead, meeting the eyes of the viewers in the chapel. Just above this group of women is the famous figure of a hooded man, which has often been identified as a self-portrait. He too is a pilgrim, like the blind pilgrim that Michelangelo chose for the reverse of his portrait medal.[30] His eyes are closed and he is withdrawn, isolated from the teeming crowd around him; he does not look at the martyrdom, but rather envisions it in his mind.

The pilgrims in the *Crucifixion of St Peter* have the effect of collapsing time. By reflecting the actions of contemporary pilgrims, they commemorate a past event, whereas the soldiers and executioners at the left of the scene are actively engaged in the martyrdom as it takes place. The portraits that scholars have found within the frescoes – whether of Pope Paul III, Michelangelo or others – would do the same, creating a connection between the historical moment and present.[31]

Like the *Last Judgment*, the Pauline Chapel frescoes were 'censored' with later repainting. The genitalia of the angels in the *Conversion of Saul* were covered with loincloths, although these were removed in the restorations of the 1930s. The covering that was painted over St Paul's genitalia is still visible, as are the nails that were added sometime after 1568. The nails are not seen in Giovanni Battista de' Cavalieri's engraving from around that time, and their omission is a topic of debate in Giovanni Andrea Gilio's *On the Errors of the Painters*, published in 1564. One of the interlocutors in the dialogue complains that certain details have been omitted, including the ropes and the nails which would show the atrocity of the martyrdom. Another answers:

One could respond that this is not uninspired, it being
known to all that St Peter was crucified, and since you
cannot say that someone has been hanged without it
being understood that he suffered a cruel and violent
death, so you cannot say that St Peter has been cru-
cified without the atrocity of martyrdom – the cross,
the nails, the ropes and whatever else is required –
being understood. And this is what Michelangelo has
done in that action, in order to ornament the mystery
he has painted and in order to introduce a new usage
through this new form . . . If you look at his pose, you
consider the effort exerted by a man turned upside
down, which you can see in his eyes and in the twist-
ing of his chest, which seems tormented from the pain
of death. It is assumed that this new way of working
will bring delight to the eyes of the viewer and beauty
to the work, more than the atrocity of the nails, ropes
and chains.[32]

Although the thrust of Gilio's treatise is to condemn any-
thing that might cause confusion in a religious image, here
his speaker offers one of the clearest statements of how such
variations could engage the audience. First, the viewers are
assumed to know the story, then they are assumed to know
what is necessary to carry out the action depicted. The omis-
sion itself causes them to look at other details (the eyes, the
twist of the chest) and, in doing so, to imagine the saint's
suffering more vividly. Even as the viewers feel the anguish of
the saint, this new participation causes delight by capturing
attention their more effectively than a traditional image.

The point of such engagement is to focus on Peter's death. In an age when the authority of the pope was being questioned and the foundations of the Church shaken by Protestant Reformers, St Peter's martyrdom was called upon as evidence that the pope was the true successor to Christ, confirmed not just by Christ's words but also by Peter's willingness to die for his faith.[33] The message in the chapel to those who would take on the leadership of the Church could not be clearer.

Love, Desire and Politics: Works for Private Viewers

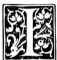N THE YEARS WHEN MICHELANGELO was engaged with ambitious projects for the popes, he also received many commissions and requests from private clients, and in a few cases he created works as gifts for special friends. These works reveal passionately held feelings on the part of the recipient or the artist, and often both. Whether erotic, political or religious, these works can often be seen as subversive statements, veiled in their meaning to prevent unwanted eyes from fully understanding their message. But in the middle decades of the sixteenth century, it was difficult to keep any work of art by Michelangelo private for long. Like the *Last Judgment*, reproductions proliferated and were interpreted by a broader public.

Michelangelo was still engaged with projects at San Lorenzo in late 1532, but he had been travelling to Rome in anticipation of a move to the city. A new contract had been negotiated with Julius II's heirs, and he was eager to get back to work on the tomb project. On one of those trips to Rome, probably in December 1532, he was introduced to a handsome young nobleman named Tommaso de' Cavalieri. Michelangelo was smitten, and his letters to Tommaso display

an awkward servility that seems unbecoming of a man in his mid-fifties directed towards a person about 35 years younger than him. But the feeling was apparently mutual: they exchanged affectionate letters, and Michelangelo created remarkable drawings and dozens of poems for the young man. These letters, poems and drawings all date to the early 1530s, but the friendship between the two men remained strong for decades; Cavalieri was at Michelangelo's deathbed in 1564. In the interim, Cavalieri married, became a respected member of the city government and rose to the position of Conservator of Rome. He became deeply involved in city planning projects in Rome, including some of those that Michelangelo designed, and after Michelangelo's death he made sure that later architects would complete those projects in a style compatible with Michelangelo's ideas.[1] Cavalieri owned a collection of antique sculpture that was considered important enough to be included in Ulisse Aldrovandi's guide to Rome, and he became an avid collector of drawings and prints, amassing over 1,400 works by the time his collection was sold in 1580.[2] Among those he sold were four drawings by Michelangelo himself, but he must have owned others by him, since Vasari says that Michelangelo gave Tommaso drawings that he had used in collaborative projects with Sebastiano del Piombo, and other drawings passed into the Farnese collection when Cavalieri died in 1587.[3]

It has often been remarked that the drawings Michelangelo made for Tommaso de' Cavalieri are best compared to letters or poems, and these written communications have been mined for clues about what the drawings mean. The drawings are also like written messages in that they are

intimate communications, referring to things only the recipi-
ent and the author would know. There is a personal quality
to the objects themselves: Michelangelo's hand moved across
the paper, sometimes turning it over or changing a detail.
Tommaso held that same paper in his hands. The letters that
were exchanged between Tommaso and Michelangelo also

47 Michelangelo (or copy after), *Rape of Ganymede*, 1532, black chalk.

give some sense of how the drawings were viewed. Tommaso acknowledged receiving drawings in a letter dated 1 January 1533, which almost certainly included the *Rape of Ganymede* (illus. 47) and the *Punishment of Tityus* (illus. 48).[4] He promised that he would contemplate the drawings for two hours a day, adding, 'the more I gaze [*miro*] upon them, the more they please me.' His words suggest a kind of studiousness, and Vasari later said that Michelangelo gave the drawings to the young man so that he could learn to draw. In such extended looking Tommaso must have been mesmerized by the meticulous technique, created by soft touches of chalk that blend together as if breathed onto the sheet. The main figure and the bird in each drawing are carefully modelled to create the illusion of three-dimensionality, but other details are so lightly drawn as to be nearly invisible. These include a dog howling at Ganymede and a monstrous tree trunk shrieking in Hades, where Tityus lies. The beauty of the male bodies

48 Michelangelo, *Punishment of Tityus*, 1532, black chalk.

themselves – both boy and man – would draw the eye, while the contrasting compositions, techniques and expressions create a fascinating *contrapposto*.

But other lessons could be learned from the drawings. Cavalieri surely knew the story of Ganymede, the young boy who was carried up to Mount Olympus to be the cup-bearer (and lover) of Jupiter. Works such as Ovid's *Metamorphoses*, one of many places where the myth is told, would have been readily accessible to an educated young aristocrat. The other drawing depicts Tityus, a giant who tried to rape Apollo's mother Leto and was punished by having his liver torn out by vultures, only to have it regrow in a perpetual cycle. Michelangelo used an eagle, as in the *Rape of Ganymede*, rather than a vulture, which helps to confirm that the two drawings were meant to be seen as a pair. This myth too is told in many classical sources, but it seems to have rarely been given visual form. Cavalieri may have been familiar with this story, since the young man's instruction in classical literature probably surpassed Michelangelo's. But Michelangelo's way of presenting the myth is not conventional, which would increase its interest.

The two myths are about sexual attraction, and the drawings surely encode messages about Michelangelo's attraction to Tommaso. The *Rape of Ganymede* is the more overtly homo-erotic of the group. Ganymede is a beautiful boy and Tityus a mature man whose attraction to the young man must be restrained. The parallel with Tommaso and Michelangelo's relationship is clear. Many connections could be made with Michelangelo's feelings as expressed in his letters and poetry, but the writings, like the drawings, are veiled in their meaning. Certainly the letter that accompanied these drawings is

circumspect. It ends with a postscript: 'Though it is usual
for the donor to specify what he is giving to the recipient, for
obvious reasons it is not being done in this instance.'[5] There
was reason to be wary. The drawings as well as letters and
poems that Michelangelo wrote to this beautiful young man
demonstrate his homosexual desire. Overtly homosexual
behaviour could be punished severely in both Florence and
Rome, and Michelangelo hid his desire in various ways.[6] In
his poems he changes the gender of pronouns so that they
seem to be addressed to a woman, not a man, and the draw-
ings themselves – especially *Ganymede* – are 'disguised' not
just by their classical literary sources but also by the apparently
moral meanings attached to them. Ganymede, an innocent, is
carried to heaven by love; Tityus, arrogant and violent, suffers
eternal torture. The meanings of the two drawings may have
been glossed by Neoplatonic ideas about divine love versus
earthly passion – ideas Michelangelo knew from his own
youth – but even without philosophical explanations, the
contrasting messages are evident.

The drawings depicting the fall of Phaeton (illus. 49 and 50),
which were sent to Tommaso between June and September
1533, are somewhat different. Whereas Michelangelo appar-
ently sent the *Ganymede* and *Tityus* drawings without any sort
of prompting from Cavalieri, the Phaeton drawings were the
result of a more complex collaboration. Michelangelo made
several versions of *The Fall of Phaeton*; three of these survive and
are accompanied by notes in which Michelangelo asks for
the young man's advice.[7] There is very good reason to think
that the story of Phaeton was familiar to Cavalieri; a Roman
sarcophagus showing the scene of Phaeton's fall was attached

to the facade of the church of Santa Maria in Ara Coeli, where Tommaso's family had a chapel, and Michelangelo and Tommaso may have studied the sarcophagus together.[8] But Michelangelo's drawings are not just copies of the relief; rather they significantly fill out the story and interpret it. Michelangelo – possibly with Tommaso – must have read a full version of the story, the most accessible version of which was certainly in Ovid's *Metamorphoses*. In Books I and II, Ovid describes how Phaeton was taunted by a friend who claimed that the sun god Helios was not really Phaeton's father. When Phaeton confronted Helios, the latter affirmed his paternity and promised him whatever he desired, but to the dismay of his father, Phaeton asked to drive the chariot of the sun across the sky. As Helios had feared, his son could not control the horses, and they careered around the heavens, flying too close to the earth and setting it on fire. To keep the earth from utter destruction Jupiter intervened, bringing down the chariot with a thunderbolt. Phaeton and the horses fell to the earth and into the river Eridanus. Phaeton's mother and sisters, the Heliades, roamed the earth until they found his tomb, and there the sisters grieved for so long that they became rooted to the ground. They turned into poplar trees, shedding tears of amber.

In all three versions that survive, Michelangelo creates a three-part composition. At the top is Jupiter sitting on an eagle and mightily hurtling his thunderbolt; Phaeton and the chariot are in the centre; and the grieving family members are below. The British Museum and Windsor Castle drawings show Phaeton frontally, and falling head first in a curved pose that is very similar to the way he is shown on the Ara Coeli

sarcophagus. The relief shows the horses upright, as if they have simply thrown the rider to the ground;[9] however, all three of Michelangelo's designs accentuate the fall to earth, with the horses falling headlong and twisting wildly in their panic. In each drawing, the composition of this group is different. In the drawing in the Venice Accademia collection the group is almost symmetrical with Phaeton in the centre. In the other two drawings the falling figures are arranged more chaotically.[10] The sketches of the Heliades show the most variations. In the Venice drawing, they are sketched only lightly, but their wild gestures are visible; a male figure – apparently the river god – also reaches upwards in panic. These figures are quite large, and seem to be reacting to the threat of the falling chariot. But in Ovid's tale the Heliades appear long after Phaeton has fallen and has been buried; their transformation into poplar trees (seen in the British Museum drawing, illus. 49) is the result of their seeing his tombstone. The most finished drawing is that in the Windsor Castle collection (illus. 50); in it, the women's metamorphoses are not shown, but instead they look as if they are just coming upon the scene. However, in this version Cygnus, Phaeton's friend, has already been transformed into a swan even though in Ovid's text this happens long after he witnesses Phaeton's fall. The swan is a detail found on the sarcophagus, and Michelangelo also includes it on the London drawing, but there it is in the background (and looks a little like a duck). In the Windsor drawing, the swan's prominence and pose are more like what is seen on the sarcophagus, as is the pose of the river god.

We do not know with certainty if Cavalieri preferred one drawing over another, but it seems clear that the story itself

49 Michelangelo, *Fall of Phaeton, c.* 1533, black chalk.

50 Michelangelo, *Fall of Phaeton*, c. 1533, black chalk.

appealed to him, as it would to probably any young man – it
is fast-paced, exciting and filled with amazing sights, ranging
from the sun god's palace to the earth ablaze. Ovid's story also
portrays Phaeton as a very believable, if impetuous, boy and
his parents as cautious but loving, and desperately concerned
for their son's safety. To be sure, this is a story with a moral
about the dangers of overreaching one's place in life. But the
moral can be read two ways: that a young man really should
learn restraint, and that a young man should strive greatly even
if he fails greatly – the latter, according to Ovid, was the sen-
timent written on Phaeton's tombstone. However, Cavalieri's
own interest in the story or the relief is rarely given much
consideration by other scholars. Instead we are told that the
drawings are Michelangelo's way of expressing his 'utter
inferiority' with regard to the status of the young nobleman.[11]
Michelangelo did feel socially inferior to Tommaso de'
Cavalieri, and other writers of his time did attach erotic mean-
ings to the myth of Phaeton, but here at least there is a possi-
bility that Tommaso's interests might have inspired the design.

The other presentation drawings that were probably sent
to Tommaso de' Cavalieri are less tied to specific classical
myths. The *Children's Bacchanal* (illus. 51) and *Archers Shooting
at a Herm* include references to classical and Renaissance art,
but both are self-consciously obscure.[12] *The Dream of Human
Life* (illus. 52), on the other hand, seems to be most directly
moralizing, although it becomes more complex with closer
study. In this drawing a nude male figure appears to respond
to the call of Fame – a winged figure sounding a trumpet –
but temptations surround him. The young man is seated on
a box of masks (delusions?), leans on a ball (surely a symbol

of unstable fortune) and is surrounded by figures engaged in activities representing six of the seven deadly sins.[13] Some of these figures are so lightly drawn that in trying to discern them the viewer might discover details that are not obvious at first glance.[14] The only deadly sin missing is pride, which is perhaps the vice the man might be most drawn to if he answered the call of fame. There are quotations from Michelangelo's own work in the drawing, so the message seems to be something about Michelangelo's own temptations, though these same vices could keep any aspiring artist from achievement.

Making the imagery intentionally obscure or giving the drawings a moralizing tone might have been strategies for keeping the meaning private, to be understood only by the sender and the recipient, especially after it became clear that others would see the pieces. From the beginning, other people were involved in sending the letters and drawings between Michelangelo and Cavalieri.[15] As we know from Cavalieri's letter dated 6 September 1533, almost as soon as he received the finished version of *Phaeton*, Pope Clement VII and Cardinal Ippolito de' Medici asked to see the drawings by Michelangelo that Cavalieri owned. Although this may sound ominous, their purposes were benign: the cardinal wanted to borrow the Tityus and Ganymede drawings so that their designs could be engraved in crystal. Cavalieri was reluctant to part with them and apologetically told Michelangelo that he especially wanted to 'save' the Ganymede drawing. Perhaps it was particularly precious to him, or maybe he feared it would be damaged. Nevertheless, the three drawings mentioned in the letter – *Tityus, Ganymede* and *Phaeton* – were indeed copied as engraved crystals, by Giovanni Bernardi, one of the best gem engravers

of the time; Bernardi also made bronze plaques from the composition, which could be more readily reproduced.[16] These reproductions would have been acquired by fairly wealthy collectors, but discussions about them became increasingly public until by the 1540s all six of the drawings associated with Tommaso de' Cavalieri had been engraved and published so that they could be purchased by people of modest means. Collectors may have purchased them because of their classical subjects or because they were made by Michelangelo (most are inscribed with his name as inventor of the design), but it is unlikely those collectors would have understood whatever meaning the images held for Michelangelo and Tommaso.

A few years later, Michelangelo created another group of highly finished drawings, which he gave to Vittoria Colonna. Colonna was the widowed Marchesa of Pescara

51 Michelangelo, *Children's Bacchanal*, 1533, red chalk.

52 Michelangelo, *The Dream of Human Life*, c. 1533, black chalk.

and a well-known poet whose works had been in circulation since the early 1530s. She was also a leading figure in the Spirituali, a group of devout clergy and laity who followed the teachings of Juan de Valdés, who believed in a more direct way of understanding scripture, a more personal relationship with the divine and justification through faith alone.[17] The Spirituali worked towards reform of, but did not want to break from, the Catholic Church. However, the religious ideas they discussed came dangerously close to those of the Protestant reformers, and some members of the Spirituali would later be condemned as heretics. *Sola fide* – the idea that salvation could be gained through faith alone, without need for good works – was declared heretical at the Council of Trent in 1547, just before Vittoria Colonna died.

Michelangelo's presentation drawings for Vittoria Colonna around 1538–40 are in many ways comparable to the drawings for Cavalieri. They are finished drawings of full compositions, although the focus is on the main figures, and background details are more lightly sketched or omitted entirely. They are done in the same precious technique, using extremely delicate touches of chalk to create subtle gradations of light and dark, with effects ranging from solid muscularity to transparency. Like Cavalieri, Colonna studied the drawings intently; in one undated letter written after receiving the *Crucifixion* (illus. 53), she says that she looked at it in the light, with a magnifying glass and with a mirror, and has never seen anything so finished. The subjects of the drawings for Colonna are very different to those of the Cavalieri drawings, however. All depict traditional religious themes, but each is varied in unique ways that point to Colonna's own concerns.

The first two drawings Michelangelo gave to Colonna are a Crucifixion with Christ still alive on the cross, and a Pietà (illus. 54). In the undated letter mentioned above, Colonna describes some of her thoughts as she looked at the *Crucifixion*: 'it crucified in my mind all other pictures I have ever seen'; it is 'alive' and 'miraculous'. In another letter she tries to explain how the drawing of Christ has affected her, saying that it has pushed her to go beyond the limits of her own understanding, and that through it she has realized that 'all things are possible for those who believe.' Colonna does not go further in her description (indeed, she says she is incapable of doing so), but the drawings themselves suggest how they might have encouraged such transcendence. Both are iconic images, emphasizing the direct presentation of the holy figures for contemplation, rather than narrative images meant to be 'read' as a story progressing through time. Both are most intensely modelled – made most physically present – on the body of Christ. This draws the viewer's attention to his body during or just after the moment when that body was sacrificed to redeem the sins of humanity. In doing so, the drawings reinforce the most important theological premise of the Spirituali: that the gift of salvation was freely given through Christ's death, not earned by works.[18] The letters and poems that passed between Michelangelo and Vittoria Colonna along with the drawings were likewise gifts: that is, they were offerings to show love, without expectation of recompense and certainly without the kind of relationship that artists and patrons usually had.

Michelangelo's decision to show Christ alive on the cross emphasizes his humanity and encourages empathy between

the viewer and Christ. Christ looks upwards and seems to be appealing to God the Father. Michelangelo's two biographers imagined Christ saying different things. Condivi thought his words were, 'My God, my God, why have you forsaken me?' (Matthew 27:45; Mark 15:34), while Vasari instead pointed to his utterance at the last moment of life, 'Father, into your hands I commend my spirit' (Luke 23:44). Either way, the emphasis is on Christ's action – not on contemplation of his dead body as if it were a relic. Vittoria Colonna herself seems not to have focused on the words Christ may be uttering. Two poems, which were probably inspired by Michelangelo's drawing, speak only of the wisdom, love, peace and grace that come to us through Christ's death.

In the *Pietà*, the clear concordance between the pose of Christ and the raised arms of the Virgin show her identification with Christ's suffering. Vittoria Colonna herself showed this sort of empathy in her *Pianto . . . sopra la passione di Cristo*, which was first published in 1556 (though it was written between 1539 and 1541).[19] This is an intense, personal visualization of the Crucifixion, full of emotion and written in vivid language. In most of the text Colonna speaks as if for the Virgin, imagining her suffering as she contemplates the tortured body of her son even as she acknowledges that his death was for the benefit of all humanity. Yet Michelangelo gives visual form to these ideas in a way that gives little emphasis to blood and the wounds in the *Crucifixion*, or to the Virgin's tears in the *Pietà*. Colonna herself seems to have preferred more emotional images – she certainly showed appreciation for the weeping Magdalene that Titian painted for her in 1531.[20] There are various ways of explaining Michelangelo's

53 Michelangelo, *Crucifixion, c.* 1540, black chalk.

54 Michelangelo, *Pietà*, *c.* 1540, black chalk.

depiction of these scenes. Even in his earliest religious works he was reluctant to show the sacred body distorted, and reformers such as Girolamo Savonarola (whom Michelangelo heard and admired in his youth) argued against excessively emotional displays of piety; Michelangelo seems to have held the idea that such images were weak and excessively feminine.[21] The marks of Christ's torture and the Virgin's grief are only subtly displayed, perhaps to encourage the viewer to inwardly visualize them.

The third design Michelangelo made for Vittoria Colonna is *Christ and the Samaritan Woman*; it is mentioned in a letter that can be dated to July 1542 or 1543. Colonna had been away from the city and hoped that when she returned she would find that Michelangelo had a renewed image of Christ in his soul, brought alive by true faith, just as the artist depicted him in what she describes as 'my woman of Samaria'. For Colonna, the drawing was not just a beautiful object or an illustration of a biblical story; rather it was the means to create an inner vision of the living Christ. The design, which is only known through copies like Nicolas Beatrizet's engraving (illus. 55), is very different from the *Crucifixion* or the *Pietà*, since it is a narrative scene describing a moment from Christ's ministry when he reveals his divinity to a woman of questionable morals and from an ethnic group that the Hebrews considered anathema. Vittoria Colonna, of course, was neither of those things, yet the woman's acceptance of grace and her role in spreading Christ's message caused Colonna to identify with her. The composition derives from another design that Michelangelo made for Colonna in 1531, the *Noli me tangere*. Michelangelo did not know Colonna personally then,

and the commission was negotiated through intermediaries. That design shows Mary Magdalene – another strong female model for Colonna – in a similar pose to that of the *Samaritan Woman* and in a moment of encounter with Christ. This connection to the earlier commission and references found in Colonna's poetry make it very likely that the Samaritan Woman design was made at her request, and perhaps with her input on specific details.[22]

As told in the fourth chapter of the Gospel of John, the woman encounters Christ at a well, and he asks for a drink. When she hesitates because she knows that people of Samaria may not share food or drink with Jews, Jesus tells her that she should instead ask him for the 'living water'. This is not water that can be drawn with a bucket from a well (the focus of their pointing hands) but a spiritual water that quenches inner thirst. This last point is made visually, by Christ pointing to his heart; a similar gesture in the *Noli me tangere* painting conveyed the idea that Mary Magdalene must form Christ's image in her heart.[23] The story contains many ideas dear to the Spirituali: that grace was offered freely, that confession of sin was not necessary to receive grace, and that a direct understanding of Christ's message was possible without the mediation of the clergy. These were dangerous ideas that would cause some of the members of Colonna's circle to be accused of heresy in the following years, although both Colonna and Michelangelo escaped such charges.

All the designs made for Vittoria Colonna, like those made for Tommaso de' Cavalieri, were reproduced soon after they were made. At first small paintings were made for those in Colonna's immediate circle, but soon engraved

55 Nicolas Beatrizet, after Michelangelo, *Christ and the Samaritan Woman*,
c. 1550, engraving.

copies appeared. The engravers and their publishers often made subtle changes, presumably to appeal to various types of buyers; the most common change was to add a prayer or a scriptural passage. Such captions surely helped assuage any viewers who might have questioned the implied meanings of the images, but there is really nothing heretical in the images themselves. The viewers of the prints would have brought their own expectations and ideas to them, and the publishers probably cared little for theological arguments; the commercial success of the engravings speaks for itself.[24]

In these same years, from the early 1530s to the early 1540s, Michelangelo took on a number of projects for individual patrons. These were not as personal and private as the gift drawings for Tommaso de' Cavalieri and Vittoria Colonna, but each shows a particular relationship with a patron, and in some cases a particular appeal to a type of viewer. It is worth remembering that at the beginning of this period Michelangelo was at work on the Medici Chapel and Laurentian Library, while the *Last Judgment* in the Sistine Chapel occupied him from 1534 until 1541, followed immediately by work on the Pauline Chapel frescoes. All the while, the tomb of Pope Julius II was still unresolved. Often, the works for individual patrons in this period were designed by Michelangelo but delegated to other painters or, in the case of sculpture, finished by assistants.

Two of the paintings commissioned in the early 1530s show erotically posed nude women, although their classical subjects, Leda and Venus, tend to give an intellectual gloss to their eroticism. Both were commissioned by men and meant to be seen in relatively private settings, although as it

turns out neither was ever given to the original patron. *Leda* was requested by Alfonso d'Este, Duke of Ferrara, in 1529 while Michelangelo was visiting him to learn about fortifications. Alfonso had admired Michelangelo's work since the time he was able to climb the scaffolding to see the Sistine Chapel ceiling. The subject of the painting apparently was not determined, although Michelangelo must have understood that the painting would have been set in Alfonso's Camerino, where amorous paintings by Giovanni Bellini and Titian were already installed. The painting was finished by autumn 1530, but it was never given to Alfonso. Condivi and Vasari relate the story that Michelangelo refused to release the painting to the Duke's agent because the man questioned its value. This story has some grain of truth, but the painting may have been intended as a diplomatic gift to secure Alfonso's aid for Florence, and other circumstances caused Michelangelo to withhold delivery.[25]

Although Michelangelo may have created the *Leda* with the other paintings of the Camerino in mind, it is not at all certain how it would have been installed in the room or even if that would have been its ultimate location. The other paintings, including Giovanni Bellini's *Feast of the Gods* and Titian's *Bacchus and Ariadne*, would have lined three walls and care was taken that the landscape elements in each of them coordinated to create a unified scene.[26] Michelangelo's painting, which is today known only through copies, gives little attention to the landscape. In all the copies Leda herself dominates the composition, with her hanging left arm and a rectangular drape echoing the shape of the frame. This fabric background not only blocks any view of the background, but adds to the

impression that we are seeing something that should be hidden. Indeed, the *Leda* is much more explicitly erotic than any of the other paintings in the Camerino. Jupiter in the form of a swan and Leda are shown in the act of coitus, at once highlighted and hidden by carefully placed tail feathers. The viewer can easily imagine the titillating brush of the swan's feathers against skin, although the talons seem dangerously close.

The eroticism of the image seems at odds with the hard muscularity of Leda's body, especially as seen in the print by Cornelis Bos (illus. 56), which is probably the best record of the finished painting. However, a red chalk study for Leda's head, Vasari's description of the cartoon ('painted as it were with breath') and some of the copies made from it suggest that Michelangelo created a softer, more convention-ally feminine form for the duke. Whether or not the painting was intended to be placed in the Camerino, Michelangelo very likely did think of it as a response to the paintings he saw there, and specifically to Titian's female eroticism, which he found so formless and lacking in *disegno*. Leda's pose has a pronounced twist, her right arm and left leg crossing over the swan to lock him in an embrace. Her anatomy – obvi-ously based upon a male model – is more precisely defined when compared to the reclining nude woman in Titian's *Bacchanal of the Andrians*. Michelangelo met Titian on his own ground in many details which are fairly consistent in the copies: Leda's elaborate hairstyle and the fine folds of the sheet that she reclines upon can be compared to the more free-flowing hair of Titian's women and his richly textured fabrics. Even in Bos's engraving, the silky whiteness of the

fabric contrasts with the heavier, darker drape held up behind Leda.

The painting created quite a stir among contemporaries. Rather than delivering the painting to the Duke of Ferrara, Michelangelo gave it, the cartoon and other drawings and models to his assistant Antonio Mini to sell. Mini took the cache to France, where he found that there was such a demand for copies of the painting that he could not keep up. Mini eventually sold the painting to King Francis I, where it became a treasured part of the collection at Fontainebleau. Unfortunately, its eroticism was also its undoing; it was burned, probably on the order of the Queen Mother, Anne of Austria, in the seventeenth century.[27]

Leda was not the only example of heterosexual erotica by Michelangelo's hand in these years. He also designed the

56 Cornelis Bos, after Michelangelo, *Leda and the Swan*, late 1530s–c. 1550, engraving.

Venus and Cupid (illus. 57) for his friend Bartolommeo Bettini around 1532. Like the *Noli me tangere* designed only a year earlier, the painting was executed by Pontormo from Michelangelo's cartoon. While *Venus and Cupid* has some elements in common with *Leda* – and in fact later copyists paired them – the painting for Bettini includes many additional elements that confirm that it was meant to be read in the context of poetry.[28] Bettini was a merchant from a noble family whose status had diminished by the sixteenth century. He aspired to regain prestige and cultivated relationships with the literary lights of Florence; his love and support of poetry was well known among his peers.[29] As Vasari relates in his biography of Pontormo, the painting was to hang in Bettini's chamber; this was probably a bedchamber, but also a place like a studiolo, where precious objects could be shown to visitors. The *Venus and Cupid* would have hung between half-length portraits by Bronzino of the three great Tuscan poets, Dante, Petrarch and Boccaccio. A box on the left edge of the painting contains a small, sharply foreshortened image of a seemingly dead man. A vase of flowers is set upon it, and Cupid's bow and two masks hang around the vase's foot. A similar box, filled with masks, is seen in *The Dream of Human Life* drawing, which was done around the same time, and it seems that both refer to vain delusions of pride or love. But in *Venus and Cupid* there are more pointed references to the myth of Venus and Adonis as related in Book v of Ovid's *Metamorphoses*. It tells of how Cupid kissed his mother, Venus, but in doing so his arrow inadvertently scratched her, which makes her fall in love with the mortal Adonis. When Adonis is killed by a wild boar, Venus is wild with grief, and when she weeps at his tomb, the

white roses turn red. Michelangelo's design is not a precise illustration of the story but it alludes to its many elements, requiring the viewer to complete the details. For example, Ovid says that Venus was wounded on the breast; the points of Cupid's arrows seem to scratch her thigh instead, but she points to her breast to suggest the act completed.

Like the *Leda*, the *Venus and Cupid* was never set in the location for which it was made. Bettini was a strong supporter of the Florentine Republic during its resurgence from 1527 to 1530. The Medici were then restored to power under the unpopular Duke Alessandro de' Medici, but there was continued opposition to his rule in the city. *Venus and Cupid* became a pawn in the struggles between the Medici and supporters of the Republic. According to Vasari, the painting was taken 'almost by force' by Alessandro de' Medici by 1534; this

57 Pontormo, *Venus and Cupid*, c. 1532, oil on wood.

would have been around the same time that Michelangelo left Florence to live permanently in Rome. Bettini was left with only the cartoon.

There is little reason to think the painting's new owner particularly valued its association with poetry. It remained in Medici collections, and it was listed in the inventory of Duke Cosimo I, where it was described as having a green silk curtain – very likely a curtain that was pulled over the painting to hide it from observers until the duke chose to reveal it.[30] This was a common way to display erotic works. Benedetto Varchi also highlighted its eroticism. In a section of his *Due lezioni* where he gives examples of how lifelike ancient Greek art was, he says that men fell in love with Praxiteles' statue the Aphrodite of Cnidus. He adds, 'However, today the same thing happens every day with the *Venus* designed by Michelangelo and painted by Pontormo.'[31] These viewers did not need to have special access to the Medici collections; they were most likely reacting to the many copies of the painting or its cartoon, which remained in Bettini's possession.

Venus and Cupid could be thought of as booty in the continuing struggles between the Medici and the supporters of the Florentine Republic. An even more politically charged work, *Brutus* (illus. 58), was commissioned by Donato Giannotti on behalf of Cardinal Niccolò Ridolfi, the leader of the exiled anti-Medici Florentine community in Rome, the *fuorusciti*. Giannotti had served as secretary in the chancery of the Florentine republic and was Ridofi's secretary in Rome. Giannotti, Ridolfi and their fellow Florentine exiles, the *fuorusciti*, were especially heartened when Duke Alessandro was murdered by his own cousin, Lorenzino de' Medici. Lorenzino

was hailed as a hero by the *fuorusciti* – he killed a tyrant just as Brutus had murdered Julius Caesar to preserve the Roman Republic. The Florentines erected statues of Lorenzino and wrote classicizing poetry in his honour; they called him 'the new Tuscan Brutus'. Lorenzino himself justified his actions by comparing Alessandro to tyrannical emperors like Caligula and Nero, and had a medal cast commemorating the murder which copied a coin of Brutus.[32]

Michelangelo's connection to Giannotti came from his sympathy with the Florentine cause and from their shared interest in Dante. Around 1545, Giannotti wrote a dialogue on the number of days Dante spent in Hell and Purgatory in the *Divine Comedy*; Michelangelo is one of the main interlocutors in the dialogue. Towards the end, the discussion turns to Brutus and Cassius, whom Dante had placed in the mouths of Satan in the lowest ring of Hell because of their political murder of Julius Caesar. Giannotti wanted to see them placed in Paradise instead, since their action was in defence of freedom. In the dialogue Michelangelo is called upon to defend Dante's choice, which he does rather weakly. It is impossible to both defend Dante's infallibility and Brutus' heroism, and Michelangelo's words are probably just a foil for Giannotti's own ideas.

Michelangelo's sculpture leaves little room to doubt that Brutus was to be seen as a hero. Unfinished at the back, it was clearly meant to be seen in a niche or against a wall with Brutus' face turned in profile as if on a Roman coin.[33] Such a coin was the model for the fibula on Brutus' shoulder, which shows a less idealized portrait of him. His determination as he faces the task of murdering Julius Caesar is shown in his clenched jaw, pursed lips and furrowed brow.

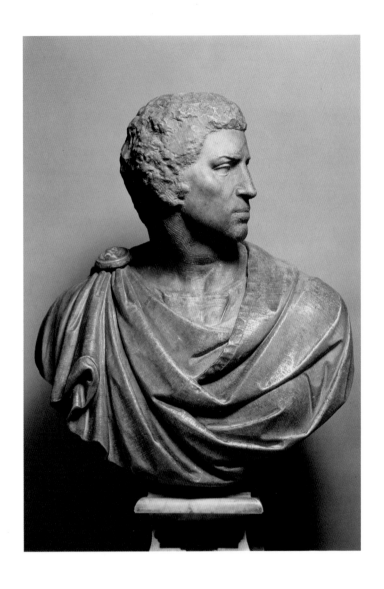

58 Michelangelo, *Brutus*, c. 1540–42 or c. 1548, marble.

The *Brutus* was never delivered to Cardinal Ridolfi, who died in 1550. Rather, it stayed in Michelangelo's workshop until around 1555, when he gave it to Tiberio Calcagni to finish. Calcagni put some finishing touches on the drapery, but he left the hair and face rough. This work too was acquired the Medici, not by force and not until around 1580 after the duchy was firmly established. Still, the new owners added a plaque that explained the imagery in terms congenial to the family. It says that the bust had been left unfinished because Michelangelo realized that Brutus had committed a crime.[34]

Later in his life, Michelangelo denied that he was a member of the *fuorusciti*. This about-face was probably a way to lessen risk to his nephew Lionardo, who was still in Florence. Michelangelo's political relationships with the Medici were always ambivalent. He could hardly forget that some of his most supportive patrons were Medici, including Lorenzo the Magnificent and Pope Clement VII, and yet he also played a key role in the defence of Florence against the Medici. Around 1530, just after the Medici had retaken the city, he agreed to carve a statue of Apollo for Bartolomeo (Baccio) Valori. Valori had been appointed papal governor of Florence after the city capitulated, and in that capacity had rounded up Republican supporters and imprisoned them. Michelangelo surely feared for his own safety, and he apparently took on the task of carving the statue to appease Valori. He may have reworked a sculpture begun for a different purpose (some unfinished material at the base have led some scholars to see it as originally a David), and when Valori was given a new position in northern Italy, Michelangelo abandoned the piece.[35] If Michelangelo (like many artists of his time) showed

that he would comply with requests for work from patrons no matter what their political beliefs, Valori himself was opportunistic and politically fickle. He became the enemy of the Medici, and was captured at the Battle of Montemurlo and beheaded in 1537.

Vision and Space: Michelangelo's Roman Architecture

OES IT MAKE SENSE to talk about the 'viewer' of Michelangelo's architecture? Architecture, after all, is experienced spatially and physically. A person does not simply look at a building but moves through it – climbing stairs, touching walls, feeling confined by tight spaces or exhilarated by airy ones. And yet it seems that Michelangelo's earliest architectural designs did privilege sight more than other ways of sensing. The design for the drum of the Duomo in Florence demonstrates how much visual qualities mattered to Michelangelo. The first segment of a transitional element between the drum and dome was designed by Baccio d'Agnolo and finished in 1515. Michelangelo famously called the delicate fence-like structure 'a cage for crickets'; it can still be seen on the southeastern face of the dome. Michelangelo's own design, reconstructed from drawings, shows much greater awareness of scale, not just covering the space that Brunelleschi left unfinished but carrying the new facing down to the cornice below the oculi. The old-fashioned green and white marble panelling would be replaced by larger panels of clean white marble,

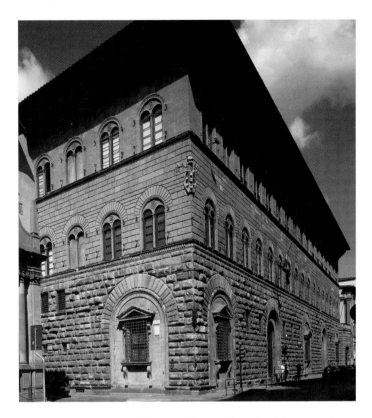

and each corner would be emphasized by double Corinthian pilasters.[1]

Visual effects figure greatly in the San Lorenzo projects (discussed in Chapter Four). In the Laurentian Library a vista leads on to a blank wall; there are plays of perspective and architectural elements added to give visual, not physical, support. However, both the Laurentian Library and the Medici Chapel allowed Michelangelo to create interior spaces that would challenge the visitor in physical and psychological ways. Even minor designs that he did for the Medici, such

59 Windows, Palazzo Medici Riccardi, Florence, c. 1526.

as the windows for the ground-level loggia of the Medici Palace, create an experience that is felt as well as seen. The large arched loggia was an important symbol of openness for the original patron, Cosimo the Elder, and it was used by ordinary Florentines as a place to conduct business, sell goods and meet friends.[2] Sometime before 1526 Michelangelo was asked to block up those openings and create instead windows, which where covered with iron grates and embellished with large consoles (illus. 59).[3] The swelling forms of the consoles inspired Vasari to call them 'kneeling windows'. Whether they are seen in anthropomorphic terms (as many later critics have) or are simply variations of elements found in Florentine architecture, these windows have a real presence that must have been discomforting for passers-by, if not in a physical way then at least as political statements, for they were meant to make the palace impregnable at a time when Medici authority was coming under increasing criticism.[4]

To be sure, at San Lorenzo and at other sites, structural and material considerations as well as site restrictions influenced Michelangelo's designs. In his designs for fortifications, ballistics and defensive strategies came into play, but a glance at the fascinating drawings for these projects suggests how a fearsome appearance could be used to intimidate the enemy (illus. 60).[5] In plan, the fortifications resemble claws, pincers or arrays of pointed blades. Some of the designs seem gentler, even flower-like, in plan, but if a less threatening appearance was intended it was only a way to hide the structure's real purpose. On these Michelangelo drew the lines of fire coming from hidden crevices.

Architecture dominated Michelangelo's career after 1546, when Antonio da Sangallo the Younger died. Sangallo had been Pope Paul III's personal architect as well as the head architect at St Peter's Basilica. Among the projects Michelangelo took over was the completion of the Palazzo Farnese, which Sangallo had begun around 1514 when Alessandro Farnese was still a cardinal (illus. 61).[6] From the beginning, the facade was given greatest priority, and when Farnese was elected pope in 1534, the palace became an even more important visual symbol. The palace itself was enlarged and the area around it cleared of earlier structures to create a broad, open piazza to allow for grand entrances and unrestricted viewing. The road that leads to the main entrance, Via dei Baullari, was straightened so that the palace could be clearly seen from the Via Papale, one of the city's main pilgrimage and ceremonial routes.

By the time Michelangelo took over, the facade was built to the third-storey windows, but the courtyard facade had not progressed much beyond the *piano nobile*. Michelangelo's contributions to the exterior are fully in keeping with the desire for magnificent display. He emphasized the central portal by removing a window just above the entrance and inserting instead a balcony from which the pope could address the crowds. He replaced the arch above the window with a flat lintel, which served as a base for an enormous Farnese coat of arms. Clustered half-columns on the jambs gave greater visual weight to the ensemble. He also increased the height of the uppermost storey and capped it with a substantial cornice. This last element was crucial, and to make sure he got it right he created a full-size wooden mock-up that was hoisted

into place to judge its visual effect. Members of the Sangallo family were very interested in this demonstration, and some grumbled that the cornice did not conform to the rules of classical architecture. In a letter to Pope Paul III, Antonio da Sangallo's brother, Giovanni Battista, complained:

> Here [in the cornice] there is no *qualità* because the work should be done from good memory according to the rules of Vitruvius, and this cornice is made rather in the barbarous manner than otherwise . . . [Michelangelo's cornice] is neither Doric, nor Ionic, nor Corinthian; it is willfully bastard.[7]

Later in the letter, Giovanni Battista complained about the weight of the cornice – he was afraid it would pull down the entire facade. The installed cornice never posed such a

60 Fortification drawing, Casa Buonarroti, Florence, 1528–9, pen and brown ink and wash.

threat, but the comment points to its 'visual weight'. It was surely for this reason that Michelangelo insisted on seeing the effect with his model and on showing his patron how necessary it was. The palace is monumental and broad; it required a substantial cornice to offset and complete its forms.

Michelangelo had taken a 'licentious' approach to architecture already in the Medici Chapel and Laurentian Library vestibule – indeed, it is evident to some degree in every architectural design he did. There were critics of these Florentine projects whose complaints are echoed in the defensive statements of later writers such as Vasari and Bocchi.[8] But the Medici commissions were less visible on the streets of Florence, and Florentine architecture was generally less dogmatically classical than Roman. Giovanni Battista da Sangallo was reacting to the combination of elements on the cornice, including

61 Farnese Palace, Rome, begun by Antonio da Sangallo the Younger in 1516; continued by Michelangelo beginning in 1546.

the generous use of the Farnese fleur-de-lys, an embellishment that the patron must have found flattering. Michelangelo does use elements drawn from the classical orders, but in unusual combinations or places: egg-and-dart moulding combined with dentils, and brackets topped in an unprecedented way by lion heads. These inventive details would have been visible to those examining the model, and for those trained to recognize the fine points of Vitruvian rules, they would have been disturbing even from afar. These rules, they would claim, were developed because the specific elements and proportions were pleasing to the eye. Michelangelo knew the rules; he had participated in a Vitruvian study group and he copied details of classical architecture in a series of drawings done around 1516, just when he was embarking on his first major architectural commission, the facade of San Lorenzo. But even in these exercises in self-instruction, Michelangelo abstracted forms from his models and combined them in ways that worked against rigid classification.[9]

According to Vasari, Michelangelo planned another visual effect at the Palazzo Farnese: visitors would be able to see through the front portal, past a fountain built around the recently unearthed *Farnese Bull*, and out the back to a bridge crossing the Tiber leading to the family's property on the opposite bank. The effect is suggested in a view of the courtyard engraved in 1560. This print bears an inscription praising Michelangelo's 'astounding artifice'.[10] It would have been an amazing sight, to see at once the grand palace and the extent of the lands the Farnese owned, all presented as if it were a painting framed by the building itself. Unfortunately, the effect was not realized. Only a small part of the bridge was

built (it now crosses Via Giulia behind the palace), and a wall blocks the view across the river.

In 1546 Michelangelo was named chief architect of St Peter's. This project was surely his most significant, but it is also the one in which his contributions are most difficult to discern, because of work done by earlier and later architects. He was the seventh architect to produce designs for the basilica since the mid-fifteenth century; he would be followed by four more.[11] For two hundred years, until the middle of the seventeenth century, the area around St Peter's was a construction site. At first the renovations of the old basilica only involved the apse, where Bernardo Rossellino began an enlarged choir. It was never completed, although its foundations guided the designs of Bramante in 1505. By that time, Julius II had been convinced that the entire church should be rebuilt at a much grander scale, to emulate ancient Roman architecture. Bramante proposed several plans, finally settling on a central plan that fitted a Greek cross within an essentially square perimeter. In the middle would be a huge dome, with smaller domed Greek crosses in each corner. The piers to support the dome were connected with coffered arches by 1511. Little work was done between then and 1534, due to financial difficulties and the Sack of Rome, but then construction resumed with more vigour under Paul III. Antonio da Sangallo made a design to complete St Peter's; in 1546, when Michelangelo took over, work was proceeding according to Sangallo's model.[12]

Vasari recorded Michelangelo's reaction to Sangallo's model: it lacked sufficient windows, there were too many orders of columns stacked one on top of the other, and there

were so many projections and pinnacles that its style was more 'German' (that is, Gothic) than either classical or modern. Sangallo's wooden model, which still survives in St Peter's, was enormous: it took years to build and cost four thousand scudi – equivalent to the annual wages of eighty skilled workmen. Michelangelo claimed he could make a new model in two weeks at the cost of 25 scudi. Furthermore, if his design for the church were built, it would cost 300,000 scudi less than Sangallo's would and be completed fifty years sooner. A letter that Michelangelo himself wrote to Bartolommeo Ferratino in 1546/7 confirms the criticisms that Vasari recorded and fills out some details. The size of Sangallo's planned building would cause the destruction of other Vatican structures – possibly even the Sistine Chapel, and Michelangelo of course had a personal interest in preserving that. The most offensive element, however, was the ambulatory that Sangallo planned around the north, west and south apses. The walls for the ambulatory were already rising when Michelangelo wrote his letter; their removal would be costly but the smaller design he envisioned would save even more in the long run. This was not just a matter of saving the pope's money; there were other important ideas involved. Michelangelo came to this project at a time when the Church was still under attack from Protestant Reformers, and much of their criticism had to do with the way money was extracted from the faithful for the building of St Peter's. The city was also still recovering from the disastrous Sack of Rome of 1527. For some viewers, the vast unfinished building called to mind the ancient ruins of Rome, but for others it might have signified the need to re-establish the wholeness of the Church.[13]

The letter shows that Michelangelo wanted to return to Bramante's design, which was 'not full of confusion [like Sangallo's] but clear and open, luminous and isolated at the same time'. Indeed, there is no better description of Michelangelo's own design. Since the nave and facade were added later, Michelangelo's ideas are best seen in a plan engraved by Étienne Dupérac and published in 1569 (illus. 62); Dupérac's views of the exterior (illus. 63) and interior are undated but were probably published at the same time.[14] Compared to

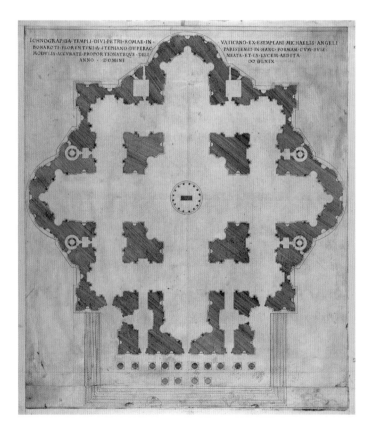

62 Étienne Dupérac's plan of St Peter's, published 1569, engraving and etching.

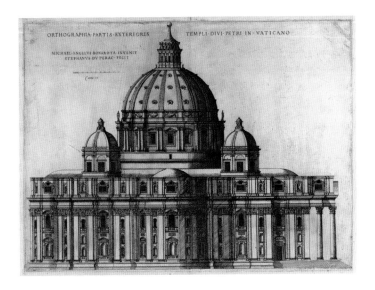

Bramante's plan, Michelangelo's design is much simpler and more robust. He simplified and opened the interior space so that the Greek cross of the plan was dominant. The smaller crosses in each corner were eliminated, and instead the vaulting forms a square superimposed on the large Greek cross. In a sense this square serves as a substitute for Sangallo's ambulatory, but on a larger scale, which allowed a greater sense of openness and offered visitors freer circulation. The church is decidedly centralized, in keeping with Renaissance ideals already articulated a century before by Leon Battista Alberti, who said that the divine was revealed in simple, geometric forms.[15] In saying that he admired the 'isolated' quality of Bramante's plan, Michelangelo may even have been referring to Alberti's words, since Alberti wanted the perfect church to be elevated and set in an open square so it could be seen from all sides and apart from everyday distractions.[16] Michelangelo

63 Étienne Dupérac's view of St Peter's, published *c.* 1569, engraving and etching.

apparently ignored the practical arguments against the central-plan church: such a plan was less amenable to the liturgy and accommodated fewer people than did a church with a long nave. Other architects who developed plans for St Peter's, including Bramante himself, considered adding a nave, and in the end one was added onto Michelangelo's plan in the later sixteenth century.

So much of the interior of St Peter's has changed since the sixteenth century that Michelangelo's designs can only be seen clearly in a few places, such as the south and north apses, and even those have been modified. A careful study of documents and visual evidence by Henry A. Millon and Craig Hugh Smyth has shown that the interior would have been more austere than it now appears, with travertine used for all detailing, but with subtle variations coming from the precisely cut and layered forms.[17] Even today, the viewer's changing position would determine how the pilasters, walls and windows related to each other. Elements that at times appear structural become disconnected from a different viewing angle. The vaulting over the apses seems to billow up at the ends, but this too is an illusion. Upward movement is emphasized by the giant pilasters that embellish walls; these are a repeated motif on the exterior as well.

Michelangelo gave careful attention to light within St Peter's; the lack of light was one of the main faults he found in Sangallo's model. In Michelangelo's design much of the light would have entered through windows in the attic storey, which had been changed even by the time Dupérac created his engraving. An engraving published by Vincenzo Luchino in 1564 shows these windows set in arched recesses that funnel

light into the building. When he was writing the second edition of his *Lives* in 1568, Vasari was able to see the effect within the south apse; he described it as being 'alive with light'. An even more dramatic effect is seen in the sixteen windows on the drum of the dome (illus. 64). These are constructed so that they are lower on the inside than on the exterior; all entering light is shunted downwards towards the main altar, which stands above St Peter's tomb. The effect is of a halo of light, with the dome itself floating above it. The luminous quality that Michelangelo admired so much in Bramante's plan here becomes visionary.

The compactness of Michelangelo's plan is reflected on the exterior by the avoidance of all steeples and bell towers. It was not only Sangallo who wanted such traditional ecclesiastical signs; the commemorative medal struck in 1506 shows that Bramante also planned for tall bell towers on the corners of the facade. Sangallo used the towers to frame a benediction loggia from which the pope could address the crowds. Michelangelo eliminated the bell towers and instead made the tallest element the dome marking St Peter's grave. He apparently gave no thought to a benediction loggia. He may not have even designed the classical portico seen in Dupérac's engraving – no drawings by Michelangelo's hand indicate a facade of any sort.

What did matter to him was the dome. Bramante had established this element in his plan of 1505, and the supports for it were in place by 1511. The question of whether these supports would be sufficient to support the dome troubled architects even in Bramante's time, and Michelangelo augmented them again in his plan. Michelangelo's design for the

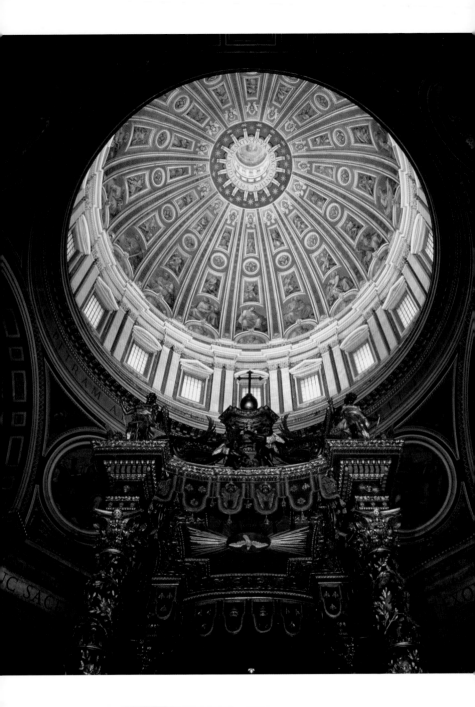

64 View into the dome of St Peter's, Vatican City.

dome is best seen in the Dupérac engraving (see illus. 63). Although he considered a more pointed profile for structural reasons, he settled on a hemispherical form. This shape recalls the Roman Pantheon, the largest dome in the city, which St Peter's dome was clearly meant to rival. The interior diameter of the dome of St Peter's is slightly smaller than the Pantheon's, but its height is much greater – it was to be the tallest dome in Rome, visible from every part of the city. It was to serve as a beacon to pilgrims coming from afar and symbolically proclaimed the Church as the successor to the Roman Empire. Michelangelo never saw his design for the dome realized; it was completed with a more pointed profile under the direction of Giacomo della Porta in 1590, more than a quarter of a century after Michelangelo's death.

No other public architectural project by Michelangelo demonstrates concern with visual effects more than the Capitoline Plaza, known in the vernacular as the Campidoglio.[18] The Capitoline Hill was a sacred precinct of ancient Rome, built on a precipice that overlooked the western end of the Forum. In the early Middle Ages it was a fortress, and in the twelfth century the secular government of the city took up residence there. Work on the Palazzo del Senatore (Senatorial Palace) was begun in the following century, and the Palazzo dei Conservatori (Conservators' Palace) was added in the fifteenth century. The space between these palaces and the medieval church of Santa Maria in Ara Coeli was uneven, unpaved and disorderly. The rather sad appearance of the area is seen in well-known drawings by Maarten van Heemskerck and others made in the mid-sixteenth century. In spite of its haphazard appearance the Campidoglio was used for

important ceremonies and would sometimes be decorated with temporary elements to provide an appropriately impressive setting. Plans for such a setting were made in December 1535 in preparation for the entry of the Holy Roman Emperor, Charles V, although they were not completed and the entrance procession only circled the base of the hill.

This embarrassment may have led to the first efforts to improve the site, but nothing was done until 1537, when the city government allocated funds to upgrade the Palazzo dei Conservatori and the surrounding area. Around the same time, Pope Paul III ordered the Roman equestrian statue of Marcus Aurelius to be moved from the Lateran to the space in front of the two palaces. Michelangelo was commissioned to create a pedestal for this statue, which was erected there in 1539. Remodelling of the Conservators' Palace began around this time as well, but the overall design took shape gradually over several decades.

Étienne Dupérac's engraving of 1569 (illus. 65) captures many of Michelangelo's ideas for the Campidoglio before the interventions of Giacomo della Porta, who took over after Michelangelo died. It is an ideal view, in that a person would need to be hovering in the air to see this precise view, but it also concentrates on the viewer's experience – only the facades of the buildings are indicated. The visual unity of the piazza is created through bilateral symmetry – an equivalence of parts on either side of an axis that is like the symmetry of the human body. Michelangelo's clearest statement of his theory of architecture involves just this idea.[19]

Michelangelo regularized the entire site by creating a strong axis that moved up the ramped stairs from the city,

through the *Marcus Aurelius* sculpture, and ended at the main entrance of the Palazzo del Senatore. The original appearance of the Senatorial Palace was an asymmetrical collection of parts, with a staircase on the right and the bell tower off to the left. Michelangelo redesigned the facade so that it presented a completely balanced culmination to the plan. The campanile was centred, the windows repositioned within a more classical framework, and a new double staircase created to call attention to the main portal. On either side of the axis, Michelangelo created symmetry by putting a new facade on the Palazzo dei Conservatori and designing an entirely new palace opposite. This Palazzo Nuovo had no real purpose – it was fundamentally a facade, although rooms were planned to match those in the Conservatori. The entire effect is like a theatrical set design, and in many ways it does recall ideal set designs that were being published around this time.[20]

65 Étienne Dupérac, *View of the Campidoglio*, 1569, engraving and etching.

The buildings provide a rich backdrop for the wide range of ceremonies and public activities that took place in the piazza, ranging from imperial entrances to carnivals.

In detailing the buildings, Michelangelo gave visual form to the multiple functions of the buildings and the space.[21] The Palazzo del Senatore was a place of justice, where high tribunals were held and executions took place. The senator was the city's chief judicial officer and came from outside the city to ensure impartiality; however, by the sixteenth century he was appointed by the pope.[22] The entire plan of the Campidoglio culminates in the Senatorial Palace, which is given greater height than the other buildings, not just from the campanile towering above the main entrance, but also from

66 Capitals from the Palazzo dei Conservatori, Rome.

setting the main body of the building on a tall basement level, with symmetrical ramps of stairs creating a focus. The conservators were elected representatives of the Roman people and were often involved in business affairs and regulation of the guilds, who traditionally occupied spaces in the loggia of the palace. The Palazzo dei Conservatori is lower overall than the Senatorial Palace, but a hierarchical structure is set up even on the facade of this building. Michelangelo's facade maintains the open loggia below, ornamented with fanciful Ionic columns with grotesque satyr faces (illus. 66). The leathery form of the volutes is very likely a reference to the butchers' guild and the importance of bulls, which were displayed in the open field of the Campidoglio before city festivities. These columns with their references to popular activities are held in check by the colossal, and much more traditional, Corinthian pilasters that span the two levels. They emphasize the status of the conservators who met in the rooms above the loggia. These officials liked to emphasize their ties to ancient Rome. On the interior, an attic that was destroyed because of the new facade allowed for a taller, grander space for the conservators' ceremonial hall, articulated in an antique style.[23]

Dupérac's engraving shows a view that is far more complete than the buildings themselves were in Michelangelo's lifetime. Indeed, the publication of these prints can be seen as part of the renewed effort to finish the project, which had progressed little since the late 1540s. The staircase of the Palazzo del Senatore was completed by 1552; the main portal was started a few years later, but was not complete by the time Dupérac's engraving was published. The facade itself was still under construction in the 1580s. The facade of the

Palazzo dei Conservatori was begun in 1563, just a year before Michelangelo's death, and it was not finished until 1586. The Palazzo Nuovo, which mirrors the Conservators' Palace, was not even started until the early seventeenth century. Inscriptions on Dupérac's prints affirm that the overall conception was Michelangelo's, although it is probable that Michelangelo himself would have made changes as the work progressed.

Michelangelo was involved with many other architectural projects in the final twenty years of his life.[24] For some he provided drawings or models; on others he simply offered advice. Some projects were realized, but, as always, later modifications alter whatever effect he might have intended. The very last architectural project Michelangelo planned has special significance when considering the viewer of his work. The Porta Pia (illus. 67) was commissioned in 1561 by Pope Pius IV, a member of the Milanese branch of the Medici family. The pope wanted to create a broad, magnificent avenue running from the Quirinale hill to the basilica of Sant'Agnese, outside the Roman walls.[25] Building the new road caused the destruction of whole neighbourhoods and necessitated the building of a new gateway through the walls. The gate Michelangelo designed is on the side facing the city.

Michelangelo presented three designs to the pope for his approval. These were described by Vasari as 'very beautiful and extravagant', and even though the drawings that survive are probably not the same ones, the description applies to them as well (illus. 68). They show that Michelangelo's creativity was unabated even though he was now over 85 years old, and that his use of classical elements continued to be unorthodox. In the drawings, motifs drawn from his earlier

work and from the classical tradition are combined, selected, rejected and recombined in a continuous creative process that only stopped when the presentation drawings for the pope were made. As it exists today, the gate displays contrasting layers of textured stone that build up from the heavily rusticated inner opening to the refined fluted pilasters that support a broken, curved pediment. The tightly wound volutes in the pediment are echoed in the flat images of volutes below. The windows, both blind and actual, seem applied to the surface, and the upper edge of the gate is crowned with elegant projections that recall crenellations found in more defensive structures. (The uppermost part of the gate was added in the nineteenth century; it may not reflect Michelangelo's

67 Porta Pia, Rome, 1561–4.

68 Study for the Porta Pia, *c.* 1560, black chalk, pen and brown watercolour on brown paper.

design.) Michelangelo was never one to feel constrained by the rules of classical architecture, but the freedom he exhibited in the Porta Pia is probably a reflection of the fact that this gate was at the end of a road lined with suburban villas, each with their own elaborate gate. Villa gates, because they led on to natural areas, could be more licentious; they present to viewers aspects that are welcoming and threatening at the same time.[26] They are passages into other worlds where visitors might experience something more beautiful, wilder, or more mysterious than the urban world from which they have come.[27]

Last Works

LTHOUGH MICHELANGELO continued to design buildings even as he approached ninety years of age, he had stopped painting frescoes in 1549. He had taken a break from sculpture as well. The *Brutus* was finished probably around 1540; *Rachel* and *Leah* for the Tomb of Pope Julius II were finished by 1545. The completion of the other sculptures for the tomb of Julius and the Medici Chapel was delegated to others. In the late 1540s, certain his own death was imminent, Michelangelo picked up his chisel again. After working so many years on tombs for cardinals and popes, he now turned to his own tomb.

The Florentine *Pietà* (illus. 69) was started around 1549.[1] Vasari briefly described the four-figure group in his first edition of the *Lives*, which was published the following year. He calls it a 'Deposition', which perhaps more accurately describes the scene. Christ has been taken down from the cross, and his collapsing body is held up by his mother. Two other figures help to lower him into his mother's arms, relieving some of the body's weight: a woman usually identified as Mary Magdalene supports his thigh, while a hooded man standing behind the group holds up Christ's right arm and

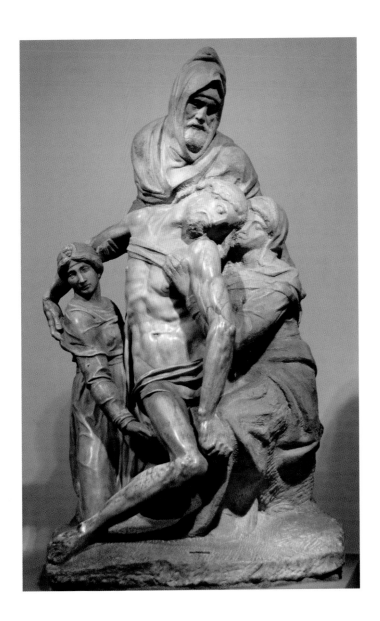

69 Florentine *Pietà*, begun *c.* 1549, marble.

supports Mary with a hand on her back. The man is most
often identified as Nicodemus, who helped with Christ's bur-
ial, although Joseph of Arimathea has also been proposed. Since
the figure is undoubtedly a self-portrait – this was acknow-
ledged in a letter from Vasari to Michelangelo's nephew –
Nicodemus is more likely, since Nicodemus was believed to
be a sculptor who carved the true face of Christ. Nicodemus
was also linked with those who believed in the divinity of
Christ, but who did so privately, just as Michelangelo only
privately expressed ideas he learned from Vittoria Colonna.[2]
Throughout his life, beginning with the Vatican *Pietà* and
continuing in late drawings, Michelangelo returned to the
theme of the display of Christ's dead body.[3] It is a type of
image meant to capture the viewer's attention, focusing the
gaze and leading the worshipper to a transcendent experi-
ence of the meaning of Christ's death. By including himself
in this sculpture, Michelangelo is both an actor in the sacred
drama and an observer, looking down and meditating on the
body of Christ.

Michelangelo wanted to be buried in a simple tomb at the
foot of an altar; this sculptural group would stand above the
altar. Since the group is well over two metres tall, the hooded
figure would tower over the celebrant at the altar, or other
visitors who came to pay their respects. If the group were
turned so the base paralleled the altar, the faces of Christ
and Mary would be most directly in line with the viewer's
gaze, with Nicodemus' just behind theirs.[4] Nicodemus does
not engage the viewer's line of sight, however; his focus is
on Christ. The sculpture gains greater significance by being
positioned above the altar, since the body of Christ is

sacramentally present in the Eucharist, which was held up for adoration in front of the image.[5]

To carve four figures from a single block of marble was a formidable challenge, and this group may have been Michelangelo's attempt to challenge the ancients one last time.[6] But this time the challenge may have been too much. The Florentine *Pietà* shows evidence of Michelangelo's frustration: he broke off the left leg as well as both arms of Christ and the visible arms of the Virgin Mary and Mary Magdalene. Most of these limbs were repaired by Tiberio Calcagni, who also amputated more cleanly the left leg and carved the square hole where a new leg would have been attached. Vasari gives various explanations for Michelangelo's actions: the stone had proved unworkable, the artist's concept was too great, or even that he had grown tired of hearing his servant Urbino nag him to finish it. More recently, Leo Steinberg has proposed that Michelangelo broke off the leg because he realized that Christ's leg slung over the Virgin's lap suggested a sexual relationship between them. It seems unlikely that Michelangelo would have brought the piece as far as he did before noticing this inappropriate display, and this explanation does not account for the fact that so much else was deliberately removed, as though Michelangelo wanted to reduce the sculpture to a core that he could rework.[7] Whatever the reason, Michelangelo did not completely destroy the sculpture; his servant, Antonio, stopped him from damaging it further, and Michelangelo gave the sculpture to him. It was then acquired by Francesco Bandini, who commissioned Tiberio Calcagni to repair it. Michelangelo cooperated with Calcagni and provided him with models. Calcagni reassembled the broken

pieces and generally added only minor pieces to replace what could not be saved. However, he took care to finish Mary Magdalene, the only figure in the group who directly addresses the viewer. The Magdalene's size and position – smaller and slightly apart from the others in the group – was already established by Michelangelo, and her importance as a connecting figure between the worshipper and the sacred scene must have been his idea.[8] Calcagni left the work incomplete when he died in 1565.

Another variation on the theme, the Rondanini *Pietà* (illus. 70), was started around 1553 – perhaps even before Michelangelo damaged the four-figure group, since Vasari implies that he immediately took up work on another *Pietà* that was already roughed out. This is a simpler image than the Florentine *Pietà*, with only two figures rather than four, but in many ways it is even more complex, since remnants of at least one other version remain visible in the sculpture. Again the focus is on Christ, whose body is held up as if to display it for the contemplation of the viewer. This figure standing behind Christ now appears to be the Virgin Mary, but the sculpture itself bears evidence that Michelangelo conceived of another person here. A face looking upwards is roughed out on Mary's veil, and the bare leg of this figure implies that originally the figure supporting Christ was male.[9] Since the Nicodemus figure in the Florentine *Pietà* is dressed in a similar workman's short tunic, with a bared leg, Michelangelo may have first thought to show himself again as Nicodemus holding Christ's body. Although in the end Michelangelo removed himself from the representation, it is easy to imagine him hovering over the sculpture, continuously,

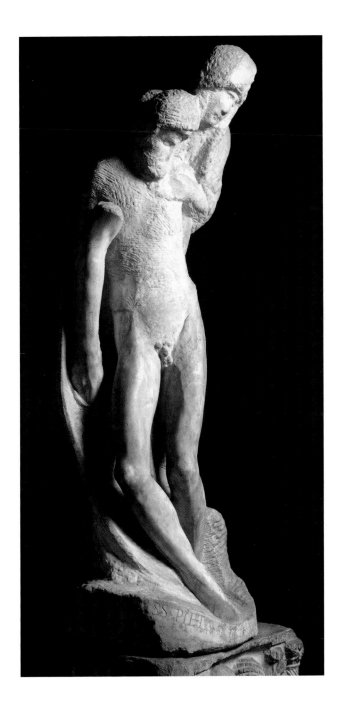

70 Rondanini *Pietà*, begun *c.* 1555, marble.

even obsessively, reworking Christ's body. At an earlier moment Christ was larger and held in a higher position; the highly finished remains of his right arm and the polished areas on his legs are vestiges of that earlier figure. The second version remains very roughly carved, the bodies seemingly emaciated and collapsing together.

Neither the Florentine *Pietà* nor the Rondanini *Pietà* was placed on Michelangelo's tomb. When Francesco Bandini died in 1562 the Florence *Pietà* passed to his son, Pierantonio, who set it within a niche in his villa's garden on the Quirinale. There it might have retained some of its religious significance, with the garden recalling the area around Golgotha where Christ was buried, but subsequent owners probably did not maintain that association.[10] Just before Michelangelo died in 1564, he told Vasari that he wanted to recover the sculpture for his tomb, but this was not done.

The Rondanini *Pietà* was in Michelangelo's shop when he died. In a document dated 21 August 1561 Michelangelo deeded a sculpture of the dead Christ (presumably the Rondanini *Pietà*) to his servant Antonio di Giovanni Maria del Francese da Casteldurante, but it is not clear whether Antonio ever owned it.[11] Its whereabouts cannot be traced before the early nineteenth century, when it was in the collection of Marquis Giuseppe Rondanini in Rome. An inventory of the Rondanini collection has an annotation saying that the work is said to be by Michelangelo, but that this is a misunderstanding and the piece is modern. With its extraordinary expression and abstract sweep of the paired bodies, it is easy to understand why. As it is displayed now in Castello Sforzesco in Milan, viewers can examine the sculpture from all sides

and from a relatively close distance, almost as if they were in Michelangelo's studio.

Michelangelo continued to make art until a week before he died, at the age of 89, but in the last few years of his life he turned away from patrons and viewers. His final sculptures were made for his tomb; many of his late drawings were made only for himself. These works show the continuous cutting away at stone or the repeated drawing of lines, as if the artist were still searching for something that never quite appeared. It is as though the actions of carving or drawing were all that mattered – not whether anyone else would recognize the forms.

Conclusion

HROUGH MICHELANGELO'S long career he created works that engaged many types of viewers. He respected specific settings and adjusted his works so that they could be seen well under particular conditions. He thought about the distortions and tricks of human vision, and he created works that tried to capture visions of the divine.

Who were these viewers? Like most Renaissance artists, Michelangelo often made works that served religious purposes. His earliest commissioned work, the Santo Spirito crucifix (see illus. 6), is an iconic image which would focus worshippers' attention and help them feel Christ's suffering. Its realistic details would have made the image more present to the devout. Other paintings and sculptures served as altarpieces that would have encouraged pious meditation on the meaning of the Mass. One example is the Bruges *Madonna* (see illus. 21). Here a robust but deeply serious Christ Child leaves the comfort of his mother and steps forward into his fate. At the same time he seems to enter the worshippers' space, making a connection with them. Its place upon the altar of a funerary chapel allowed family members to think

about a path to salvation for their deceased loved ones and themselves. So many of Michelangelo's sculptures mark tombs or memorial chapels, including the Vatican *Pietà* (see illus. 12) and the *Risen Christ* in Santa Maria sopra Minerva (see illus. 20). In these cases the image of Christ's body – whether dead upon his mother's lap or standing in triumph after his own resurrection – offers believers hope of life even after physical death. These two examples also show how the meaning of Michelangelo's work evolves as the worshippers move up to and past the work. The movement of the pilgrim is inscribed in the form. Works in churches or pilgrimage sites were accessible to all, and we have some evidence that suggests how unsophisticated visitors responded – for example, the woman who wanted some chips of marble from the Vatican *Pietà*.

Other works were in much more restricted settings, where specific types of viewers would be present. *The Battle of Cascina* (see illus. 15), for example, would have been exhibited in the Hall of the Great Council, where the men who governed the city of Florence would see the values of heroic strength and preparedness for battle exhibited in monumental form. The primary audience in the Pauline Chapel consisted of the pope and cardinals; again, the messages told in the *Conversion of Saul* (see illus. 45) and the *Crucifixion of Peter* (see illus. 46) had special relevance to that audience, since they affirmed the importance of ministry and the strength needed to defend the Church in times of crisis. The viewers who experienced Michelangelo's frescoes in the Sistine Chapel (see illus. 29) did include some members of the public, but the papal court had a privileged position there. Michelangelo's frescoes not only include specific details that refer to doctrines and liturgies,

but also take into account the movement of the clergy as they process through the chapel and take their places within the presbyterium near the altar. This area was sometimes called the Holy of Holies, which indicates both the sacredness of the space and the privilege given to those allowed within. Michelangelo preserved that sense of privilege by created images that demanded interpretation and a sophisticated understanding of visual forms. Ironically, the *Last Judgment* on the altar wall (see illus. 42) became Michelangelo's most public painting, as it was widely reproduced shortly after it was completed. The *Last Judgment* was no longer only available to the privileged few, but could be seen by all – even women and children, as the critics were quick to point out – and as a result was censored.

Although women would almost never be present in some settings, such as the Sistine Chapel or the Palazzo della Signoria, there were other spaces more open to them – parish churches, for example. Women would have also experienced works meant for a domestic setting; indeed, they were probably the intended viewers of the *tondi* (see illus. 22). Unfortunately, we know very little about specific women of the Doni, Pitti and Taddei households. It would be truly fascinating to come across a response from a woman or a child who had lived in a home where a Michelangelo *tondo* was displayed.

Some of the viewers of Michelangelo's works were collectors who could discriminate between works made by the great classical sculptors and other Renaissance painters. Isabella d'Este and her brother Alfonso d'Este are among these, and both acquired or commissioned works by Michelangelo that could be examined at close range within their own palaces.

Michelangelo himself encouraged such close viewing when he gave exquisitely worked drawings to his friends Tommaso de' Cavalieri and Vittoria Colonna. It is very likely that these four viewers studied the objects they owned for very different reasons. Isabella d'Este encouraged her guests to discern whether the *Sleeping Cupid* was the work of an ancient master or an unknown sculptor from Florence. Her brother commissioned the *Leda* (see illus. 56) from Michelangelo when he was an acknowledged master. It was perhaps meant to be seen next to paintings by other great Italian painters in his Camerino. Whether it was displayed there or not, *Leda* is an erotic image showing the illicit union of a woman and swan. While they seem to hide behind a curtain, they are fully visible to Alfonso and his guests. Eroticism is also behind most of the drawings for Tommaso de' Cavalieri, but in drawings such as *Ganymede* and *Tityus* (see illus. 47 and 48) the eroticism is veiled by the reference to classical mythology and by the pretext that these were meant to be drawing lessons for his beloved young friend. Colonna's close examination of the *Crucifixion* and *Pietà* drawings (see illus. 53 and 54) also speaks of desire, not for sexual union but for a spiritual engagement that was equally intense.

The presentation drawings for Colonna and Cavalieri are Michelangelo's most private creations. Did Michelangelo mean for them to be kept secret? On the one hand these precious drawings could have been interpreted by others in incriminating ways; on the other, Michelangelo knew very well that other people were involved in delivering the drawings to their recipients and that both Cavalieri and Colonna shared them with others. In some of the drawings for Cavalieri,

meanings were encoded to make them more difficult for others to understand; other pieces, however, could be interpreted as illustrations of classical myths or moralizing allegories. These designs, too, found a much wider audience than Michelangelo could have anticipated. They were quickly copied as engraved crystals and paintings for wealthy collectors, and as prints that could be purchased by people of ordinary means.

Although many of Michelangelo's sculptures were made for specific places and would have been placed at heights and under lighting conditions that he took into account as he designed them, they were sometimes put in very different locations after they were completed. Many of his works were moved without his knowledge or approval, but two of his most significant sculptures were repositioned with his knowledge, and possibly his input. The *David* (see illus. 14), initially meant to be set high on a buttress of the Duomo in Florence, was eventually placed in front of Florence's city hall, the Palazzo della Signoria, where its meaning changed with its new context. What was once a religious statue became a political statement, although whether it was one about the strength of the Republic or the strength of the Medici depended on who was in power.

The tomb of Julius II presents the most fascinating example of how a project was planned for a particular space and reinvented as the commission and location changed. The early free-standing version of the tomb had imperial connotations and was probably meant to be seen in comparison with Antonio del Pollaiuolo's tomb for Sixtus IV, Julius' uncle, beyond the main altar of St Peter's. As the tomb evolved, the statue of *Moses* (see illus. 24) was repositioned, and in its

final form in San Pietro in Vincoli it seems that *Moses*, not the effigy of the pope, is the main focus. It was probably not Michelangelo's intention that the pope's image be diminished in this way, but the powerful remnant of the earlier design is simply too compelling.

There can be no doubt that Michelangelo was an extraordinary talent, but he was also supported by extraordinary people. As a very young artist, he was nurtured within the stimulating environment of Lorenzo de' Medici's household, where he was given the freedom to explore materials and imagery unfettered by specific commissions. He also met other members of the Medici family who would support him in varying ways. One pivotal figure was Lorenzo di Pierfrancesco de' Medici, who encouraged the artist to seek opportunities in Rome. Although the method was suspect – he convinced Michelangelo to pass off the *Sleeping Cupid* as an antique work – it accomplished the desired effect, and the young artist became known to the Roman elite and eventually the pope himself. The ambitions of Pope Julius II provided him with the field to create works of unprecedented grandeur and transcendent beauty. Later, Pope Clement VII, who knew Michelangelo when they were both boys in the Medici household, enlisted Michelangelo to create monuments to the Medici family in Florence. Clement allowed him the freedom to imagine unorthodox architectural forms, to create sculpture that seemed to share in the viewer's experience and to imagine a painting that would give form to the terrible vision of the end of the world. That great painting project for Clement, the *Last Judgment* (see illus. 42), was finished under his successor, Paul III, whose ambitions to

glorify his own family and to create a renewed Rome lead to some of Michelangelo's most important architectural commissions, including the Farnese Palace (see illus. 61) and St Peter's (see illus. 63 and 64). The Capitoline complex (see illus. 65), a civic project done with the approval of Paul III, made an elegant governmental centre from a previously neglected site. These Roman projects were not just expressions of the patron's wishes or the artist's feelings, but were monuments designed to create views and spaces for the Roman people. Each helped to restore the city to its former grandeur. In the case of St Peter's, the space was not just for the Roman people but for the entire Catholic church.

Michelangelo planned these and other architectural projects in his old age, when the challenges of ageing made fresco painting and the carving of large-scale sculpture difficult. Even as he neared ninety years of age, the artist still found strength to carve two final sculptures, intended for his own tomb. These are deeply personal works, and it might be imagined that he did not want them to be seen by others. Yet what is a tomb monument but a statement to the world that this is how you want to remembered? In the Florentine *Pietà* (see illus. 69), Michelangelo included an image of himself in the guise of Nicodemus. He was both an actor in and a viewer of the heart-wrenching scene in which Mary holds her dead son for the last time. In the Rondanini *Pietà* (see illus. 70), Michelangelo removed this self-reference so that only the image of Christ and the Virgin remained —and even they became less and less materially present under his obsessive reworking of the stone. Here, at the end of his life, inner vision meant more than what the eye could see.

REFERENCES

Introduction

1　See Martin Jay, 'Scopic Regimes of Modernity', in *Vision and Visuality*, ed. Hal Foster (Seattle, WA, 1988), pp. 3–23. More broad-ranging is Wandel's introduction to *Early Modern Eyes*, ed. Walter S. Melion and Lee Palmer Wandel (Leiden, 2010), pp. 1–9.

2　Caroline Elam, '"Ché ultima mano!": Tiberio Calcagni's Marginal Annotations to Condivi's *Life of Michelangelo*', *Renaissance Quarterly*, LI/2 (1998), p. 492.

3　See David Summers, *Michelangelo and the Language of Art* (Princeton, NJ, 1981), pp. 368–79.

4　Michael Baxandall's *Painting and Experience in Fifteenth-century Italy*, first published in 1972, is the fundamental discussion of these ideas. A more recent consideration of Michelangelo's forceful figures is Michael Cole, *Leonardo, Michelangelo, and the Art of the Figure* (New Haven, CT, and London, 2014).

5　This mode of seeing is often associated with the Middle Ages but was still operative in the Renaissance. See Michael Camille, 'Before the Gaze: The Internal Senses and Late Medieval Practices of Seeing', in *Visuality Before and Beyond the Renaissance: Seeing as Others Saw*, ed. Robert S. Nelson (Cambridge, 2000), pp. 197–223, and Christian K. Kleinbub, *Vision and the Visionary in Raphael* (University Park, PA, 2011), pp. 2–9.

6　Joost Keizer, 'Site-specificity', in *Michelangelo in the New Millennium*, ed. Tamara Smithers (Leiden, 2015), pp. 36–7.

7　The standard Italian editions are Giorgio Vasari, *Le vite de' più eccellenti pittori, scultori e architettori nelle redazioni del 1550 e 1568*, ed.

Rosanna Bettarini and Paola Barocchi (Florence, 1966), and
Ascanio Condivi, *Vita di Michelagnolo Buonarroti*, ed. Giovanni
Nencioni (Florence, 1998). Vasari's biography of Michelangelo
is available in several English translations, while the best
translation of Condivi's is *The Life of Michelangelo*, ed. Hellmut Wohl,
trans. Alice Sedgwick, 2nd edn (University Park, PA, 1999).

1 The Artist in Search of an Audience

1 Jeanne K. Cadogan, *Domenico Ghirlandaio: Artist and Artisan*
(New Haven, CT, 2000), p. 162.

2 The drawing reproduced here has been associated with
Masaccio's destroyed *Sagra*, although it is more likely copied
from a drawing by Ghirlandaio which was influenced
by Masaccio's style. See Francis Ames-Lewis, 'Drapery
"Pattern"-drawings in Ghirlandaio's Workshop and
Ghirlandaio's Early Apprenticeship', *Art Bulletin*, LXIII/1
(1981), p. 51.

3 Ibid., pp. 107–46.

4 Caroline Elam, 'Lorenzo de' Medici's Sculpture Garden', in
Michelangelo: Selected Scholarship in English, ed. William E. Wallace
(New York and London, 1995), vol. 1, pp. 139–81.

5 Vladimir Jůren, 'Fecit Faciebat', *Revue de l'art*, XXVI (1974),
pp. 27–30.

6 James David Draper, *Bertoldo di Giovanni, Sculptor of the Medici
Household: Critical Reappraisal and Catalogue Raisonné* (Columbia,
MO, 1992), p. 41.

7 Rona Goffen, *Renaissance Rivals* (New Haven, CT, and London,
2002), pp. 79–87; however, it is not certain that the Madonna
referred to in the letter of 31 January 1506 is the *Madonna of the Steps*
or the Bruges *Madonna*.

8 Ibid., pp. 45–6; Rona Goffen, 'Mary's Motherhood According
to Leonardo and Michelangelo', *Artibus et Historiae*, XX/40 (1999),
pp. 4–5.

9 For a review of the scholarship on the statue, see Janet Cox-
Rearick, *The Collection of Francis I: Royal Treasures* (New York, 1996),
pp. 302–13.

10 Kathleen Weil-Garris Brandt et al., eds, *Giovinezza di Michelangelo*, exh.
 cat., Palazzo Vecchio, Florence (Florence and Milan, 1999), p. 288;
 Margrit Lisner, 'Il crocifisso ligneo di Michelangelo per il vecchio
 coro della chiesa di Santo Spirito a Firenze', in *Il Crocifisso di Santo
 Spirito/The Crucifix of Santo Spirito*, ed. Direzione cultura, Comune di
 Firenze, trans. Therese Nagali Ghezzi (Florence, 2000), pp. 35–6.
11 A sixteenth-century drawing shows it on a screen near the main
 altar. See Charles de Tolnay, *The Youth of Michelangelo* (Princeton,
 NJ, 1947), p. 196 and fig. 151, and Lisner, 'Il crocifisso', p. 34.
 The crucifix is currently installed in the sacristy of the church.
12 Barbara Schleicher, 'Il restauro/The Restoration', in *Il Crocifisso
 di Santo Spirito/The Crucifix of Santo Spirito*, p. 70.
13 Alexander Nagel and Christopher Wood, *Anachronic Renaissance*
 (New York, 2010), pp. 218–39; David S. Areford, 'Multiplying
 the Sacred: The Fifteenth-century Woodcut as Reproduction,
 Surrogate, Simulation', *Studies in the History of Art*, LXXV (2009),
 pp. 135–8, 152 n. 78.
14 Savonarola's words from *Trattato dell' amore di Jesu Christo*, written in
 1492, are quoted and translated by Chris Fischer, *Fra Bartolommeo,
 Master Draughtsman of the High Renaissance*, exh. cat., Museum Boy
 mans-van Beuningen, Rotterdam (Rotterdam, 1990), pp. 82,
 104 n. 89.
15 Anita Fidere Moskowitz, *Nicola Pisano's Arca di San Domenico and Its
 Legacy* (University Park, PA, 1994), pp. 9–13, 17, 20.
16 Alison Luchs, 'Michelangelo's Bologna Angel: "Counterfeiting" the
 Tuscan Duecento?', *Burlington Magazine*, CXX/901 (1978), pp. 222–5.
17 Ellen L. Longsworth, 'Michelangelo and the Eye of the Beholder:
 The Early Bologna Sculptures', *Artibus et Historiae*, XXIII/46
 (2002), pp. 77–82.
18 Michael Hirst, 'The Artist in Rome, 1496–1501', in Michael Hirst
 and Jill Dunkerton, *The Young Michelangelo*, exh. cat., National
 Gallery, London (London, 1994), pp. 22–4.
19 Ibid., p. 32; Erin Sutherland Minter, 'Discarded Deity: The
 Rejection of Michelangelo's *Bacchus* and the Artist's Response',
 Renaissance Studies, XXVIII/3 (2014), pp. 443–58.
20 Christoph Luitpold Frommel, 'Raffaele Riario, la Cancelleria,
 il teatro e il *Bacco* di Michelangelo', in Weil-Garris Brandt et al.,

Giovinezza di Michelangelo, pp. 143–8. Pope Alexander VI's reforms are discussed in Minter, 'Discarded Deity', pp. 453–5.

21 Ralph Lieberman, 'Regarding Michelangelo's *Bacchus*', *Artibus et Historiae*, XXII/43 (2001), pp. 67–72.

22 Frank Zöllner, Christof Thoenes and Thomas Pöpper, *Michelangelo, 1475–1564: The Complete Works* (Cologne, 2007), p. 407. On Galli's sculpture garden, see Kathleen Christian, *Empire without End: Antiquities Collections in Renaissance Rome, c. 1350–1527* (New Haven, CT, and London, 2010), pp. 317–20.

23 Francesco Bocchi, *The Beauties of the City of Florence: A Guidebook of 1591*, trans. Thomas Frangenberg and Robert Williams (London and Turnhout, 2006), p. 64.

24 Michael Hirst, *Michelangelo*, vol. I: *The Achievement of Fame, 1475–1534* (New Haven, CT, and London, 2011), pp. 32–4.

25 The history of the building is summarized in Kathleen Weil-Garris Brandt, 'Michelangelo's *Pietà* for the Cappella del re di Francia', in *Michelangelo: Selected Scholarship*, ed. Wallace, vol. I, pp. 218–20.

26 Ibid., p. 226.

27 These arguments are summarized in Weil-Garris Brandt, 'Michelangelo's *Pietà*', pp. 222–6; and Hirst, 'The Artist in Rome', pp. 49–52. Wallace has argued for its being set on a low plinth; William E. Wallace, 'Michelangelo's Rome *Pietà*: Altarpiece or Grave Memorial?', in *Michelangelo: Selected Scholarship*, ed. Wallace, vol. I, pp. 261–77.

28 Prints that show the crucifix include those by Bonasone, G. B. Cavalieri and Mario Cartaro. See Bernadine Barnes, *Michelangelo in Print* (Farnham and Burlington, VT, 2010), pp. 149–53, 199.

29 Lisa Pon, 'Michelangelo's First Signature', *Source*, XV/4 (1996), pp. 16–21.

30 Giorgio Vasari, *Der literarische Nachlass*, ed. Karl Frey (Munich, 1923), vol. II, pp. 64–5. The letter is assumed to have been sent to Vasari, but even this is not certain.

31 Aileen June Wang, 'Michelangelo's Signature', *Sixteenth Century Journal*, XXXV/2 (2004), pp. 450–51, and Sarah Blake McHam, *Pliny and the Artistic Culture of the Italian Renaissance* (New Haven, CT, and London, 2013), pp. 184–6.

32 Pon, 'Michelangelo's First Signature', p. 19.
33 McHam, *Pliny*, pp. 185–8, 346.
34 The translation is based on Wang, 'Michelangelo's Signature',
 p. 451 n. 6.
35 Rebekah Smick, 'Evoking Michelangelo's Vatican *Pietà*:
 Transformations in the Topos of Living Stone', in *The Eye of the Poet*,
 ed. Amy Golahny (Cranbury, NJ, 1996), pp. 23–52. Strozzi's poem
 is quoted on p. 30.

2 The Heroic Body

 1 Two recent books review the history of the *David*: John Paoletti,
 Michelangelo's 'David': Florentine History and Civic Identity (New York,
 2015), pp. 17–55, with documents transcribed and translated by
 Rolf Bagemihl on pp. 201–322; and Arnold Victor Coonin, *From
 Marble to Flesh: The Biography of Michelangelo's 'David'* ([Florence], 2014),
 pp. 17–90.
 2 See Israel Silvestre's engraving reproduced in Coonin, *From Marble
 to Flesh*, fig. 1.8. See also Paoletti, *Michelangelo's 'David'*, pp. 27–8
 and fig. 9.
 3 Paoletti, *Michelangelo's 'David'*, pp. 32–6, and related documents
 on pp. 286–9.
 4 The model is mentioned only in Vasari's second edition. See
 Coonin, *From Marble to Flesh*, pp. 60–61.
 5 The minutes of the meeting are transcribed and translated in
 Paoletti, *Michelangelo's 'David'*, pp. 313–22. All quoted passages are
 from this translation.
 6 As noted in the entry for 14 May 1504, in Luca Landucci, *A Florentine
 Diary from 1450 to 1516* (New York, 1969), pp. 213–14. For their
 identities, see Michael Hirst, 'Michelangelo in Florence: *David* in
 1503 and *Hercules* in 1506', *Burlington Magazine*, CXLII/1169 (2000),
 p. 490.
 7 Coonin, *From Marble to Flesh*, pp. 90–94; Paoletti, *Michelangelo's
 'David'*, pp. 52–3.
 8 Natalie Tomas, 'Did Women Have a Space?', in *Renaissance Florence:
 A Social History*, ed. Roger J. Crum and John T. Paoletti (New York,
 2006), p. 314.

9 The painting, *Festa degli omaggi in Piazza della Signoria*, by an anonymous Florentine artist, is in the Uffizi.

10 Paoletti, *Michelangelo's 'David'*, pp. 65–6, referring to comments by Pietro di Marco Parenti and Raffaello Borghini.

11 Hubertus Günther, 'Michelangelo's Works in the Eyes of His Contemporaries', in *The Experience of Art in Early Modern Europe*, ed. Thomas Frangenberg and Robert Williams (Aldershot, 2006), p. 60.

12 Paoletti explores these ambiguities in *Michelangelo's 'David'*, Chapter Two.

13 On the difficulties of using this painting as a true representation of the design, see Michael Cole, *Leonardo, Michelangelo, and the Art of the Figure* (New Haven, CT, and London, 2014), pp. 74–7.

14 Michael Cole reviews the debate about the planned location of the murals in *Leonardo, Michelangelo*, pp. 161–2 n. 52. Hatfield recently proposed that the two paintings would instead be set on opposite walls; Rab Hatfield, *Finding Leonardo: The Case for Recovering the 'Battle of Anghiari'* (Florence, 2007).

15 *Memoriale di molte statue e picture di Florentia*, in *Five Early Guides to Rome and Florence*, ed. Peter Murray (Farnborough, 1972), n.p.

16 The altarpiece has been identified with the painting *The Entombment*, now in the National Gallery in London; it was never completed. See Alexander Nagel, *Michelangelo and the Reform of Art* (Cambridge, 2000), pp. 102, 246 n. 68.

17 Harold R. Mancusi-Ungaro, *Michelangelo: The Bruges Madonna and the Piccolomini Altar* (New Haven, CT, and London, 1971).

18 Ibid., pp. 64–71.

19 The statues have been positioned properly only since 1964; see ibid., p. 24. The names of the extant saints are given in an anonymous letter from 1511.

20 Ibid., p. 69.

21 Michaël J. Amy, 'The Dating of Michelangelo's *St Matthew*', *Burlington Magazine*, CXLII/1169 (2000), pp. 493–6.

22 Michaël J. Amy, 'Imagining Michelangelo's *St Matthew* in Its Setting', in *Santa Maria del Fiore and Its Sculpture*, ed. Margaret Haines (Fiesole, 2001), pp. 161–2.

23 David Summers, 'Maniera and Movement: The *Figura Serpentinata*', *Art Quarterly*, XXXV/3 (1972), pp. 269–301.

24 The documents related to the two versions are discussed in
 Michael Hirst, *Michelangelo*, vol. I: *The Achievement of Fame, 1475–1534*
 (New Haven, CT, and London, 2011), pp. 115–16, 169–73; the
 contract of 1514 is quoted on p. 307 n. 22. For a concise overview
 of the scholarship on this sculpture, see Frank Zöllner, Christof
 Thoenes and Thomas Pöpper, *Michelangelo, 1475–1564: The Complete
 Works* (Cologne, 2007), pp. 425–6.

25 The observations in this paragraph draw on those made by
 William E. Wallace, 'Michelangelo's *Risen Christ*', *Sixteenth Century
 Journal*, XXVIII/4 (1997), pp. 1251–80.

26 See Wallace, 'Michelangelo's *Risen Christ*', pp. 1272, 1276–9; and
 Zöllner et al., *Michelangelo, 1475–1564*, p. 426.

27 See Mancusi-Ungaro, *Michelangelo*, pp. 42–3. For counter-
 arguments, see Joachim Poeschke, *Michelangelo and His World* (New
 York, 1996), pp. 77–9.

28 The document is transcribed and discussed in Lindsay R. E.
 Sheedy, 'Marble Made Flesh: Michelangelo's Bruges *Madonna* in the
 Service of Devotion', MA thesis, Washington University, St Louis,
 MO (May 2016), pp. 15–16.

29 Chiara Franceschini, 'The Nudes in Limbo: Michelangelo's *Doni
 Tondo* Reconsidered', *Journal of the Warburg and Courtauld Institutes*,
 LXXIII (2010), pp. 137–80. This article is an excellent review of
 scholarship on the *tondo*, including its later history. See also Andrée
 Hayum, 'Michelangelo's *Doni Tondo*: Holy Family and Family Myth',
 in *Michelangelo: Selected Scholarship in English*, ed. William E. Wallace
 (New York and London, 1995), vol. I, pp. 417–59. On Taddei and
 Pitti, see Hirst, *Achievement of Fame*, pp. 77, 291–2 nn 48–50; and
 R. W. Lightbown, 'Michelangelo's Great Tondo: Its Origins and
 Setting', in *Michelangelo: Selected Scholarship*, vol. I, pp. 460–69.

30 Roberta J. M. Olson, *The Florentine Tondo* (Oxford, 2000),
 pp. 22–31, 162–5, 220–26. See also Franceschini, 'Nudes in
 Limbo', pp. 148–50.

31 Rona Goffen, 'Mary's Motherhood According to Leonardo and
 Michelangelo', *Artibus et Historiae*, XX/40 (1999), pp. 50–51.

32 I refer here to the interpretations of Charles de Tolnay, *The Youth
 of Michelangelo* (Princeton, NJ, 1947) pp. 109–11; Colin Eisler, 'The
 Athlete of Virtue: The Iconography of Asceticism', in *Artibus opuscula*

XL: *Essays in Honor of Erwin Panofsky*, ed. M. Meiss (New York 1961), vol. I, pp. 93–4; and Franceschini, 'Nudes in Limbo', pp. 137–80.

33 See Franceschini, 'Nudes in Limbo', pp. 163–5, for the alternate possibility that it was made for Lorenzo di Pierfrancesco de' Medici, Michelangelo's patron, a few years later.

3 Visions of Majesty: Projects for Pope Julius II

1 Christoph Luitpold Frommel, 'St Peter's: The Early History', in *The Renaissance from Brunelleschi to Michelangelo: The Representation of Architecture*, ed. Henry A. Millon and Vittorio Magnago Lampugnani (New York, 1994), pp. 401–10. See now Christoph Luitpold Frommel et al., *Michelangelo, il marmo e la mente: la tomba di Giulio II e le sue statue* (Milan, 2014), which incorporates findings from the restoration of the tomb in 1998–2003.

2 Nicholas Temple, *Renovatio Urbis: Architecture, Urbanism, and Ceremony in the Rome of Julius II* (New York, 2011), pp. 168–70, 187.

3 A recent discussion of these drawings, including the drawing for a wall tomb (illus. 26) now thought to be the earliest idea for the tomb, is in Cammy Brothers, *Michelangelo, Drawing, and the Invention of Architecture* (New Haven, CT, and London, 2008), pp. 87–9, 102–5.

4 For example, Neoplatonic interpretations see the ape as a symbol of the lower, animal appetites against which the soul struggles.

5 Condivi calls attention to the literary source, which is found in *Purgatorio* XVII, ll. 100–108. For other interpretations, see Frank Zöllner, Christof Thoenes and Thomas Pöpper, *Michelangelo, 1475–1564: The Complete Works* (Cologne, 2007), p. 424.

6 See Janet Cox-Rearick, *The Collection of Francis I: Royal Treasures* (New York, 1996), p. 296.

7 Zöllner et al., *Michelangelo, 1475–1564*, p. 423.

8 Michael Hirst, *Michelangelo*, vol. I: *The Achievement of Fame, 1475–1534* (New Haven, CT, and London, 2011), pp. 258–9, 373 nn. 65–7.

9 See Claudia Lazzaro, *The Italian Renaissance Garden* (New Haven, CT, and London, 1990), pp. 201–6, 315 n. 50.

10 On the *Speculum*, see Rebecca Zorach et al., *The Virtual Tourist in Renaissance Rome: Printing and Collecting the Speculum Romanae Magnificentiae*, exh. cat., University of Chicago Library (Chicago, IL, 2008).

11 Gerd Blum, 'Vasari on the Jews: Christian Canon, Conversion, and
 the Moses of Michelangelo', *Art Bulletin*, XCV/4 (2013), pp. 558–77.
12 Rab Hatfield, *The Wealth of Michelangelo* (Rome, 2002), pp. 19–23.
13 John Shearman, 'The Chapel of Sixtus IV', in *The Sistine Chapel: The
 Art, the History, and the Restoration*, ed. Massimo Giacometti (New
 York, 1986), pp. 22–4.
14 See Niels Krogh Rasmussen, 'Maiestas Pontificia: A Liturgical
 Reading of Étienne Dupérac's Engraving of the Capella Sixtina
 from 1578', *Analecta Romana Instituti Danici*, XII (1983), pp. 142–4.
15 On the fifteenth-century frescoes, see Shearman, 'Chapel of
 Sixtus IV', pp. 38–87, and Ulrich Pfisterer, *La Cappella Sistina*, trans.
 Giovanna Targia (Rome, 2014), pp. 18–45 (the original ceiling is
 discussed on pp. 39–41).
16 Kathleen Weil-Garris Brandt, 'Michelangelo's Early Projects for
 the Sistine Ceiling: Their Practical and Artistic Consequences',
 in *Michelangelo: Selected Scholarship in English*, ed. William E. Wallace
 (New York and London, 1995), vol. II, p. 552.
17 Charles Robertson, 'Bramante, Michelangelo and the Sistine
 Ceiling', *Journal of the Warburg and Courtauld Institutes*, XLIX (1986),
 pp. 91–2.
18 Peter Gillgren, 'The Michelangelo Crescendo: Communicating
 the Sistine Chapel Ceiling', *Konsthistorisk tidskrift/Journal of Art History*,
 LXX/4 (2001), pp. 206–16.
19 John Shearman, 'The Functions of Michelangelo's Color', in *The
 Sistine Chapel: A Glorious Restoration* (New York, 1992), pp. 80–89.
20 Ibid., p. 82.
21 Sven Sandström, *Levels of Unreality: Studies in Structure and Construction in
 Italian Mural Painting during the Renaissance* (Stockholm, 1963), pp. 173–86.
22 Rab Hatfield, 'Trust in God: The Sources of Michelangelo's
 Frescoes on the Sistine Ceiling', in *Michelangelo: Selected Scholarship*,
 vol. II, pp. 463–542.
23 Peter Howard, 'Painters and the Visual Art of Preaching: The
 "Exemplum" of the Fifteenth-century Frescoes in the Sistine
 Chapel', *I Tatti Studies: Essays in the Renaissance*, XIII (2010), pp. 33–77.
24 Charles Seymour, *Michelangelo: The Sistine Chapel Ceiling* (London,
 1972), p. 94.
25 Lynette M. F. Bosch, 'Genesis, Holy Saturday, and the Sistine

Ceiling', *Sixteenth Century Journal*, XXX/3 (1999), pp. 643–52; the prophets are discussed on pp. 651–2.

26 Kim E. Butler, 'The Immaculate Body in the Sistine Ceiling', *Art History*, XXXII/2 (2009), pp. 251–83.

27 Ibid., pp. 260–62. For other arguments, see the exchange of letters between Marcia Hall and Leo Steinberg, in *Art Bulletin*, LXXV/2 (1993), pp. 340–44.

28 Yael Even, 'The Heroine as Hero in Michelangelo's Art', in *Michelangelo: Selected Scholarship*, vol. II, pp. 381–2.

29 John W. O'Malley, 'The Religious and Theological Culture of Michelangelo's Rome, 1508–1512', in Edgar Wind, *The Religious Symbolism of Michelangelo: The Sistine Ceiling*, ed. Elizabeth Sears (Oxford, 2000), pp. xlvii–xlviii.

30 See Pfisterer, *Cappella Sistina*, p. 77, for related ideas applied to Julius II.

31 Edgar Wind, 'Michelangelo's Prophets and Sibyls', in Wind, *Religious Symbolism*, pp. 124–48.

32 Michael Hirst, *Michelangelo*, vol. I, p. 98; and Lisa Pon, 'A Note on the Ancestors of Christ in the Sistine Chapel', *Journal of the Warburg and Courtauld Institutes*, LXI (1998), p. 258.

33 See Pon, 'Note on the Ancestors', pp. 254–8.

34 The first two lunettes in the series were destroyed when the *Last Judgment* was painted, but their appearance is known through prints.

35 Barbara Wisch, 'Vested Interest: Redressing Jews on Michelangelo's Sistine Ceiling', *Artibus et Historiae*, XXIV/48 (2003), pp. 143–72.

36 On Haman, see Wind, *Religious Symbolism*, pp. 36–42. The image of Haman crucified, not hanged as described in the Bible, comes from Dante, *Purgatorio*, XVII, ll. 25–30, and was associated with Jewish celebrations of Haman's death.

37 Wisch, 'Vested Interest', pp. 152–3.

38 Sketches for the Ancestors of Christ are in the Oxford sketch book; see Paul Joannides, *Drawings of Michelangelo and His Followers in the Ashmolean Museum* (Oxford, 2007), pp. 92–117.

39 André Chastel, 'First Reactions to the Ceiling', in *The Sistine Chapel: The Art, the History, and the Restoration*, ed. Giacometti, pp. 154–8.

4 Power and Illusion: Commissions for the Medici

1 John Shearman, 'The Florentine Entrata of Leo X, 1515', *Journal of the Warburg and Courtauld Institutes*, XXXVIII (1975), p. 153 n. 60.

2 See David Hemsoll, 'The Laurentian Library and Michelangelo's Architectural Method', *Journal of the Warburg and Courtauld Institutes*, LXVI (2003), pp. 31–3.

3 Henry A. Millon, 'The Façade of San Lorenzo', in Henry A. Millon and Craig Hugh Smyth, *Michelangelo: Architect*, exh. cat., National Gallery of Art, Washington, DC (Milan, 1988), pp. 4–12; William E. Wallace, *Michelangelo at San Lorenzo* (Cambridge, 1994), pp. 9–15.

4 The visualization by studioDIM associati can be seen at www. studiodim.it/San_Lorenzo_Firenze.htm, accessed 20 June 2016.

5 Millon and Smyth, *Michelangelo: Architect*, pp. 27–31, 50–52, 63–5. See also Jennifer Finkel, 'Michelangelo at San Lorenzo: The Sculptural Program for the Façade', in *Renaissance Studies: A Festschrift in Honor of Professor Edward J. Olszewski*, ed. Jennifer H. Finkel et al. (New York, 2013), pp. 7–46.

6 Andrew Morrogh, 'The Medici Chapel: The Designs for the Central Tomb', *Studies in the History of Art*, XXXIII (1992), pp. 142–5.

7 William E. Wallace, 'Clement VII and Michelangelo: An Anatomy of Patronage I', in *The Pontificate of Clement VII*, ed. Kenneth Gou wens and Sheryl E. Reiss (Aldershot and Burlington, VT, 2005), pp. 189–98.

8 Caroline Elam, 'The Site and Early Building History of Michelangelo's New Sacristy', in *Michelangelo: Selected Scholarship in English*, ed. William E. Wallace (New York and London, 1995), vol. III, pp. 165–96.

9 The process is succinctly described by Estelle Lingo, 'The Evolution of Michelangelo's Magnifici Tomb: Program versus Process in the Iconography of the Medici Chapel', *Artibus et Historiae*, XVI/32 (1995), pp. 91–100.

10 See William E. Wallace, 'Two Presentation Drawings for Michelangelo's Medici Chapel', *Master Drawings*, XXV/3 (1987), pp. 242–60.

11 Written sources indicate that the decorations still existed in the seventeenth century; see Raphael Rosenberg, *Beschreibungen und Nachzeichnungen der Skulpturen Michelangelos* (Berlin, 2000), p. 144.

12 Zygmunt Waźbiński, *L'Accademia medicea del disegno a Firenze nel Cinquecento. Idea e istituzione* (Florence, 1987), vol. I, pp. 83–4, 103–4.

13 Ibid., pp. 80–84.

14 L. D. Ettlinger, 'The Liturgical Function of Michelangelo's Medici Chapel', in *Michelangelo: Selected Scholarship*, vol. III, pp. 147–64.

15 Peter Gillgren, 'The Soundscape of the Medici Chapel', unpublished paper delivered at the Renaissance Society of America conference in Berlin, 2015. I thank Professor Gillgren for sharing the text of his paper with me. On the blindness of the figures, see Creighton E. Gilbert, 'Texts and Contexts of the Medici Chapel', in *Michelangelo: Selected Scholarship*, vol. III, pp. 115–16.

16 I refer here to interpretations in Ettlinger, 'Liturgical Function', Gilbert, 'Texts and Contexts', and James Beck, *Michelangelo: The Medici Chapel* (New York, 1994), p. 21.

17 Responses of early visitors are in Rosenberg, *Beschreibungen*, pp. 127–39, 146–50.

18 John Shearman, *Only Connect: Art and the Spectator in the Italian Renaissance* (Washington, DC, 1992), pp. 47–8; Gilbert, 'Texts and Contexts', pp. 110–13.

19 Anton Francesco Doni, *I marmi* (Venice, 1552), pp. 23–4. For a discussion of this theme in Renaissance art, see Paul Barolsky, 'As in Ovid, so in Renaissance Art', *Renaissance Quarterly*, LI/2 (1998), pp. 455–6.

20 Leonard Barkan, *Michelangelo: A Life on Paper* (Princeton, NJ, 2011), pp. 32–3.

21 Raphael Rosenberg, 'The Reproduction and Publication of Michelangelo's Sacristy: Drawings and Prints by Franco, Salviati, Naldini and Cort', in *Reactions to the Master*, ed. Francis Ames-Lewis and Paul Joannides (Aldershot and Burlington, VT, 2003), pp. 114–36.

22 Paris, Louvre, Inv. 4554.

23 Waźbiński, *L'Accademia medicea*, pp. 86, 88–90. Vasari's and Borghini's letters to Cosimo were sent on 1 and 3 February 1563, respectively.

24 Francesco Bocchi, *The Beauties of the City of Florence: A Guidebook of 1591*,

ed. and trans. Thomas Frangenberg and Robert Williams (London and Turnhout, 2006), pp. 240–54.

25 Caroline Elam, '"Tuscan Dispositions": Michelangelo's Florentine Architectural Vocabulary and its Reception', *Renaissance Studies*, XIX/I (2005), pp. 74–82.

26 These were carved by Francesco da Sangallo. See Wallace, *Michelangelo at San Lorenzo*, pp. 124–7.

27 Charles de Tolnay, *The Medici Chapel* (Princeton, NJ, 1948), p. 32, and figs 208 and 330.

28 John Paoletti, 'Michelangelo's Masks', *Art Bulletin*, LXXIV/3 (1992), p. 432.

29 Portraits exist of both *Capitani* but they do not bear much resemblance to Michelangelo's sculptures. Michelangelo's comments were recorded by Niccolò Martelli in 1544; see Michael Hirst, *Michelangelo*, vol. I: *The Achievement of Fame, 1475–1534* (New Haven, CT, and London, 2011), pp. 199, 343 n. 147.

30 James G. Cooper, 'Michelangelo's Laurentian Library: Drawings and Design Process', *Architectural History*, LIV (2011), pp. 71–4.

31 Rudolf Wittkower, 'Michelangelo's Biblioteca Laurenziana', in *Idea and Image: Studies in the Italian Renaissance* (London, 1978), p. 28.

32 See David Summers, 'Michelangelo on Architecture', *Art Bulletin*, LIV/2 (1972), pp. 146–57.

33 Ralph Lieberman, 'Michelangelo's Design for the Biblioteca Laurenziana', in *Michelangelo: Selected Scholarship*, vol. III, pp. 373–80.

34 Cooper, 'Michelangelo's Laurentian Library', pp. 80–82.

5 Painting the Visionary Experience: Frescoes for Pope Paul III

1 Marcia B. Hall, 'Michelangelo's *Last Judgment*: Resurrection of the Body and Predestination', *Art Bulletin*, LVIII/I (1976), pp. 85–92; and ibid., 'Michelangelo's *Last Judgment* as Resurrection of the Body: The Hidden Clue', in *Michelangelo's 'Last Judgment'*, ed. Marcia B. Hall (Cambridge, 2005), pp. 95–112.

2 John Shearman, 'Una nota sul progetto di Giulio II', *Michelangelo. La Cappella Sistina, atti del convegno internazionale di studi, Roma, marzo 1990* (Novara, 1994), vol. III, pp. 32–7.

3 Bernadine Barnes, 'A Lost *Modello* for Michelangelo's *Last Judgment*', *Master Drawings*, XXVI/3 (1988), pp. 239–48.

4 Arnold Nesselrath, 'The Painters of Lorenzo the Magnificent in the Chapel of Pope Sixtus IV in Rome', in *The Fifteenth Century Frescoes in the Sistine Chapel: Recent Restorations of the Vatican Museum* (Vatican City, 2003), p. 45 and fig. 4.

5 Anne Leader, 'Michelangelo's *Last Judgment*: The Culmination of Papal Propaganda in the Sistine Chapel', *Studies in Iconography*, XXVII (2006), pp. 103–56.

6 Fabrizio Mancinelli, in Loren W. Partridge et al., *Michelangelo: The Last Judgment. A Glorious Restoration* (New York, 1997), p. 166. On the pigments used here, see Hall, ed., *Michelangelo's 'Last Judgment'*, pp. 12 and 41.

7 Partridge, *Glorious Restoration*, p. 144.

8 Valerie Shrimplin-Evangelidis, 'Sun-Symbolism and Cosmology in Michelangelo's *Last Judgment*', *Sixteenth Century Journal*, XXI/4 (1990), pp. 607–44.

9 Allori created two versions. The first, dated 1559 (Casa Buonarroti), depicts only Christ and two trumpeting angels. The other, in SS Annunziata, Florence, dated *c.* 1560, includes more angels and selected figures from among the rising blessed and the damned.

10 The interpretations alluded to here are from Leo Steinberg, 'A Corner of the *Last Judgment*', *Daedalus*, CIX/2 (1980), pp. 207–73; Hall, 'Michelangelo's *Last Judgment* as Resurrection of the Body', p. 103; and Bernadine Barnes, *Michelangelo's 'Last Judgment': The Renaissance Response* (Berkeley, CA, 1998), Chapter Four.

11 Leo Steinberg, 'The *Last Judgment* as Merciful Heresy', *Art in America*, LXIII/6 (1975), pp. 49–63. This line of interpretation has most recently been taken up by Giovanni Careri in *La Torpeur des ancêtres. Juifs et chrétiens dans la chapelle Sixtine* (Paris, 2013), pp. 38–40.

12 See Partridge et al., *A Glorious Restoration*, pp. 58–9, 140, for other possible references to sacraments and good works.

13 See also Barnes, *Michelangelo's 'Last Judgment'*, pp. 56–7; Hall, 'Michelangelo's *Last Judgment* as Resurrection of the Body', p. 106.

14 Steinberg, 'Corner of the *Last Judgment*', pp. 214–16.

15 I review some of these arguments in 'Skin, Bones, and Dust:

Self-portraits in Michelangelo's *Last Judgment*', *Sixteenth Century Journal*, XXXV/4 (2004), pp. 969–86.

16 John Turner, 'Michelangelo's Blacks in *The Last Judgment*', *Source*, XXXIII/1 (2013), pp. 8–15.

17 Michael Bury, 'Niccolò Della Casa's *Last Judgement* Dissected', *Print Quarterly*, XXVIII/1 (2010), pp. 3–10.

18 Melinda Schlitt, 'Painting, Criticism, and Michelangelo's *Last Judgment* in the Age of the Counter-Reformation', in *Michelangelo's 'Last Judgment'*, ed. Hall, p. 114.

19 Margaret Kuntz, 'Designed for Ceremony: The Cappella Paolina at the Vatican Palace', *Journal of the Society of Architectural Historians*, LXXII/2 (2003), pp. 232–3, 241, 252 n. 56.

20 Margaret A. Kuntz, 'A Ceremonial Ensemble: Michelangelo *Last Judgment* and the Cappella Paolina Frescoes', in Hall, ed., *Michelangelo's 'Last Judgment'*, p. 154.

21 For discussion of the restoration and excellent photographs, see Maurizio De Luca et al., eds, *The Pauline Chapel* (Vatican City, 2013).

22 Leo Steinberg, *Michelangelo's Last Paintings* (London, 1975), pp. 16, 57 n. 41, with further references.

23 Kuntz, 'Designed for Ceremony', p. 235.

24 William E. Wallace, 'Narrative and Religious Expression in Michelangelo's Pauline Chapel', *Artibus et Historiae*, X/19 (1989), pp. 107–21.

25 Steinberg, *Michelangelo's Last Paintings*, pp. 30–31.

26 Arnold Nesslerath, 'A Masterpiece Blackened by Thousands of Candles', in *The Pauline Chapel*, ed. De Luca et al., p. 27; the photographs on pp. 106 and 107 show the detail before and after restoration.

27 The story is not in the Bible but is referred to by Eusebius and other early writers and retold with much elaboration in *The Golden Legend*.

28 Philipp Fehl, 'Michelangelo's *Crucifixion of St Peter*: Notes on the Identification of the Locale of the Action', *Art Bulletin*, LIII/3 (1971), pp. 327–43.

29 Fehl, 'Michelangelo's *Crucifixion of St Peter*', p. 330. On changes made to the Tempietto to accommodate later pilgrims, see Jack Freiberg, *Bramante's Tempietto, the Roman Renaissance, and the Spanish Crown* (New York, 2014), pp. 183–7.

30 Fehl, 'Michelangelo's *Crucifixion of St Peter*', p. 340.

31 Michelangelo's portrait has been seen in the face of St Paul and in
 a man at the upper left in *The Crucifixion of Peter* who seems to listen
 to the pointing commander. Paul III's portrait has been seen in the
 faces of St Paul as well as St Peter. See, for example, Kuntz, 'A
 Ceremonial Ensemble', p. 168, 180 n. 79. Paul Barolsky explores
 how Michelangelo identified with St Paul in *Michelangelo's Nose*
 (University Park, PA, 1990), pp. 38–41.

32 In Paula Barocchi, ed., *Trattati d'arte del cinquecento* (Bari, 1961),
 vol. II, p. 95. See my further discussion of the passage in Barnes,
 Michelangelo's 'Last Judgment', pp. 92–3.

33 Anne Dillon, *Michelangelo and the English Martyrs* (Farnham and
 Burlington, VT, 2012), pp. 88–9.

6 Love, Desire and Politics: Works for Private Viewers

1 Christoph Luitpold Frommel, *Michelangelo und Tommaso dei Cavalieri*
 (Amsterdam, 1979), pp. 76–90.

2 See Lothar Sickel's summary of issues surrounding Cavalieri's
 collection in Frank Zöllner, Christof Thoenes and Thomas
 Pöpper, *Michelangelo, 1475–1564: The Complete Works* (Cologne, 2007),
 p. 750.

3 Michael Hirst, *Michelangelo*, vol. I: *The Achievement of Fame, 1475–1534*
 (New Haven, CT, and London, 2011), p. 262.

4 *Ganymede* and *Tityus* are not named in the letter of 1 January
 1533, but they are both mentioned as if a pair in the letter of 6
 September 1533.

5 Translation from E. H. Ramsden, *The Letters of Michelangelo*
 (Stanford, CA, 1963), vol. I, p. 183. On the complex ways words
 and images interact in these and the Phaeton drawings, see
 Leonard Barkan, *Michelangelo: A Life on Paper* (Princeton, NJ, and
 Oxford, 2011), pp. 226–34.

6 James M. Saslow, *The Poetry of Michelangelo* (New Haven, CT, and
 London, 1991), pp. 48–52.

7 Maria Ruvoldt, 'Michelangelo's Open Secrets', in *Visual Cultures of
 Secrecy in Early Modern Europe*, ed. Timothy McCall et al. (Kirksville,
 MO, 2013), pp. 114–17.

8 William E. Wallace, *Michelangelo: The Artist, the Man and His Times* (Cambridge, 2010), p. 179.

9 See Phyllis Pray Bober and Ruth Rubenstein, *Renaissance Artists and Antique Sculpture* (London and Oxford, 1986), p. 70, no. 27.

10 The precise sequence is much debated; however, the Windsor Castle drawing might be considered definitive, since it is the one that served as the model for engravings.

11 Erwin Panofsky, *Studies in Iconology* (New York, 1972), p. 219.

12 For recent interpretations, see Mary D. Garrard, 'Michelangelo in Love: Decoding the *Children's Bacchanal*', *Art Bulletin*, XCVI/1 (2014), pp. 24–49.

13 See Maria Ruvoldt, 'Michelangelo's Dream', *Art Bulletin*, LXXXV/1 (2003), pp. 86–113.

14 See Judith Anne Testa, 'The Iconography of *The Archers*', *Studies in Iconography*, V (1979), pp. 53–4.

15 Ruvoldt, 'Michelangelo's Open Secrets', pp. 117–19.

16 Bernadine Barnes, *Michelangelo in Print* (Farnham and Burlington, VT, 2010), pp. 55–7.

17 On the Spirituali, see Abigail Brundin, *Vittoria Colonna and the Spiritual Poetics of the Italian Reformation* (Aldershot, 2008), pp. 42–9.

18 Alexander Nagel, 'Gifts for Michelangelo and Vittoria Colonna', *Art Bulletin*, LXXXIX/4 (1997), pp. 649–54.

19 An English translation is in Susan Haskins, ed. and trans., *Who Is Mary? Three Early Modern Women on the Idea of the Virgin Mary* (Chicago, IL, 2008), pp. 53–65.

20 Marjorie Och, 'Vittoria Colonna and a Commission for a Mary Magdalene by Titian', in *Beyond Isabella: Secular Women Patrons of Art in Renaissance Italy*, ed. Sheryl Reiss and David G. Wilkins (Kirksville, MO, 2001), pp. 193–224.

21 See Una Roman d'Elia, 'Drawing Christ's Blood: Michelangelo, Vittoria Colonna, and the Aesthetics of Reform', *Renaissance Quarterly*, LIX/1 (2006), pp. 90–129.

22 Bernadine Barnes, 'The Understanding of a Woman: Vittoria Colonna and Michelangelo's *Christ and the Samaritan Woman*', *Renaissance Studies*, XXVII/5 (2013), pp. 633–53. On the *Noli me tangere* design and its copies, see Lisa M. Rafanelli, 'Michelangelo's *Noli Me Tangere* for Vittoria Colonna, and the Changing Status of Women

in Renaissance Italy', in *Mary Magdalene: Iconographic Studies from the Middle Ages to the Baroque*, ed. Michelle Erhardt and Amy Morris (Leiden, 2012), pp. 223–48, and Christian K. Kleinbub, 'To Sow the Heart: Touch, Spiritual Anatomy, and Image Theory in Michelangelo's *Noli Me Tangere*', *Renaissance Quarterly*, LXVI/1 (2013), pp. 81–129.

23 Kleinbub, 'To Sow the Heart', pp. 90–91, 97–9.

24 Beatrizet's engraving was republished or copied at least a dozen times in the sixteenth century; see Barnes, *Michelangelo in Print*, pp. 80–81.

25 William E. Wallace, 'Michelangelo's *Leda*: The Diplomatic Context', *Renaissance Studies*, XV/4 (2001), pp. 473–99.

26 For a digital reconstruction created by the Prado Museum, see www.webexhibits.org/prado/camerino.html, accessed 4 July 2016.

27 On Mini and the painting's later history in France, see Janet Cox-Rearick, *The Collection of Francis I: Royal Treasures* (New York, 1996), pp. 237–41.

28 Rebekah Compton, 'Omnia Vincit Amor: The Sovereignty of Love in Tuscan Poetry and Michelangelo's *Venus and Cupid*', *Mediaevalia*, XXXII (2012), pp. 229–60. See also Julia Branna Perlman, 'Venus, Myrrha, Cupid and/as Adonis', in *Metamorphosis: The Changing Face of Ovid in Medieval and Early Modern Europe*, ed. Alison Keith and Stephen Rupp (Toronto, 2007), pp. 223–38.

29 See Richard Aste in 'Bartolomeo Bettini and His Florentine "Chamber" Decoration', in *Venere e Amore/Venus and Love*, ed. Franca Falletti and Jonathan Katz Nelson (Florence, 2002), pp. 10–17.

30 Charles de Tolnay, *Medici Chapel* (Princeton, NJ, 1948), p. 108.

31 Benedetto Varchi, *Due lezioni* (Florence, 1549), p. 104.

32 D. J. Gordon, 'Giannotti, Michelangelo and the Cult of Brutus', in *Michelangelo: Selected Scholarship in English*, ed. William E. Wallace (New York and London, 1995), vol. IV, pp. 159–76.

33 Thomas Martin, 'Michelangelo's *Brutus* and the Classicizing Portrait Bust in Sixteenth-century Italy', in *Michelangelo: Selected Scholarship*, vol. IV, pp. 177–93. Martin argues that the *Brutus* was begun around 1548 after Lorenzino was executed. A Roman coin showing Brutus and the fibula are reproduced in Charles de Tolnay, *The Tomb of Julius II* (Princeton, NJ, 1954), figs 92 and 93.

34 The inscription is transcribed and discussed in Tolnay, *Tomb of Julius II*, p. 133.

35 On this statue, see Zöllner et al., *Michelangelo, 1475–1564*, p. 433; and Wallace, *Michelangelo: The Artist, the Man and his Times*, p. 159.

7 Vision and Space: Michelangelo's Roman Architecture

1 Christof Thoenes, in Frank Zöllner, Christof Thoenes and Thomas Pöpper, *Michelangelo, 1475–1564: The Complete Works* (Cologne, 2007), pp. 217, 666.

2 Dale Kent, *Cosimo de' Medici and the Florentine Renaissance* (New Haven, CT, and London, 2000), pp. 230–32.

3 The windows are traditionally dated to around 1517 but have recently been dated as closer to 1526, based on formal qualities and a drawing apparently used to direct stonecutters on the project; see Vitale Zanchettin, 'A New Drawing and a New Date for Michelangelo's "Finestre Inginocchiate" at Palazzo Medici, Florence', *Burlington Magazine*, XLIII/1296 (2011), pp. 156–62.

4 On public attitudes towards the Medici in this period, see John M. Najemy, *A History of Florence, 1200–1575* (Malden, MA, 2006), pp. 427–45.

5 See Zöllner et al., *Michelangelo, 1475–1564*, pp. 706–22.

6 On the history of the palace, see Christoph Luitpold Frommel, *The Architecture of the Italian Renaissance*, trans. Peter Spring (London, 2007), pp. 176–8, and Giulio Carlo Argan and Bruno Contardi, *Michelangelo: Architect*, trans. Marion L. Grayson (New York, 1993), pp. 264–71.

7 Quoted and translated in Alina Payne, *The Architectural Treatise in the Italian Renaissance* (Cambridge, 1999), pp. 16, 243 n. 3.

8 Caroline Elam, '"Tuscan Dispositions": Michelangelo's Florentine Architectural Vocabulary and its Reception', *Renaissance Studies*, XIX/1 (2005), pp. 46–82.

9 Cammy Brothers, *Michelangelo, Drawing, and the Invention of Architecture* (New Haven, CT, and London, 2008), pp. 50–64.

10 Bernadine Barnes, *Michelangelo in Print* (Farnham and Burlington, VT, 2010), pp. 124–5; the full inscription is transcribed and translated on p. 141 n. 14.

11 On the various phases of design and construction of St Peter's, see Frommel, *Architecture of the Italian Renaissance*, pp. 48, 105–8, 124–5, 139–42, 178–81.

12 James S. Ackerman, *The Architecture of Michelangelo*, 2nd edn (Chicago, IL, 1986), pp. 317–18; Argan and Contardi, *Michelangelo: Architect*, p. 324.

13 Christof Thoenes, 'St Peter's as Ruins: On Some *Vedute* by Heemskerck', in *Sixteenth-century Italian Art*, ed. Michael Cole (Malden, MA, and Oxford, 2006), pp. 25–39.

14 Dupérac's prints also include many elements changed by the architects who took over after Michelangelo's death; for a summary see Barnes, *Michelangelo in Print*, p. 136.

15 Rudolf Wittkower, *Architectural Principles in the Age of Humanism* (New York and London, 1971), pp. 7–10.

16 Leon Battista Alberti, *On the Art of Building in Ten Books*, trans. Joseph Rykwert, Neil Leach and Robert Taverner (Cambridge, MA, and London, 1988), pp. 126 and 195.

17 Henry A. Millon and Craig Hugh Smyth, 'Michelangelo and St Peter's: Observations on the Interior of the Apses, a Model of the Apse Vault, and Related Drawings', in *Michelangelo: Selected Scholarship in English,* ed. William E. Wallace (New York and London, 1995), vol. IV, pp. 291–9.

18 The classic overview of the project is in Ackerman, *Architecture of Michelangelo*, pp. 136–70, although some of Ackerman's points have been contested. For updated bibliography, see Argan and Contardi *Michelangelo: Architect*, pp. 252–63. Charles Burroughs ('Michelangelo at the Campidoglio: Artistic Identity, Patronage, and Manufacture', *Artibus et Historiae*, XIV/28 (1993), pp. 85–111) argues that the Conservators' Palace was designed in the 1530s, while Andrew Morrogh proposes that it was designed in the 1560s, in 'The Palace of the Roman People: Michelangelo at the Palazzo dei Conservatori', *Römisches Jahrbuch der Bibliotheca Hertziana,* XXIX (1994), pp. 129–86.

19 Ackerman, *Architecture of Michelangelo*, pp. 37–52.

20 Irving Lavin, 'The Campidoglio and Sixteenth-century Stage Design', in *Michelangelo: Selected Scholarship*, vol. IV, pp. 244–50; also Burroughs, 'Michelangelo at the Campidoglio', pp. 96, 106 n.63.

21 Burroughs, 'Michelangelo at the Campidoglio', pp. 91–7; and
 Charles Burroughs, 'The Demotic Campidoglio', *Res*, XLIX/50
 (2006), pp. 171–4.

22 Laurie Nussdorfer, *Civic Politics in the Rome of Urban VIII* (Princeton,
 NJ, 1992), pp. 60–61, 69–70.

23 Morrogh, 'Palace of the Roman People', pp. 161–2; Nussdorfer,
 Civic Politics, pp. 71–3.

24 The most comprehensive list is in Argan and Contardi,
 Michelangelo: Architect, pp. 336–57. Updated bibliography on San
 Giovanni dei Fiorentini, the Sforza Chapel and Santa Maria degli
 Angeli can be found in Zöllner et al., *Michelangelo, 1475–1564*,
 pp. 485–8.

25 Elisabeth B. MacDougall, 'Michelangelo and the Porta Pia', in
 Michelangelo: Selected Scholarship, vol. IV, pp. 261–72.

26 David R. Coffin, *The Villa in the Life of Renaissance Rome* (Princeton,
 NJ, 1979), p. 213.

27 See Zöllner et al., *Michelangelo, 1475–1564*, p. 489, for a summary
 of various interpretations, as well as a reproduction of a print
 published by Bartolomeo Faleti with a crowning element that may
 be closer to Michelangelo's design. The third level seen today was
 built in the nineteenth century.

8 Last Works

1 The most thorough study of the sculpture is Jack Wasserman,
 Michelangelo's Florence 'Pietà' (Princeton, NJ, 2003).

2 The letter is dated 18 March 1564 and was written to inform
 Lionardo Buonarroti of his uncle's desires for his own tomb. On
 the tradition of Nicodemus as a sculptor, see Corine Schleif,
 'Nicodemus and Sculpture: Self-reflexivity in Works by Adam
 Kraft and Tilman Riemenschneider', *Art Bulletin*, LXV/4 (1993),
 pp. 599–626. See also John T. Paoletti, 'The Rondanini *Pietà*:
 Ambiguity Maintained through the Palimpsest', *Artibus et Historiae*,
 XXI/42 (2000), pp. 60–63. Michelangelo's identification with
 those who hid ideas related to Catholic reform is explored by
 Valerie Shrimplin-Evangelidis, 'Michelangelo and Nicodemism:
 The Florentine *Pietà*', *Art Bulletin*, LXXI/1 (1989), pp. 58–66.

3 Alexander Nagel, *Michelangelo and the Reform of Art* (Cambridge, 2000), pp. 27–33 and 143–53.

4 See Wasserman, *Florence 'Pietà'*, plate 10, where the virtual model is seen as if the viewer's eye level were near the base of the sculpture. Plate 29 shows the group frontally from a higher point of view.

5 Paoletti, 'Rondanini *Pietà*', p. 65.

6 William E. Wallace, 'Michelangelo, Tiberio Calcagni, and the Florentine *Pietà*', *Artibus et Historiae*, XXI/42 (2000), pp. 84–7.

7 Leo Steinberg, 'Michelangelo's Florentine *Pietà*: The Missing Leg', *Art Bulletin*, L/4 (1968), pp. 343–53. Wasserman proposed instead that Michelangelo deliberately disassembled the sculpture (*Florence 'Pietà'*, pp. 67–73).

8 Wallace, 'Calcagni, and the Florentine *Pietà*', pp. 91–3.

9 Paoletti, 'Rondanini *Pietà*', pp. 53–80.

10 Wasserman, *Florence 'Pietà'*, pp. 102–3.

11 Paoletti transcribes the relevant passage of the document in 'Rondanini *Pietà*', p. 74 n. 4.

SELECT BIBLIOGRAPHY

Ackerman, James S., *The Architecture of Michelangelo*, 2nd edn (Chicago, IL, 1986)

Amy, Michaël J., 'Imagining Michelangelo's *St Matthew* in Its Setting', in *Santa Maria Del Fiore and its Sculpture*, ed. Margaret Haines (Fiesole, 2001), pp. 149–66

Argan, Giulio Carlo, and Bruno Contardi, *Michelangelo Architect*, trans. Marion L. Grayson (New York, 1993)

Aste, Richard, 'Bartolomeo Bettini and His Florentine "Chamber" Decoration', in *Venere e Amore/Venus and Love*, ed. Franca Falletti and Jonathan Katz Nelson (Florence, 2002), pp. 3–25

Barkan, Leonard, *Michelangelo: A Life on Paper* (Princeton, NJ, and Oxford, 2011)

Barnes, Bernadine, "The Understanding of a Woman: Vittoria Colonna and Michelangelo's *Christ and the Samaritan Woman*', *Renaissance Studies*, XXVII/5 (2013), pp. 633–53

—, *Michelangelo in Print* (Farnham and Burlington, VT, 2010)

—, *Michelangelo's 'Last Judgment': The Renaissance Response* (Berkeley, CA, 1998)

Brothers, Cammy, *Michelangelo, Drawing, and the Invention of Architecture* (New Haven, CT, and London, 2008)

Burroughs, Charles, 'The Demotic Campidoglio', *Res*, XLIX/50 (2006), pp. 171–87

—, 'Michelangelo at the Campidoglio: Artistic Identity, Patronage, and Manufacture', *Artibus et Historiae*, XIV/28 (1993), pp. 85–111

Butler, Kim E., 'The Immaculate Body in the Sistine Ceiling', *Art History*, XXXII/2 (2009), pp. 251–83

Cole, Michael, *Leonardo, Michelangelo, and the Art of the Figure* (New Haven, CT, and London, 2014)

Compton, Rebekah, 'Omnia Vincit Amor: The Sovereignty of Love in Tuscan Poetry and Michelangelo's *Venus and Cupid*', *Mediaevalia*, XXXII (2012), pp. 229–60

Coonin, Arnold Victor, *From Marble to Flesh: The Biography of Michelangelo's 'David'* ([Florence], 2014)

Cox-Rearick, Janet, *The Collection of Francis I: Royal Treasures* (New York, 1996)

Crocifisso di Santo Spirito/The Crucifix of Santo Spirito (Florence, 2000)

De Luca, Maurizio, et al., eds, *Pauline Chapel* (Vatican City, 2013)

Elam, Caroline, '"Tuscan Dispositions": Michelangelo's Florentine Architectural Vocabulary and Its Reception', *Renaissance Studies*, XIX/1 (2005), pp. 74–82

Fehl, Philipp, 'Michelangelo's *Crucifixion of St Peter*: Notes on the Identification of the Locale of the Action', *Art Bulletin*, LIII/3 (1971), pp. 327–43

Franceschini, Chiara, 'The Nudes in Limbo: Michelangelo's *Doni Tondo* Reconsidered', *Journal of the Warburg and Courtauld Institutes*, LXXIII (2010), pp. 137–80

Frommel, Christoph Luitpold, 'St Peter's: The Early History', in *The Renaissance from Brunelleschi to Michelangelo: The Representation of Architecture*, ed. Henry A. Millon and Vittorio Magnago Lampugnani (New York, 1994), pp. 399–423

Frommel, Christoph Luitpold, *The Architecture of the Italian Renaissance*, trans. Peter Spring (London, 2007)

Günther, Hubertus, 'Michelangelo's Works in the Eyes of his Contemporaries', in *The Beholder: The Experience of Art in Early Modern Europe*, ed. Thomas Frangenberg and Robert Williams (Aldershot, 2006), pp. 53–85

Hall, Marcia B., 'Michelangelo's *Last Judgment*: Resurrection of the Body and Predestination', *Art Bulletin*, LVIII/1 (1976), pp. 85–92

Hirst, Michael, 'Michelangelo in Florence: *David* in 1503 and *Hercules* in 1506', *Burlington Magazine*, CXLII/1169 (2000), pp. 487–92

—, *Michelangelo*, vol. I: *The Achievement of Fame, 1475–1534* (New Haven, CT, and London, 2011)

Kleinbub, Christian K., 'To Sow the Heart: Touch, Spiritual Anatomy, and Image Theory in Michelangelo's *Noli Me Tangere*', *Renaissance Quarterly*, LXVI/1 (2013), pp. 81–129

Kuntz, Margaret, 'Designed for Ceremony: The Cappella Paolina at the Vatican Palace', *Journal of the Society of Architectural Historians*, LXXII/2 (2003), pp. 228–55

Leader, Anne, 'Michelangelo's *Last Judgment*: The Culmination of Papal Propaganda in the Sistine Chapel', *Studies in Iconography*, XXVII (2006), pp. 103–56

Lingo, Estelle, 'The Evolution of Michelangelo's Magnifici Tomb: Program versus Process in the Iconography of the Medici Chapel', *Artibus et Historiae*, XVI/32 (1995), pp. 91–100

Mancusi-Ungaro, Harold R., *Michelangelo: The Bruges Madonna and the Piccolomini Altar* (New Haven, CT, and London, 1971)

Michelangelo: Selected Scholarship in English, ed. William E. Wallace, 5 vols (New York and London, 1995)

Millon, Henry A., and Craig Hugh Smyth, *Michelangelo Architect*, exh. cat., National Gallery of Art, Washington, DC (Milan, 1988)

Morrogh, Andrew, 'The Palace of the Roman People: Michelangelo at the Palazzo dei Conservatori', *Römisches Jahrbuch der Bibliotheca Hertziana*, XXIX (1994), pp. 129–86

Nagel, Alexander, 'Gifts for Michelangelo and Vittoria Colonna', *Art Bulletin*, LXXXIX/4 (1997), pp. 647–68

—, *Michelangelo and the Reform of Art* (Cambridge, 2000)

Paoletti, John, *Michelangelo's 'David': Florentine History and Civic Identity* (New York, 2015)

Pfisterer, Ulrich, *La Cappella Sistina*, trans. Giovanna Targia (Rome, 2014)

Rafanelli, Lisa M., 'Michelangelo's *Noli Me Tangere* for Vittoria Colonna, and the Changing Status of Women in Renaissance Italy', in *Mary Magdalene, Iconographic Studies from the Middle Ages to the Baroque*, ed. Michelle Erhardt and Amy Morris (Leiden, 2012), pp. 223–48

Ruvoldt, Maria, 'Michelangelo's Open Secrets', in *Visual Cultures of Secrecy in Early Modern Europe* (Kirksville, MO, 2013), pp. 105–25

Shearman, John, 'The Chapel of Sixtus IV', in *The Sistine Chapel: The Art, the History, and the Restoration*, ed. Massimo Giacometti (New York, 1986), pp. 22–87

—, 'The Functions of Michelangelo's Color', in *The Sistine Chapel: A Glorious Restoration*, ed. Pierluigi de Vecchi (New York, 1992), pp. 80–89

Steinberg, Leo, *Michelangelo's Last Paintings* (London, 1975)

—, 'The *Last Judgment* as Merciful Heresy', *Art in America*, LXIII/6 (1975), pp. 49–63

Summers, David, 'Maniera and Movement: The *Figura Serpentinata*', *Art Quarterly*, XXXV/3 (1972), pp. 269–301

—, *Michelangelo and the Language of Art* (Princeton, NJ, 1981)

Tolnay, Charles de, *Michelangelo*, 5 vols (Princeton, NJ, 1945–60)

Wallace, William E., 'Michelangelo's *Risen Christ*', *Sixteenth Century Journal*, XXVIII/4 (1997), pp. 1251–80

—, 'Narrative and Religious Expression in Michelangelo's Pauline Chapel', *Artibus et Historiae*, X/19 (1989), pp. 107–21

—, *Michelangelo at San Lorenzo* (Cambridge, 1994)

Wasserman, Jack, *Michelangelo's Florence 'Pietà'* (Princeton, NJ, 2003)

Weil-Garris Brandt, Kathleen, et al., eds, *Giovinezza di Michelangelo*, exh. cat., Palazzo Vecchio, Florence (Florence and Milan, 1999)

Wisch, Barbara, 'Vested Interest: Redressing Jews on Michelangelo's Sistine Ceiling', *Artibus et Historiae*, XXIV/48 (2003), pp. 143–72

Zöllner, Frank, Christof Thoenes and Thomas Pöpper, *Michelangelo, 1475–1564: The Complete Works* (Cologne, 2007)

ACKNOWLEDGEMENTS

My thanks to Barbara Wisch, William Wallace and Tiffany Hunt for their expertise and their willingness to read chapters. Many other scholars and colleagues answered specific questions, among them Marcia Hall, Francesca Persegati Martini, Lindsay Sheedy, Robert Ulery, Laura Veneskey and Chanchal Dadlani, while David Lubin served as my official 'intelligent non-specialist reader'. The conference on the Sistine Chapel organized by Ulrich Pfisterer and Arnold Nesselrath in 2015 gave me the opportunity to ask questions I'd had for years and alerted me to much recent research by the participants and others (their works are cited in references). Special thanks to David Summers, whose ideas are more present here than the references might indicate. I'm very grateful to Michael Leaman of Reaktion Books who encouraged me to take on this project, while Becca Wright assisted with many details and Martha Jay, as editor, brought the text to a more polished form. My husband, Steven Barnes, accompanied me to many site visits and asked innumerable questions, some of which I hope I have answered here.

PHOTO ACKNOWLEDGEMENTS

The author and publishers wish to express their thanks to the below sources of illustrative material and/or permission to reproduce it. Some locations of works are given below rather than in the captions.

© Albertina, Vienna: 2; © Alinari / Art Resource, NY: 11 (Museo Nazionale del Bargello, Florence), 33, 34; photo Steven Barnes: 32, 66; © Nicolo Orsi Battaglini / Art Resource, NY: 22 (Uffizi, Florence); © Biblioteca Medicea-Laurenziana, Florence, Italy / Bridgeman Images: 38; © photo Bibliotheca Hertziana, Max-Planck-Institut für Kunstgeschichte, Rome: 19; British Museum, London, © The Trustees of the British Museum: 49, 53; © De Agostini Picture Library / A. de Gregorio / Bridgeman Images: 9; © De Agostini Picture Library / M. Carrieri / Bridgeman Images: 70 (Castello Sforzesco, Milan); © De Agostini Picture Library / G. Nimatallah / Bridgeman Images: 6 (Santo Spirito, Florence); Harvard Art Museums / Fogg Museum, Gifts for Special Uses Fund, 1955.75, photo Imaging Department © President and Fellows of Harvard College: 47; © Isabella Stewart Gardner Museum, Boston, MA, USA / Bridgeman Images: 54; by kind permission of Lord Leicester and the Trustees of Holkham Estate, Norfolk / Bridgeman Images: 15 (Holkham Hall, Norfolk); © Erich Lessing / Art Resource, NY: 10 (Museo Nazionale del Bargello, Florence), 21 (Notre-Dame, Bruges), 35 (Medici Chapels, New Sacristy); image © The Metropolitan Museum of Art: 23; image © The Metropolitan Museum of Art, OASC, Rogers Fund, Transferred from the Library, 1941: 62, 63, 65; © Musei e Gallerie Pontificie, Musei Vaticani, Vatican City Mondadori Portfolio / Bridgeman Images: 42; photo © 2017 Museum of Fine Arts, Boston:

Readers are free:

> to share – to copy, distribute and transmit the work(s)
> to remix – to adapt the work(s)

under the following conditions:

> you must attribute the work(s) in the manner specified by the author or licensor (but not in any way that suggests that they endorse you or your use of the work(s))
>
> 'share alike' – if you alter, transform, or build upon this work/ these works, you may distribute the resulting work(s) only under the same or similar license to this one.

INDEX

Illustration numbers are indicated by *italics*.